CASSIOBURY

THE ANCIENT SEAT *of the* EARLS OF ESSEX

PAUL RABBITTS & SARAH KERENZA PRIESTLEY

AMBERLEY

First published 2014

Amberley Publishing
The Hill, Stroud
Gloucestershire, GL5 4EP

www.amberley-books.com

Copyright © Paul Rabbitts & Sarah Kerenza Priestley , 2014

The right of Paul Rabbitts & Sarah Kerenza Priestley to be identified as the Authors of this work has been asserted in accordance with the Copyrights, Designs and Patents Act 1988.

ISBN 978 1 4456 3863 8 (print)
ISBN 978 1 4456 3880 5 (ebook)

British Library Cataloguing in Publication Data.
A catalogue record for this book is available from the British Library.

Typesetting by Amberley Publishing.
Printed in the UK.

CONTENTS

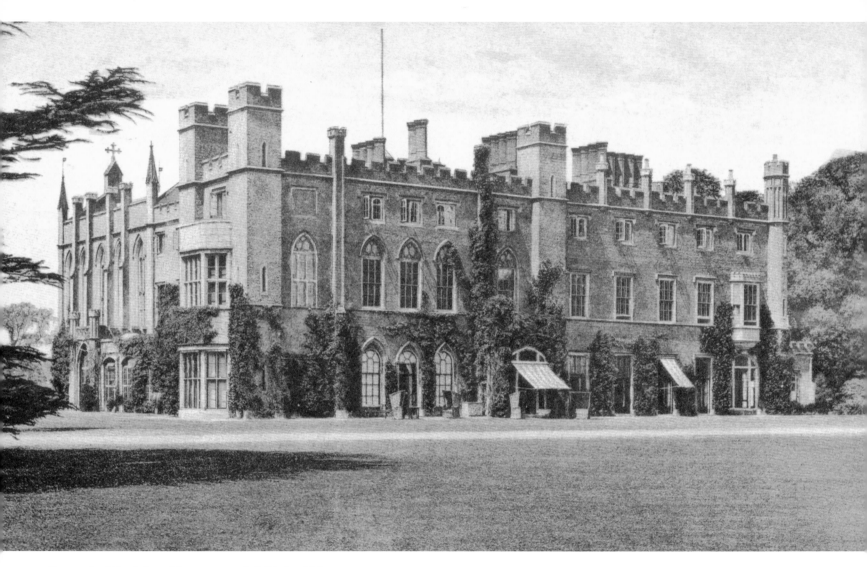

Postcard of Cassiobury House, *c.* 1906, © Watford Museum.

One Night (me thoughts) walking up one of my Lords line-walks, I heard the grateful Trees
Thus Paying the Tribute of their thanks to his Lordship:
Like Pyramids our Stately Tops wee'l Raise,
To Sing our Noble Benefactor's Praise;
Freshly we will to After-ages show
What Noble Essex did on us bestow;
For we our very Being owe to him,
Or else we had long since entombed been
In Crop of Bird, or in Beasts Belly found,
Or meet our Death neglected on the ground;
By him we cherish'd were with Dung and Spade,
For which wee'l recompence him with our Shade;
And since his kindness saw us prun'd so well,
We will Requite him with our Fragrant smell;
In Winter (as in Gratitude is meet)
Wee'l strew our humble Leaves beneath his Feet.
Nay, in each Tree, Root, Trunck, Branch, all will be
Proud to Serve him and his Posterity.

Moses Cook, 1676

ACKNOWLEDGEMENTS

Sarah Kerenza Priestley writes: That this is such a long acknowledgment is testament to the contribution of so many individuals and organisations to our understanding of the history of Cassiobury, and to so many who have supported me personally, and professionally, in my work at Watford Museum.

Firstly, my thanks go to Paul Rabbitts, for realising this dream for myself and the museum. Our partnership on this book has been a constant joy, which I hope is reflected in its pages. I must thank Mary Forsyth and Marian Strachan for their generosity and enthusiasm in sharing their knowledge of Cassiobury, and for being such a source of encouragement and inspiration to me. The team at Watford Museum, past and present, deserve everyone's gratitude for their commitment to the history of Cassiobury and Watford. Thank you to Luke Clark for his stewardship of the Cassiobury collections and assistance with the creation of this book and Sonia Sagoo, Naina Vadgama, Gemma Meek and Laura Horn for their support with the book and their friendship and dedication. Thank you also to Marion Duffin, Victoria Whitson, Lindsay Hayward, Victoria Barlow and Helen Poole, and to the army of museum volunteers and contributors, too many to list all by name but including Christine Orchard, Annette Kendall and Sara Smallwood.

Cassiobury's heritage been greatly developed through the work and support of Dr Laurie Harwood, Laurie Elvin, Vanessa Lacey, Justin Webber, Sian Finney-MacDonald, Jenny Milledge, and organisations including Watford Central Library, Hertfordshire Archives and Local Studies, Friends of Cassiobury Park, St Mary's church, Friends of Watford Museum, Art Fund, Hertfordshire Heritage Fund, National Portrait Gallery, British Museum, Courtauld, Tate, Friends of Little Cassiobury and Watford Football Club. Thank you to Dave Parker for his wonderful work in the photography of museum images for the book, to Nick Davidson for his design work, and to Graham Taylor OBE, Dorothy Thornhill MBE, Revd Tony Rindl, Kay Rees, Richard Walker, Alan Cozzi, Gary Oliver, Alan Gough, Tracey Jolliffe, *Watford Observer*, Peter Wilson-Leary, Chris Bennett, Sarah Costello, Robert Bard, Bridget Finch, Colin Bullimore, Gordon Cox, Ian Grant, Farzana Chaudry, Ruth Stratton, Karen Bell, Mo Mills, Jane Munns, Lesley Dunlop, Morag Kinghorn & the Mission and the Miscarriage Association, who have all played a part.

Finally I would like to thank two very special families – the Capells and my own. Thank you to Paul de Vere Capell, 11th Earl of Essex for his kindness and support, and to his distant cousins in California – William Jennings Capell, Viscount Malden, and his family; Sandy, Kevin, Jen, Freddy and Cooper for their dear friendship. I am so grateful to my parents, Sheila and Malcolm Jones, for inspiring me with a love of history and Watford, and for encouraging me to combine the two with my work at Watford Museum. Simon, Lynn and all my relatives deserve thanks, but most of all my gratitude to my husband, John, and daughter, Lowenna – who both love Cassiobury so dearly.

Paul Rabbitts writes: My earliest encounter with Cassiobury Park was my first day at work as head of parks and open spaces for Watford Borough Council in March 2011. I was not one of the privileged few to have a parking space in the town hall, so had to find an alternative solution. The nearest free space was the car park off Gade Avenue, at the bottom end of Cassiobury Park. As I nervously walked up through the park on a cold March morning, not knowing what to fully expect in what I hoped would be my dream job, I could not believe the scale of this place. Cassiobury Park was immense, the elongated avenues as I passed the Cha Cha Cha Tea Pavilion, reaching out a long way ahead of me, the silent, mature specimen trees to my left, and the heavy dew remaining on the croquet lawns. Walking back to the car that night, the view across to Whippendell Wood and the iconic Cedar of Lebanon, on the brow of the hill, was spectacular. This park is magnificent, and I love it, yet its story has never been fully told. Watford Museum has done much in researching the history of Cassiobury, the Capels and the Earls of Essex and beyond. In particular, the extremely passionate and knowledgeable Sarah Kerenza Priestley, Heritage and Arts Manager, who joined me on this venture – without her, this book would not have been possible. It has been a pleasure to work with her on it. At the same time, one of the most dedicated people to local history I have come across is Mary Forsyth, who works tirelessly at the museum, and my thanks go to her for her help. My thanks go to Laurie Elvin for advice and information on local archaeology. My appreciation also goes to Land Use Consultants, LDA Design and John Phibbs, garden historian, for their excellent interpretation of this landscape; Lesley Palumbo, Rona Clayton Robb and all my parks colleagues, past and present, at Watford Borough Council, and in particular Debbie Brady, Cassiobury's Community Park Ranger, for many of the wonderful photographs taken by her within this book. I would like to thank the Friends of Cassiobury Park for their daily commitment and never-ending love of the park – you are truly valued and not forgetting the Herts and Middlesex Wildlife Trust too. My final thanks to my family once again, for tolerating yet another obsession for the last twelve months – thank you especially to my wife Julie.

For Lowenna and Cooper – separated by over 5,000 miles, but both the future of Cassiobury.

FOREWORD BY FREDERICK PAUL DE VERE CAPELL, THE RIGHT HONOURABLE 11TH EARL OF ESSEX

The history of Cassiobury and the Earls of Essex goes back many hundreds of years. The work that Watford Museum has done in studying and detailing the history of this once great estate is to be admired. Yet the history of Cassiobury, the house, the park, the lodges and those that once lived there has never been captured into a single publication, and I wholly welcome this first book, *Cassiobury – The Ancient Seat of the Earls of Essex*. The story of the house and the estate, dating from the Morisons to the arrival of the Capels, to the rebuilding of the great Gothic masterpiece by Wyatt, to the wonderful park that now remains as a legacy to this once great estate – this book tells it all. I am delighted to support this, and hope that many people and future generations will continue to enjoy the Cassiobury of today, but with a greater understanding of how this now great park, came into being.

Frederick Paul de Vere Capell,
11th Earl of Essex, July 2014.

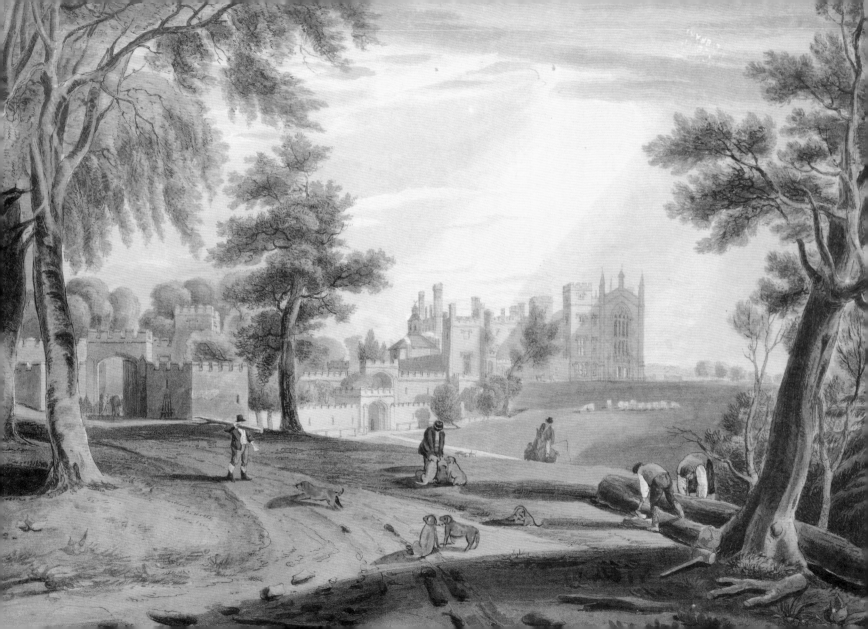

INTRODUCTION

Cassiobury Park bounds the western edge of Watford, lying at the eastern edge of the Chiltern Hills. This 300-hectare site is twice the size of Hyde Park. It is bounded to the north by the Grove parkland and adjacent agricultural land, to the south-west by woodland and agricultural land, to the south by a twentieth-century housing development, and to the north-east by the Cassiobury Park estate – a post-war housing estate of private houses laid out in spacious surrounds. Before the 1920s, the south-east boundary was marked by Rickmansworth Road, and the east boundary by Hempstead Road. The eastern tip of the park lies largely on level ground. West of the canal, the ground rises steeply to the plateau of Jacotts Hill, before descending westwards through Whippendell Wood. On a low hillside, sloping up north-east from the parkland looking towards Jacotts Hill, lies the former site of Cassiobury House, this area now being occupied by housing. The setting to the east and south is urban, and to the west and north is rural.

Left: Tinted engraving of the north-west front of Cassiobury, 1816. Engraved by J. Hill after J. M. W. Turner, from *The History and Description with Graphic Illustrations of Cassiobury* Park by John Britton, 1837, © Watford Museum.

Views extend east and south-east from the top of the eastern edge of Jacotts Hill plateau, across urban Watford to distant hillsides, including the hill on which the house formerly stood. Further views extend north from the edge of the park, across the Grove parkland.

Cassiobury Park is now the principal park for the town of Watford, serving not only local people but visitors from around the region, across Hertfordshire and from north London. But this park has a hidden history – it is the ancient seat of the Earls of Essex, who lived at Cassiobury House. But its history goes back much further – to the dissolution of the monasteries between 1536 and 1541. Yet taking a walk in the park in 2014, there is little recognition of this extensive history. It does not take long to find the park, as it is well signposted from most directions. Arriving in the car park at Gade Avenue, just ahead are the rather bizarre looking 'pepper pots' or 'dovecotes' adjoining the brash, but extremely popular, pools. On a hot sunny day, it is kept extremely busy as is the nearby miniature railway, bouncy castle and play area. There have been pools in the park since the early 1930s, and they are as popular today as they were then. This area is full of activity, is bold

in design and busy with people of all ages. Yet a short walk away, you can be lost in the relative peace and tranquillity of Pheasant's Island, and the local nature reserve, where the Friends of Cassiobury Park work tirelessly alongside the Herts and Middlesex Wildlife Trust. The River Gade and the Grand Union Canal dissect this area, and through the undergrowth can be seen the site of an old mill by a bubbling weir. The Iron Bridge lock and bridge offer great views up and down the canal, and if you dare venture further, the lime avenue is discovered – the gateway to Whippendell Wood. If you want solitude, the wood is the place to be and is seemingly a million miles away from the splash pads of the pools. Whippendell Wood is a truly magical place, famed for its carpets of bluebells every spring. Yet there is something formal about the place, hinted at by the lime avenue, the roundel at its apex and the many rides that radiate from it. It begs the question why?

Returning to the park, the pools are still vibrant with the sounds of children ringing in your ears. Yet, the park stretches out beyond you, with majestic avenues of trees lining the hill, popular with dog walkers, joggers, families out for the day, cyclists, and those heading into town nearby. Depending on your route, the Cha Cha Cha Tea Pavilion is certainly quieter than the pools, but extremely popular with young families who are there to enjoy a latté and to play. There is the bowling-green, home of Watford Cassiobury Bowls Club, the croquet lawns, home to the Watford (Cassiobury) Croquet Club and tennis courts, where the Grosvenor Tennis Club is based; many of the grass courts have been removed further along, but clearly sport is an important part of this park. As you near the end of the avenues, you can sense the hum of the busy Rickmansworth Road, which

becomes more of a drone as you get closer. The busy town of Watford is never far away. Returning back down the avenue which runs alongside the adjacent Cassiobury housing estate, one really gets the sense that history abounds in this place. Veteran trees are plentiful though appear strategically placed, and while views appear carefully planned, many of them seem compromised. A lone Cedar of Lebanon sits on the brow of the hill, overlooking the pools. Looking back towards Whippendell Wood and Jacotts Hill, the park visitor is actually stood in the middle of what was once an immense and vast country estate, looking from what was once the home park, towards the high park, of the former Cassiobury House and its vast estate, the ancient seat of the Earls of Essex and those before it. So what happened and why? What are the origins of this immense parkland? To understand the complete history of Cassiobury, it is important to appreciate the wider context of the rise and demise of the country estate nationwide.

When, in 1910, *Country Life* visited Cassiobury, it must have seemed like a fortress against the forces of the twentieth century. That was certainly the impression given in the article eventually written, where the house is described as:

> Set in great and delightful grounds and surrounded by a grandly timbered park. Therein is peace and quiet; the aloofness of the old-world country home far from the haunts of men reigns there still, and Watford and its rows of villas and its busy streets is forgotten as soon as the lodge gates are passed.

It is very clear that the twentieth century was pressing hard at the gates, and they would yield before long. The calm on which

Deep into Whippendell Wood, a formal ride delineated by a beech avenue.

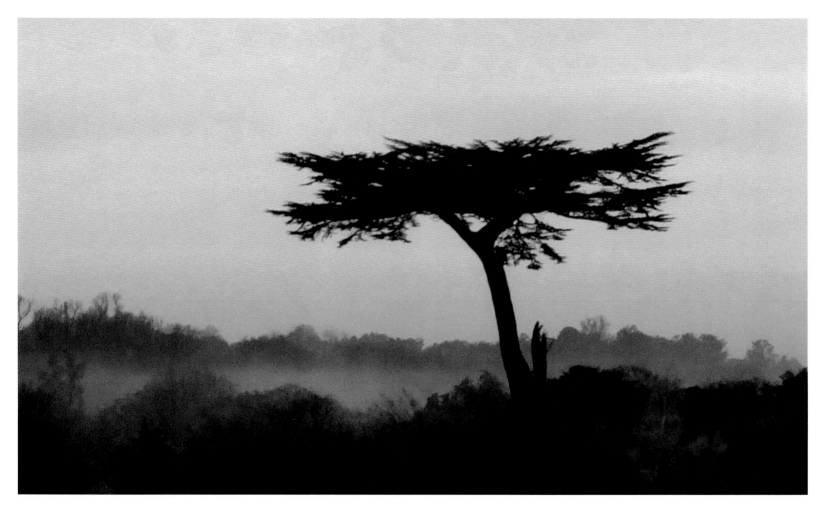

A misty morning over Whippendell Wood, and the solitary Cedar of Lebanon.

Country Life commented was not to last. In 1916, the 7th Earl of Essex, aged only fifty-eight, died after being run down by a taxi. Six years later, his widow and his heir, the 8th Earl, who was aged thirty-two, put the house and the park up for sale. The *Estates Gazette* commented, rather coldly, that Watford had recently grown into a great manufacturing centre and the estate offered the most natural expansion for the town, with much of the land ripe for building. The house was stripped of its fittings and its contents sold far and wide, with the subsequent demolition of the house in 1927. Parts of the park became a golf course, with some retained as public parkland and the remainder slowly developed as housing, only seventeen years since *Country Life* had visited.[1]

However, the demise of Cassiobury was not alone or unique. In the last 100 years there has been a severe decrease in the number of English estates, with a third having disappeared, and most reduced in size by 50 per cent or more since 1880. The reasons are many, and range from basic personal incompetence and extravagance to individual whim, which has led to the inevitable extinction of some old land-owning families. They have all played a part in the ruin and extinction of property. But it has not just been the horses, amateur theatricals or poor judgement. What has undermined the great estates in the last century has been large social change and economic decline, capital taxation to pay for two destructive world wars, occasional political hostility, not to mention relentless urbanisation and uncontrolled over-population, and it is these which primarily contributed to the loss of Cassiobury.[2]

The country estate is without doubt one of England's most enduring picturesque images. It is described by John Martin Robinson as 'a mellow country house surrounded by gardens, parkland, farms and woods with an attendant village or cottages, and a church with family tombs'. Between the seventeenth and nineteenth centuries, the ownership of a landed estate was also the basis of political power, when in England the landed aristocracy took over much of the role of government from the Crown, thus laying the foundations for late nineteenth and early twentieth-century parliamentary democracy.

The destruction of these landed estates in England runs parallel to the twentieth-century destruction of the English country house, as seen at Cassiobury, and shares several of the same causes, although the parallel is not exact. On many occasions, an estate survived when the principal house was demolished; on others, the house itself has sometimes survived in institutional use, sitting stranded when the supporting land has been broken up and sold, or at worst, built over. The nearby Grove estate for instance, was left by the Earls of Clarendon in the 1920s and it became the headquarters of the National Institute of Nutrition and College of Dietetics. It then passed into the ownership of the Equity & Law Life Assurance Co., from whom it was purchased for railway use and became the headquarters of Britain's largest railway company, and is now a luxury hotel. But generally, landed estates have disappeared under brick, tarmac and concrete, cut up by motorways and ring roads, built over by new towns and suburbs, airports, power stations and buildings for industry, retail and distribution, or flooded for reservoirs in the course of the twentieth-century.[3]

But what of the origins of these estates? In the early Middle Ages, an estate comprised wide areas of general jurisdiction, as well as the demesne farm of the owner. An estate, or *fief*, was

more an assemblage of customary rights and revenues than a physical unit. The Norman Conquest introduced to England the Frankish feudal system, whereby land was held by service to the Crown. This laid the foundations of the English estate as it developed over subsequent centuries and was partly responsible for the principle of primogeniture (inheritance by the eldest son or senior male heir), which has been the most distinctive and successful feature of hereditary English landowning. Over the centuries, English estates have been held together by the consistent application of primogeniture. Often this has involved descent to a sister's son, or more remote relation, rather than directly to a son of an owner, as he either did not marry himself or did not produce a male heir. A great many English estates have therefore passed through the female line, and a direct male-line descent of property from the Middle Ages to modern times in England is very rare.

It is, however, the Normans and Plantagenets who can be credited with several distinctive features of the English estate, not least the exploitation of its sporting uses, the invention of the park and the introduction of fallow deer, rabbits and organised hunting. Indeed, the deer park was *the* medieval status symbol.[4] By the fourteenth century, there were over 3,000 deer parks in England, some great landowners having several parks. As well as deer, they were stocked with other animals such as wild cattle. Medieval parks were also wooded, as one of their functions was to provide timber along with shelter for the deer. This is the origin of the 'forest glade' character of parks with alternating woods and grass, which was perpetuated for aesthetic reasons in later centuries. In the eighteenth century, some medieval parks were transformed into landscape parks, including Windsor, Hatfield and Petworth.

The sixteenth century saw a quickening of the market for land, with the transfer to private hands of large tracts from the Church and Crown. The grant and sales of church and monastic lands to private individuals had significant social and economic consequences, augmenting many existing landholdings and leading to the establishment of new estates, which perpetuated the monastic names: Woburn Abbey, Combermere Abbey, Beaulieu Abbey and Mottisfont Abbey to name a few. As well as expanding the holdings of the great owners, this dissemination of old church land swelled the ranks of the lesser landowners or gentry, often the descendants of lawyers or merchants, newly investing in land and establishing themselves as country squires. The new patterns of ownership varied from county to county. In Essex, Hertfordshire and Bedfordshire, the proximity of London led to an influx of courtiers, royal servants and administrators who established themselves as new landowners on the strength of the profits of the office. The estate landscape of Hertfordshire itself is essentially a sixteenth-century creation. Most of the western half of the county had belonged to the abbey of St Albans until the 1540s. Eleven former monasteries were converted into houses after the demolition of their churches, including Ashridge, Hitchin and Royston.[5] At the end of the sixteenth century, John Norden wrote of Hertfordshire, 'the Shire at this day is, and more hath beene heretofore, much repleat with parkes, woodes, and rivers.'[6] His 1598 map of the county, together with the earlier map by Christopher Saxton in 1577, and the county history by Sir Henry Chauncy in 1700, formed the basis for Evelyn Shirley's 1867 historical survey of the county's parks, in which he described thirty-one 'principal parks'. Nearly a century later, Lionel Munby described

Hertfordshire as a 'county of parks' and found evidence for around forty medieval 'hunting parks or game preserves'. Oliver Rackham considered Hertfordshire 'the most parky county of all … with ninety known parks.'[7]

The fluid land market continued under the Stuarts in the seventeenth century, with the large scale sales and dispersal of Crown lands, often to public servants, before, as well as during, the Commonwealth. The Civil War had a serious impact on English estates, with much destruction and general damage to property, felling of timber and fines for being on the wrong side. Much of the economic dislocation and damage was short-term, though several landowners lost part or all of their estates for ever. The situation improved after the Restoration, with more entrepreneurial management of estates, including agricultural improvements, with new crops, planting of woods and new rental systems. Thus, by the beginning of the eighteenth century, the English estate was ready for the 'age of improvement', the most enterprising phase in the history of English farming and landscape. The development of the English estate in the eighteenth century was a product of the Age of Enlightenment, and is a fascinating reflection of contemporary socio-economic, artistic and scientific ideals and theories. The distinctive English aesthetic – the Picturesque – emerged out of the eighteenth-century landowner's way of looking at his estate and his plans for improving it in the manner of landscape painting. Many of the important eighteenth-century intellectual concerns – Utilitarianism, neo-Classicism, science, Romanticism, moral humanitarianism, the cult of the simple life – were reflected in estate management, and given permanent form by agricultural and landscape improvement.[8]

The economic success of the Georgian estate was combined with aesthetic improvements that transformed the appearance of the English landscape. Reforestation of England, following extensive clear-felling in the sixteenth and early seventeenth centuries, especially during the Civil War, began after the Restoration, with the advocacy of the newly founded Royal Society. The diarist John Evelyn, whose book *Sylva: A Discourse of Forest Trees* (1664) was intended, as he put it in his dedication to Charles II, to encourage 'furnishing your almost exhausted Dominions with more than two million of timber trees'. Evelyn urged a massive tree-planting programme not just for utility and profit, but also for aesthetic reasons because trees and woods were the means of creating an ideal landscape. In the course of the late seventeenth, eighteenth and nineteenth centuries the English estate was transformed. In its early phases, this meant a Franco-Dutch formal landscape with avenues, long straight rides, symmetrical terraces, geometrical layouts and canalised ponds – as recorded on so many occasions in Kip and Knyff's engravings published in *Britannia Illustrata*, 1707. The idea of planting a whole estate to resemble one natural landscape painting, to form beautiful prospects when viewed from the house or its grounds, or from considered vantage points in the locality, was made possible by the invention of the sunken fence by Charles Bridgeman, royal gardener, in his influential landscape layout at Stowe, Buckinghamshire, *c.* 1720. The most famous of the great landscape designers were 'Capability' Brown (1716–83), who supervised the damming of lakes, planting of shelter belts and clumps, plus the levelling and moving of earth, and Humphry Repton (1752–1818), whose manner was popularised by his

famous published *Observations on Landscape Gardening*. Repton's manner was richer and more intricate, less classically Arcadian than Brown's more densely wooded, more 'inhabited' and ornamental, landscapes.

The Georgian improvement of the landscape was not simply motivated by agricultural progress, and a desire for visual enhancement, but also through the need to create and maintain habitats for game and field sports. Sport had been an essential feature of the country estate since the Normans, with their deer parks and hunting forests. This was still very much the case in the eighteenth and nineteenth centuries, with the development of new formalised types of hunting and shooting: fox hunting and driven game shooting.

The Victorian period saw the heyday of the large landed estate with huge numbers of staff, private cricket grounds and festivities to celebrate local and national events. The developments of the previous century now came to fruition, as trees and landscapes matured and sporting became formalised with seasons for hunting, shooting and fishing. However the high Victorian estate did not significantly differ from the late Georgian estate, and was largely the product of developments in the previous century. Estates continued to expand until the 1850s, with agricultural production and revenues doubling between 1820 and 1850. The English estate in the 1860s was an economic entity, which perfectly combined profitable farming with sport, social concerns, fine architecture and superb picturesque landscaping. It was uniquely successful in modern economic development in its synthesis of high culture, and commercial aims. Its owners, who were well-educated, took the lead in local life as lord lieutenants, high sheriffs, justices of the peace and patrons of charities. The estate was the backdrop to this practical and ceremonial activity. Impressive lodge gates formed an overture to the architecture of the 'big house'. Situated in a large, beautiful park and wonderfully maintained pleasure grounds, a large nineteenth-century country house was a community itself, with acres of outbuildings: stables, kennels, laundry, brew-house, workshops, building yard, sawmill, ice-house, walled kitchen garden with extensive glasshouses, dairy, gasworks, water pumping house, riding school, tennis or squash court, and possibly even an aviary. Country house parks were also regularly used for military camps, reviews and training, so a number had rifle ranges. The Victorians perpetuated the Georgian picturesque aesthetics by careful professional management. The estate landscape is one of the greatest cultural achievements of the English. In the 1860s, they were at their most brilliant.

It was not to last. This paternalist idyll was shattered by the great agricultural depression that administered a severe blow to the economic foundations of the Victorian estate, in the last decades of the nineteenth century. Indeed, it proved to be the forerunner of the insoluble financial problems that, in the course of the twentieth century, toppled Britain from world economic dominance. The reasons for changes in ownership and the break-up of historic estates are numerous and complex; they also vary from property to property. They have included basic ineptitude, irresponsibility, and simple poor management on the part of owners. Yet the series of agricultural depressions between 1870 and 1896, after thirty years of constant prosperity came as a great shock. By the 1880s, when the landed estate as the focus of English country life seemed to be at its zenith, the political and economic power of the landed interest was already

in decline. England had changed in the fifty years after the death of George III, from a country where the rural population was in the majority to an overwhelmingly urban nation. By the 1880s, the great masses of people lived and worked in towns. Anxiety grew about the purpose and security of a landed estate, which nevertheless made those who were often still rich, and playing a traditional role in national life, lose their nerve and retreat. From the 1880s onward, estates were sold in increasing numbers. In some cases they were bought by new money and kept together as estates. In other cases, they were broken up and sold to tenant farmers or for building development in areas near towns.

But this defeatist attitude and gloom among the Edwardian upper classes was exacerbated by the policies of the Liberal Party, who had significant issues and concerns in relation to land reform. In the 1860s, there had begun a debate about aristocratic monopoly of landholding, with claims that fewer than 150 men owned half of England. With the increasing economic uncertainty facing landowners after the 1880s, and the threats of land taxes or worse, exacerbated by radical and Liberal attacks, many were frightened into divesting themselves of land. Between 1885 and 1920, the radical campaign against the 'landed monopoly' had a significant impact on the policies of the great landowners. In 1894, Lord Harcourt, the Liberal Chancellor of the Exchequer, introduced estate duty, with the maximum rate at that time being 8 per cent on estates worth £1 million, though it was soon to increase.

The introduction of death duties, by the Liberals, is in retrospect the event generally regarded as the most serious threat to landed estates, as it meant that property had to be sold every generation in order to pay the resulting tax. After one or two generations, not enough was left to be economically viable, and eventually whole estates were liquidated as a result. The death of heirs in the First World War, as well as occasionally incurring multiple death duties, also discouraged landowners, and made them feel it was no longer worth carrying on. Lloyd George saw landed estates not so much as an important element in the rural economy, to be encouraged at a time of agricultural depression, but as a source of government revenue to be taxed accordingly. In 1906, the Liberal government gave county councils compulsory powers to purchase land for smallholdings. This legislation, and the resultant political posturing surrounding it, was seen as a direct attack on landed society and the landed estate.[9] The fiscal policies of the Liberals, with the threat of worse to come, and the dark shadow of land nationalisation, advocated by the more ardent reformers and radical theorists as a solution to the 'land question', encouraged landowners to sell at least part of their estates and invest in safer options. In the period up until the outbreak of the First World War, it has been estimated by F. L. Thompson in *English Landed Society* that 800,000 acres of land were sold, equating to roughly 200 estates. This continued throughout the period of the war. The 1920s saw the real break-up and dispersal of the English landed estate. Higher taxation, death duties, the relentless decline in income from landed property, and cultural pessimism all combined to encourage selling. *The Times* wrote in 1920: 'England is changing hands. The sons perhaps lying in far-away graves; the daughters, secretly mourning someone dearer than the brother, have taken up some definitive work away from home and the old people knowing there is no son or near relative left to keep up the old traditions, or so crippled by necessary taxation take the irrevocable step...' Nearly 1,000 country houses were

demolished between 1945 and 1955. Some houses were retained for institutional uses, others converted to golf clubs, country clubs or hotels, with their respective estates sold off.

Those that survived saw a gradual up-turn by the mid-1950s. The Labour Party, in power since 1945, were more interested in nationalisation of industry rather than land, but also in introducing fiscal policies to encourage agricultural improvement. This stimulated landowners with high taxable incomes to invest in their estates on a scale not seen since before the agricultural depression of the 1870s. The turning point was 1953, when those who had not succumbed to despair and had held on at least to the nucleus of family estates found it easier to continue there, and make a living from farming and opening to the public. Effective protection of listed buildings, from 1968 onwards, and the more favourable tax system introduced in the 1980s, also helped the situation, as well as the impact of the National Trust. Despite these initiatives, the twentieth century saw a continual and steady decline in the overall number, and size, of privately owned historic estates.[10] Despite these losses, a large number of landed estates have survived and many have quietly thrived. But the fact that up to a third of established landed estates in England have disappeared in the past hundred years, is still a matter of deep regret to some.

And so we return to the loss of the Cassiobury estate – the seat of the Capels, the Earls of Essex, and their Morison ancestors from 1546 to 1922. As described earlier in the *Country Life* article, it was very clear that the twentieth century was pressing hard at the gates, and they certainly would yield before long. The history of Cassiobury echoes the rise, and demise, of many of our greatest English estates.

When John Evelyn visited in 1680, Cassiobury was a 'pleasant hunting domain, not far from London but still deeply rural and owned by the ambitious Arthur Capel, 1st Earl of Essex, Lord Lt of Ireland in 1672 and First Lord of the Treasury in 1679'. The house was described by Evelyn as a palace, with impressive interiors including fine examples of the carving and plasterwork that flourished in the last decades of the seventeenth century. Yet, despite the involvement of eminent landscape gardeners, such as Moses Cook, Humphry Repton, George London and Charles Bridgeman and renowned architects such as Hugh May and James Wyatt, nearly 250 years later Cassiobury was also to disappear. The sale of its entire contents in June 1922 was a massive affair, lasting ten days, and the house was demolished soon after, in 1927. So what happened? Why did Cassiobury, like so many of these other country estates, disappear? Who were the Morisons, the Capels and the Earls of Essex, and what was their impact on Watford and the surrounding area? Significantly, what is their legacy? This is the story of Cassiobury – the ancient seat of the Earls of Essex.

Cassiobury House from the south west, 1815, John Chessel Buckler. A watercolour view showing the Gothic additions to Cassiobury House, by James Wyatt between 1799–1805, © Watford Museum.

I

THE MORISONS OF CASSIOBURY

The well documented history of the house and park begins with the arrival of the Morisons. But Cassiobury, and its earliest origins, go back many years before the arrival of them. The name Cassiobury has stimulated debate for decades among historians. Indeed, recent discussions about the origins of the name Cassiobury have concluded that it is probably derived from an Anglo-Saxon man's name, *Caeg*, with *hoh* (spur of land). This gives the earliest known name for this area as '*Caegesho*', which appears in medieval charters. The local topography makes this a credible explanation. The spelling changed during the early period, but the addition of '-bury' has not been found before 1509, when it appears as '*Cayeshoobury*'. In 1544 it was '*Cayshobure*', and in 1545 both '*Casshobury*' and '*Cayshobury*' were in use. The addition of '-bury' to a name at this period was used to indicate a manor house, and does not mean that there was a '*burh*' here (an Anglo-Saxon fortified site), as has been suggested in the past by many.

Cassiobury itself first enters early written records when it was part of the manor of Cassio (or Cashio), which was a vast area of land belonging to the abbey of St Albans. The abbey chronicles, written in the medieval period, claimed that this manor had been given to the abbey by King Offa of Mercia in 793, though there is no earlier evidence to support this. 'I saw Watford and Rickmansworth, two market towns, touching which we have no account, until we find that King Offa bestowed them upon St Alban, as also he did Caishobery that lyes next to Watford.'[1]

Unfortunately, on many other occasions, misguided attempts have been made to connect the name Cassio with the British tribe Cassii, whose leader, Cassibelinus, is said to have had a stronghold at Verulanium.

> The name of Cassiobury is said, and with reason, to be derived from the Cassii, a tribe of the Britons who occupied the district, and whose strong-hold, Verulanium, lies only a few miles away. The Cassii were, at the time of the landing of Julius Caesar, commanded by Cassivelanu, under whom they fought many battles with the invader.[2]

Antiquarian writers often liked to make this kind of link, though there is no evidence of such a link. Nevertheless, several writers,

and later research, has indicated a distinct lack of support for this theory. Camden, in 1607, called it 'conjecture', Skeat, in 1904, stated they were 'wild theories', and more recently, Rivett & Smith in 1979, argued it was 'misguided'.

The manor of Cassio is included in the *Domesday Book* of 1086, as part of the property of the abbey. It is described as including meadow and pasture, as well as having enough woodland to support 1,000 pigs, which suggests that the area was indeed heavily wooded. The manor, including what became the Cassiobury estate, remained the property of the abbey until the sixteenth century. Nevertheless, it was far more likely that the St Albans property at Cassiobury consisted of one or more farmsteads surrounded by fields and woodland. Another logical explanation of any pre-Dissolution finds on the site could be that when the abbot's bailiff came to see how the land here was being used, he needed somewhere to shelter, if not stay overnight.

It was Henry VIII's reformation of the Church in England, which included closing the monasteries, which had important consequences for the structure, layout and governance of the Manor of Cassiobury. From 1539, the manor was effectively under new ownership, and the rule of the abbey of St Albans was over. For Henry's friends, the Reformation and Dissolution of the Monasteries was great news. Suddenly, there was an extraordinary amount of wealth in the form of chattels and estates. In 1545, Sir Richard Morison, a favourite of Henry, was able to buy Cassiobury as well as land in Yorkshire, and a new era was soon to begin.

Henry however, first gave Cassiobury to John Russell (whose tenant, William Dauncey, occupied it for a while), and then eventually, to Richard Morison MP. Included in the grant were the woods of Whependen Grove and Cashio Grove. Morison was a loyal supporter of both Henry VIII and Edward VI, on whose behalf he undertook diplomatic missions abroad, and he was well recompensed for his loyalty to the monarch. Of Richard Morison's rise to fortune we are told by Chauncy:

> The time of his [Morison's] Youth, bred up in the university, where he studied Philosophy; and when he had attained to some perfection of knowledge in the Latin and Greek tongues, and the liberal arts, he removed thence to the Inns of Court, where he became well skilled in the common and civil law, and by reason of his great learning, obtained much esteem and favour with King Henry VIII and Edward VI so that they often employed him upon several ambassages to the Emperor Charles V...

Poole describes Morison's origins as rather obscure, with references to him being born in Yorkshire as well as, more locally, in Hertfordshire. Richard was typical of the new breed of men coming to the fore on their merit, rather than by influence of money or family. In 1536, he wrote to Thomas Cromwell, 'I would not now wish to have been born of rich parents; it is almost thought disgraceful in England to be noble and learned.' Nonetheless, life was certainly not easy for Morison in his early years, as his letters are full of appeals for money, though he remained buoyant and earned the nickname of 'merry Morison'. His university days had obviously provided Morison with valuable contacts. In October 1533, he wrote to Thomas Cranmer to applaud him on becoming Archbishop of Canterbury and to request his patronage. He soon turned his

attention elsewhere, and began a long sequence of letters to Thomas Cromwell. These began in 1534, and Cromwell seems to have first employed Morison in late 1535. Cromwell's main use for Morison was as a propagandist, for which there was great scope during the turbulent period following Henry's break with Rome, and all that this implied in religious and social terms. Morison's words proved popular with his political masters, and on 17 July 1537, he was made prebendary of Yatminster in Salisbury cathedral. His successful career path continued, producing further work in support of the king. His usefulness was underlined by his eventual appointment to parliament on 17 March 1539. His diplomatic career was soon to follow, and grants of land and property continued to come his way, from the library of the Carmelites in London to former monastic lands in 1541. On 25 August 1546, Henry VIII granted the manor of Cashio to Morison 'in consideration of certain other property in Yorkshire and Worcestershire and of the sum of £176 17s 6d in money.' At the same time, he was sent as ambassador to the Hansa towns and, in 1547, he was sent to Denmark to announce the accession of Edward VI to the king there. At this time, he had an annual pension of £20, plus his ambassadorial pay, which was not very high and was frequently in arrears. On 8 May 1549, he was made a commissioner to visit the University of Oxford.[3]

Morison was knighted in 1550 and not long after, in July of that year, was assigned to the court of the Holy Roman Emperor, Charles V, the most significant of his ambassadorial postings. Morison was thorough in his work, and keeping the council apprised of his actions. Yet, Morison was not always the most diplomatic of ambassadors, and relationships were often difficult with the Catholic Emperor. Apart from political difficulties, Morison also had other problems. In May 1552, the council deliberated how they were to pay the £600 due to Morison, which must have caused him problems. When he left Augsburg, he was so short of money that he had to resort to moneylenders to pay off his creditors.[4]

At Cassiobury however, Morison had commenced building a house that would match his rising status, with a lodgings wing suitable for accommodating visiting parties from court.

> [In] the lodgings ranges of larger houses ... to ensure the greater privacy to which dignitaries were entitled, each lodging either had its own separate staircase or was reached without passing another set of rooms ... Cassiobury Park, Watford, the placing of the stair vices on the outer wall of the lodgings range establishes that there was internal access to them, possibly by a transverse passage direct from the courtyard.[5]

Morison was responsible for 'a fair and large house in this place'. It may be that he also created parks in the grounds, but Saxton's map of 1577 does not show a park at Cassiobury, and no documentary reference to such a feature occurs before 1632.[6]

Sir Richard's house was still unfinished when the accession of Mary Tudor in 1553 placed him in a politically vulnerable position. In April 1553, there were moves to replace him on grounds of his, and his wife's, poor health. One of the few state papers issued by Lady Jane Grey as queen had confirmed Sir Philip Hoby and Morison as ambassadors to the Emperor. On 5 August 1553, they were both summoned home by the new queen, Mary I, who was unlikely to promote a man described

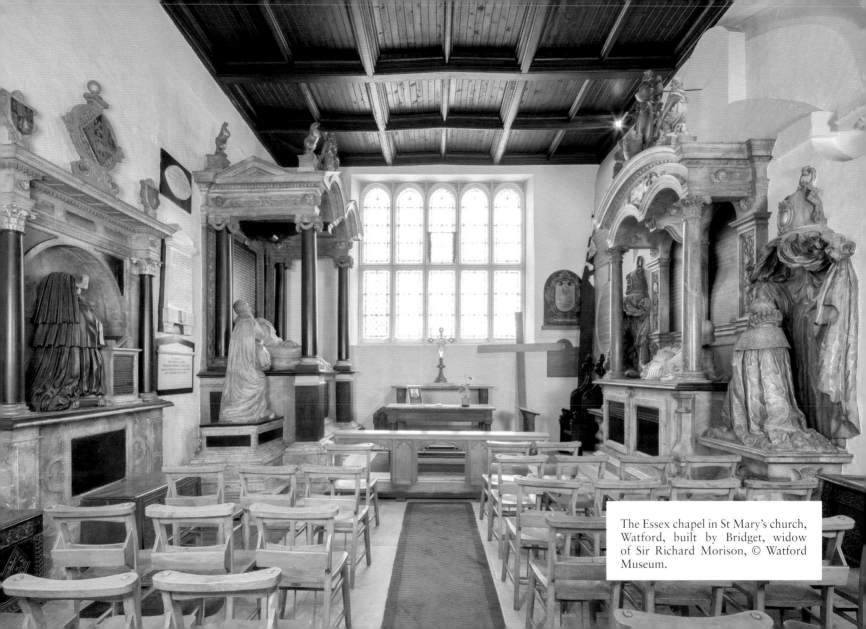

The Essex chapel in St Mary's church, Watford, built by Bridget, widow of Sir Richard Morison, © Watford Museum.

by the Bishop of Arras as 'one of the most obstinate heretics in the world.' Morison's career was basically over, and he was 'forced to fly beyond the seas' and died in 1556, in exile in Strasbourg. As his son, Charles, was still a minor, the estate was administrated by his widow, Lady Bridget – a formidable lady who went on to remarry twice, to the Earl of Rutland and the Earl of Bedford, and outlived her son. In due course, Charles Morison continued work on the house and ultimately completed it. This would have been expensive, and despite Richard Morison's frequent references to his poverty, there is evidence that he died a rich man. 'The seat is elegant, the situation as well chosen as the county affords; upon a dry spot within a park, facing the south-east sun, with the river at a proper distance below it, and a pleasant hill behind it.'[7] While he was not as important a figure nationally, like his father, Charles was clearly a person of some substance in the county. In 1579–80, he was sheriff of Hertfordshire, and in 1588 he was knighted. In his 1559 will, he makes additional provision for the almshouses and also leaves to his wife, Dorothy, a farm called Tooley.

Morison's wealth was undeniable, he was clearly interested in property, and his career illustrates the family's social standing. Charles himself married Dorothy, the widow of Henry Long of Shingay, Cambridgeshire. The couple had four children, the eldest being Bridget, born in 1575, who was to marry the Earl of Sussex. She was followed by two sisters, who both died young, and finally came the long awaited heir, Charles, born on 18 April 1587. The Essex chapel, where Dorothy and others were to lie, was the creation of Bridget, his mother, who followed the fashion of the times by building it before they died.

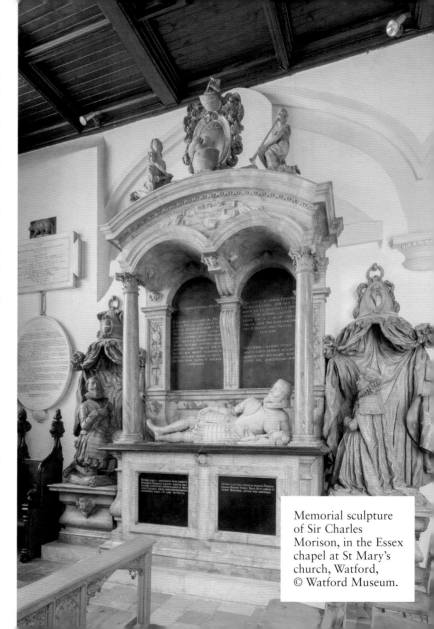

Memorial sculpture of Sir Charles Morison, in the Essex chapel at St Mary's church, Watford, © Watford Museum.

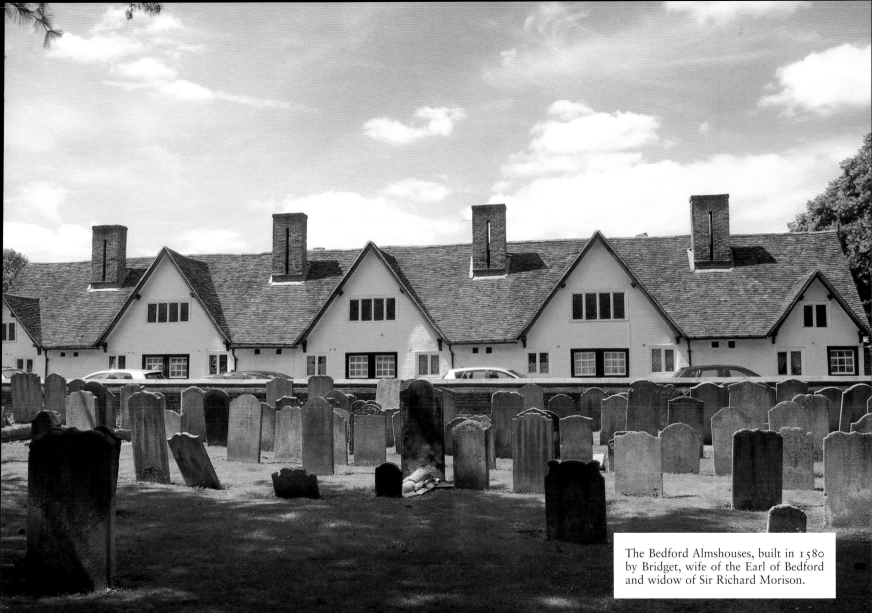

The Bedford Almshouses, built in 1580 by Bridget, wife of the Earl of Bedford and widow of Sir Richard Morison.

This formidable grandmother, Bridget, Dowager Countess of Bedford, died on 12 January 1601, and was buried in her new chapel. On the inscription, she was described as;

> a woman of singular sincerity in religion, in cyvill conversation and integritie of life unspotted, in hospitalitie, bountifull and provident, in all her actions discrete and honourable, in great favour with her prince, and generally reputed one of the noblest matrons of England for her wisdom and judgement.

Dame Dorothy Morison inherited Cassiobury on her son's behalf, and held the court until he was old enough.

Under the ownership of Sir Charles's son, also Charles, Cassiobury underwent a considerable expansion, significantly helped by the advancement of his own political career. He was made a baronet in 1611, became Deputy Lt of the county in 1618, and was an MP from 1624 onwards. In 1606, he married Mary Hicks, daughter of the wealthy London merchant Baptist Hicks, who was rich enough for both of his daughters to have a fortune of £100,000. Additional manors were added to the estate through the generosity of Hicks, and in the 1620s Morison purchased new properties, including Leavesden Wood (1625) to the east, and Jacketts Farm (1620), which would eventually become part of the high park.[8] John Speed's map, from 1611, shows the area of the high park surrounded by a pale. One would certainly expect someone of Morison's status to possess a deer park, and the lodge in high park, referred to in later surveys in 1685, may have been built in the seventeenth century as a hunting lodge or banqueting room. Maps from 1676 (Seller) and 1695 (Oliver) certainly show a park at Cassiobury, with both maps indicating a name of Cashio lodge within the park.

During Tudor times, an increased level of prosperity, brought about by the expansion of foreign trade, foreign influences were certainly felt in art, architecture and gardening. A wave of domestic building followed, which was to guarantee the survival of medieval parks, not only as game preserves but in their new role as an amenity of the house. Park making was soon to become so widespread, that a commission was set up to enquire into the number of new parks and the enlargement of old ones. Large numbers of manor houses were built. A deer park and a garden were now prerequisites for both houses and palace. It was said that 'any manor house of any pretension had a deer park … sometimes two, one for fallow deer and one for red.'[9] Between the years 1570 and 1620, more new country houses were built in some parts of England than in any other half century. By Queen Elizabeth's reign, it was clear that a park had become the sign of a gentleman; 'as much a demonstration of social rank as the pedigree and coat of arms'. Shakespeare imports this sixteenth-century emphasis into *Richard II*, where he has Bolinbroke berate his enemies for having

> Dispark'd my parks and felled my forest woods
> … leaving me no sign, -
> Save men's opinions and my living blood, -
> To show the world I am a gentleman.[10]

It was now accepted that a 'park replete with deer and conies is a necessary and a pleasant thing to be annexed to a mansion.'[11] Moreover, as manor houses were increasingly sited in or nearer

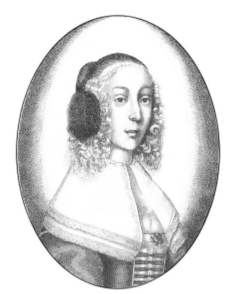

Left: Engraving of Elizabeth Morison, © Watford Museum.

Below: Memorial sculpture depicting Charles Morison, © Watford Museum.

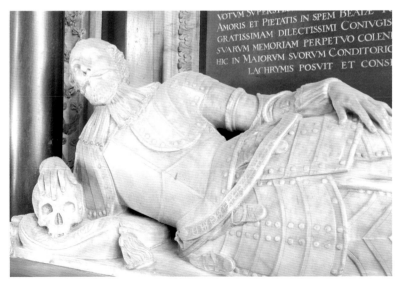

their parks, so aesthetic considerations began to play a greater part, and writers urged their patrons to choose appropriately 'divers groundes' for their parks. The county maps of England made by the cartographer Christopher Saxton, between 1575 and 1580, show some 817 parks scattered throughout England.

At Cassiobury, significant changes were afoot. Dorothy Morison had died in 1618, and Dame Mary Morison also outlived her husband, marrying secondly Sir John Cooper of Wimborne St Giles, Dorset, who died in 1631, and then Sir Richard Alford. Though Sir Charles had two sons, called Baptist and Hicks after their wealthy grandfather, they both died as infants. The only surviving child was Elizabeth, who was baptised in Watford parish church in August 1610. In 1628, Sir Charles Morison died and Cassiobury passed to his daughter, Elizabeth. A year earlier she had married Arthur Capel of Hadham Hall, near Bishop's Stortford, and these two estates were thus brought together. In Arthur Capel, Cassiobury now had an owner who was a keen and innovative gardener, though evidence does suggest that he actually spent little time at Cassiobury, preferring to devote himself to his existing gardens at Hadham. In 1641, he was made Baron Capel by Charles I, and to celebrate this ennoblement he commissioned Cornelius Janssen to paint a family portrait. In the background, yet prominently in view, is an elaborate formal garden, believed to be at Hadham Hall. The Capels had now arrived at Cassiobury.

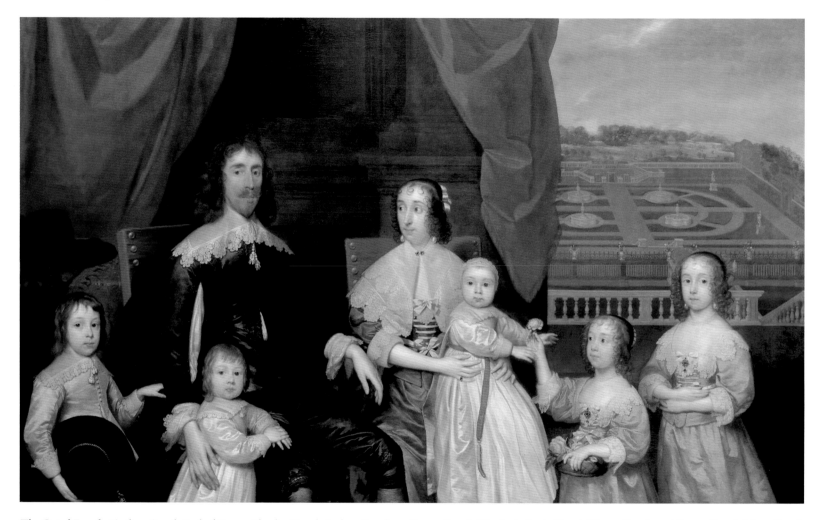

The Capel Family (Arthur Capel, Earl of Essex: Charles Capel; Arthur Capel, 1st Baron Capel: Elizabeth, Lady Capel: Henry Capel, 2nd Baron Capel: Mary Capel, Duchess of Beaufort: Elizabeth, Countess of Carnarvon): artist Cornelius Johnson (Jonson or Jonson van Ceulen). © National Portrait Gallery, London.

2

CASSIOBURY AND THE CAPELS

With the arrival of the Capels to Cassiobury, so began a new chapter in the history of the estate. Still, no sooner had Arthur Capel arrived on the scene, than his rising fortunes were to be halted by the Civil War (1642–51), during which he was active in the Royalist cause. Cassiobury was sequestrated and, in 1645, granted to Robert Devereux, the then 3rd Earl of Essex of the sixth creation, who let it to Lady Brereton. His father was also called Robert Devereux, who was successful in defeating the Spaniards in the Battle of Cadiz, taking the town in June 1596. Devereux died in 1646, and the estate was granted to a member of the Herbert family. Their impact on Cassiobury was likely to have been minimal. Towards the end of the Civil War, in 1649, Capel was arrested, charged with treason and rebellion. He was sentenced to beheading at the Tower of London. As he stood on the scaffold, his last request was that his heart should be taken from his body and placed in a silver box at the feet of Charles I in his grave. His wish was never granted, with the discovery of the box over sixty years later. His heart was placed in the family vault, but his headless ghost is said to walk the park, in early March every year. After his execution, his widow and family remained at Hadham Hall until the Restoration in 1660.

Capel's sons soon re-established the family's place at the centre of public affairs – and its reputation in gardening. The younger, Henry, later Baron Capel of Tewkesbury, continued his father's work at Kew, and laid the foundations for what would later become the Royal Botanic Gardens. Arthur, the older son, was born in 1631, and married Elizabeth Percy, daughter of the Earl of Northumberland, in 1653, became *Custos Rotulorum* and Lord Lt of Hertfordshire in 1660. In 1661, he was made Viscount Malden and the Earl of Essex, (now the seventh creation). Arthur's early education was curtailed by the Civil War, but he appears to have been self-taught in Latin, mathematics, and, in the words of John Evelyn, 15 April 1680, was 'very well vers'd in English historic and affaires, industrious, frugal, methodical, and in every way accomplish'd.' He suffered a traumatic childhood, having been captured in battle by the Roundheads, being used to bargain for the release of their soldiers held prisoner by the cavaliers, as well as suffering his father's beheading. Yet his devotion to

the Crown was suitably rewarded. In 1672 he was given the important post of Lord Lt of Ireland.[1] This post was the British monarch's official representative and head of the Irish executive, during the Lordship of Ireland (1171–1541), the Kingdom of Ireland (1541–1800) and the United Kingdom of Great Britain and Ireland (1801–1922).

Now a man of rising status and influence, he required an imposing residence. In 1668, the Earl of Essex, Arthur Capel, moved to Cassiobury and began a major transformation of the house and grounds. The architect chosen for the house was Hugh May. By the 1660s, May's profile as an influential surveyor was significant, and he was appointed as comptroller of the King's Works in 1668. May was one of the four surveyors appointed to rebuild London following the Great Fire of 1666. His most notable commissions included alterations to Eltham Lodge, London; Cornbury House, Oxfordshire; and Moor Park, Hertfordshire. Diarist John Evelyn suggested that the original intention at Cassiobury was to simply make alterations, but in the event it was almost entirely rebuilt. Only the Tudor lodgings range in the west wing was retained, and sat rather oddly beside the classical pilasters and pediments of the new central range and east wing;

The old north wing of the house which was built in the 'H' form was probably of an earlier date than the grant to Sir Richard Morison, and its bay windows and plastered walls and the form of its chimney shafts showed a monastic character, possibly indicating its connection with the abbey of St Albans. Since the time of Charles Morison, who completed the house, many additions and improvements were made. The 1st Earl of Essex

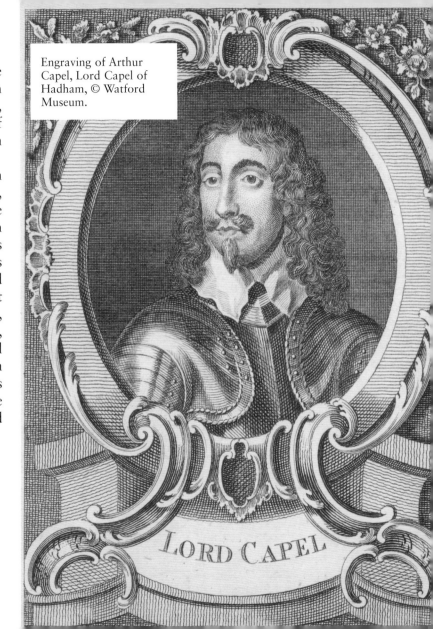

Engraving of Arthur Capel, Lord Capel of Hadham, © Watford Museum.

LORD CAPEL

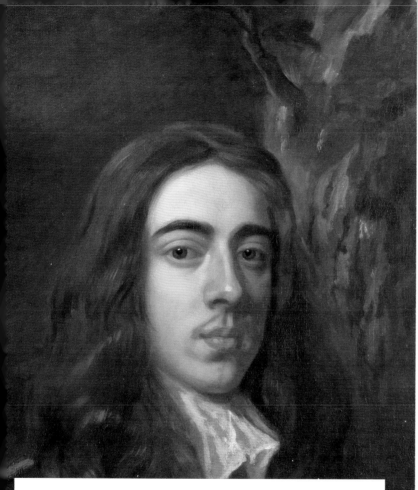

Arthur Capel, 1st Earl of Essex (1631–83): Circle of Sir Peter Lely. One of fourteen portraits donated to Watford Museum by Lady Essex, in 1989. Arthur's early education was curtailed by the Civil War, but he appears to have been self-taught in Latin, mathematics, and, in the words of John Evelyn, 'was very well vers'd in English historic and affaires, industrious, frugal, methodical, and in every way accomplished', © Watford Museum.

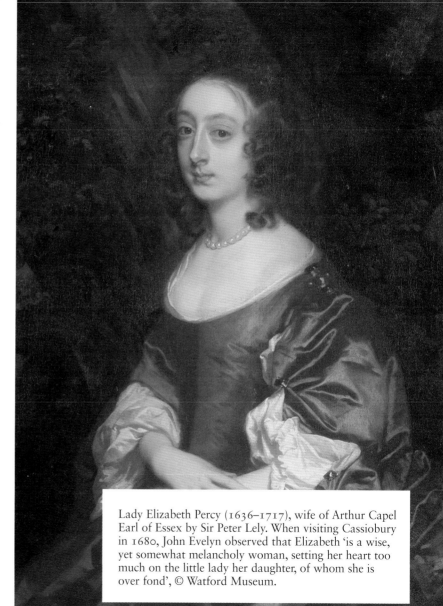

Lady Elizabeth Percy (1636–1717), wife of Arthur Capel Earl of Essex by Sir Peter Lely. When visiting Cassiobury in 1680, John Evelyn observed that Elizabeth 'is a wise, yet somewhat melancholy woman, setting her heart too much on the little lady her daughter, of whom she is over fond', © Watford Museum.

rebuilt the house, with the exception of the west wing, and in laying out the gardens he employed Moses Cook.[2]

There have been frequent assertions that the famous French designer André Le Nôtre (1613–1700) laid out the gardens and walks at Cassiobury. Andre Le Nôtre followed his father as head gardener at the Jardin des Tuilleries in Paris, and also studied fine art in Paris. The parks which Le Nôtre designed at Vaux-le-Vicomte and Versailles are the supreme examples of the French seventeenth-century style of garden design. Daniel Defoe, despite never visiting Cassiobury, in his *Tour Through the Island of Great Britain* (1748) described Cassiobury's situation as,

> the best in the county, upon a dry spot, within a park of large extent; the house is elegant, and built in the form of an H … In the front of the house is a fine dry lawn of grass … and a little below the house is a river, which winds through the park… affording great plenty of trout, crayfish, and most other kinds of freshwater fish. On the north and east sides of the house are large Wood Walks, which were planted by the famous *Le Nôtre*, in the reign of King Charles II. The woods have many large beech and oak trees in them, but the principal walks are planted with limes, too narrow for their length, and two regular for the modern taste.[3]

Despite Defoe's and others' assertions, it is unlikely that Le Nôtre was ever involved at Cassiobury.

The name most unequivocally associated with Cassiobury's late seventeenth century landscape is that of Moses Cook. Little is known of his early life. His family home was in Lincolnshire, and it is assumed that he was the son of a yeoman farmer, as he

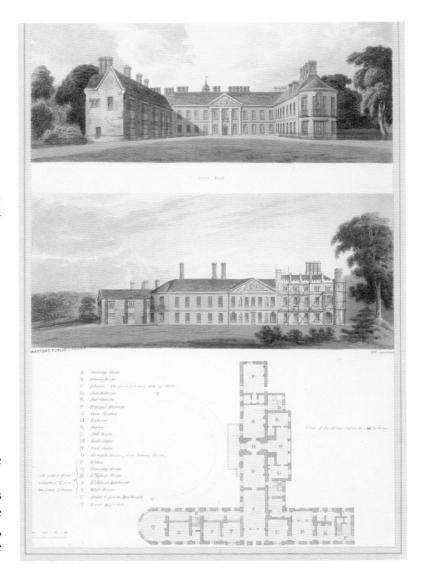

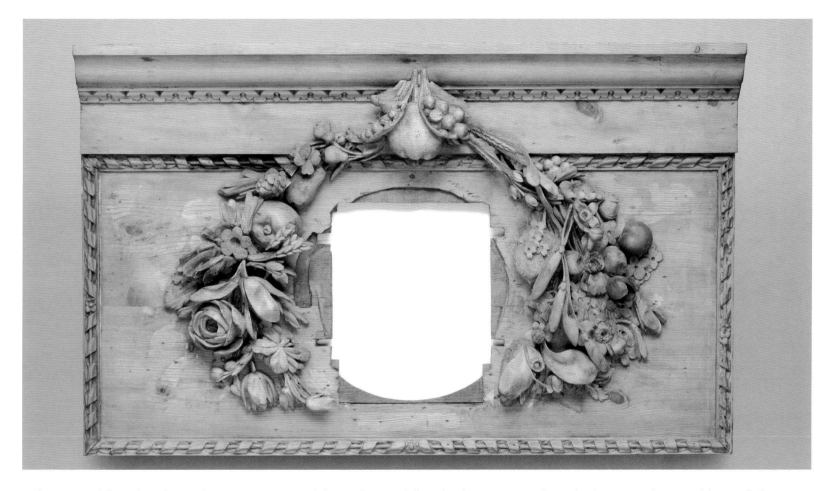

Left: Views and floorplan of Cassiobury House, prior and during the remodelling that began in 1800, drawn by A. Pugin and engraved by J. Hill, from *History of Cassiobury* by John Britton, © Watford Museum.

Above: Wood carving from Cassiobury House, on long term loan to Watford Museum from the Royal Cornwall Museum, Truro, © Watford Museum.

describes the impact of salt water flooding his father's fields when he was a boy of fourteen. On 29 September 1664, he married Ann Miller at Little Hadham, and the couple had four sons and two daughters. Cook worked at Hadham Hall, Essex, from at least 1664, and began his work at Cassiobury from around 1669. We have no knowledge of how he acquired an education. Although he is not prone to quoting the classics or Latin with the gay abandon with which Evelyn holds forth, Cook has a comprehensive understanding of mathematical calculations and geometry. His great strength was his practical knowledge of how to propagate trees, whether it be sowing seed, taking cuttings, layering or grafting. 'A thing well done is twice done. [And] those that resolve to plant, that they make their ground fit for those trees before they set them, and not bury them in a whole like a dead dog, as too many do.' He was a partner in the Brompton Park nursery, which he helped to found in 1681, and from which he retired in 1689. He was the author of *The Manner of Raising, Ordering, and Improving Forest and Fruit-Trees: Also, How to Plant, Make and Keep Woods, Walks, Avenues, Lawns, Hedges, etc.*, first published in London in 1676. In the text, Cook referred to himself as 'gardiner to that great encourager of planting, the Right Honourable, the Earl of Essex'. The book also included,

> Rules and Tables shewing how the Ingenious Planter may measure Superficial Figures, with Rules how to divide Woods or Land, and how to measure Timber and other Solid Bodies, either by Arithmetick or Geometry, shewing the Use of that most Excellent Line, the Line of Numbers, by several New Examples; with many other Rules, useful for most Men.

It was later revised in a second edition in 1717. Cook recommended the use of limes, elms and beech, and the sowing of seeds only from the best specimens. He reported that he successfully raised elms and sallows from seed, though at the time it was thought impossible to do so. His use of cherry trees and formal, mathematical, geometric planting won him the admiration of John Evelyn, who commented on his use of both, particularly at Cassiobury.

In Cook's book, which he dedicated to the Earl of Essex, he explains in some detail the work carried out at Cassiobury, and the Kip and Knyff engraving of Cassiobury, dated 1707, shows the resulting layout. Cook was already working for Essex at Hadham when, in 1668/69, he began transplanting trees from that place to Cassiobury. Some may have been used to establish new plantations in the park, or specimen trees around the house, and others to restock old woodland neglected after thirty years of Civil War and changes of ownership. The work to which Cook devotes most attention is in the area known as the Wood Walks. Here avenues were planted along *allées* cut through the wood, thus creating a network of straight walks bordered by young trees, behind which were the pre-existing woods. Cook refers to species already growing in the Wood Walks – ash, wild cherry, willow, and 'great timber', probably oak – and a survey undertaken a few years later found that the Wood Walks contained over 900 timber trees, of which 497 were oak.[4] Cook also made recommendations for improved management, including the uprooting of old timber stumps and overly large coppice stools to encourage regeneration. The Kip and Knyff engraving shows two types of woodland – dense or widely spaced in rows – with the latter possibly representing areas that had been recently replanted.

The new walk, described in greatest detail by Cook, is that leading from the 'new garden' on the east front of the house, in an east by south-east direction to the new bowling green. Here, 296 lime trees were planted, in four rows, to form three parallel walks. If Cook followed his own advice on proportions,[5] the two outer walks would have been half the width of the central one. These lime avenues are clearly seen on Kip and Knyff's engraving, terminating at the large open space of the bowling green, which appears oval due to the foreshortening effect of the angle of view, but which was according to Cook, a circle of 80 yards diameter. Around the circle was a 16 foot wide border, planted with three rows of spruce firs. At the opposite end the avenues abutted onto the garden in a triangular pattern. Cook makes no mention of how the walks were surfaced, but estate accounts show gravel being purchased for the Wood Walks.

Another walk discussed by Cook,[6] is that cut through the wood to the Hempstead Road. This is shown on the Kip and Knyff engraving, running east by north-east from the house, to a point near the road, where it joins two other walks. Cook describes, in great detail, how he arranged for these three walks to meet at an oval, and how plantings were disposed about it. Whether avenues were planted along the walks is not explained, though Evelyn mentions avenues of cherry trees. Cook also describes with pride the accuracy of his surveying technique. After discussion of offset surveying, he said 'I cut a straight line through the wood at *Cashiobury*, from the north front, over one wall and several hedges, neer a mile long, and when I came to stake it out true, there was at the very end not four foot difference, as the ingenious *Hugh May* Esq; can witness, and

several others.'[7] Other possible schemes by Cook, at Cassiobury, include the establishment of a lawn south of the house and he goes into great detail as to why they are located here.

your lawns, that is, a spacious Plane joyning to your house, which let be in largeness according as your ground will permit, as 100 acres or more. This lawn is most convenient to be on the south side, or east side of your house. For if it be on the west side, it giveth the more way for the west wind (which is most commonly the greatest) to harm your house, by its free passage thereto. Also if your best rooms front your lawn, as they always should doe, the afternoon being the most usual time in which great persons do solace themselves in these principal rooms, the afternoon sun will then be offensive to such rooms, and the prospect will both be hindred and not so pleasant; for the sun by shining against you and from the object, doeth by both hinder your prospect; and most prospects are most pleasant when the sun shineth on them. These inconveniences, which arise from your lawns being on the west side of your house, being considered, I thence conclude, by the rule of contraries, that it is most convenient for your lawn to be on the east side of your house...[8]

Also introduced was a kitchen garden, which had been staked out in an oval shape by 1675, although the Kip and Knyff engraving, and later maps and plans, show a conventional rectangular kitchen garden to the north-west of the house. Cook also produced a plan for a *parterre*, which is highly likely to have also been executed at Cassiobury, given the similarity of his plan and that shown by the Kip and Knyff

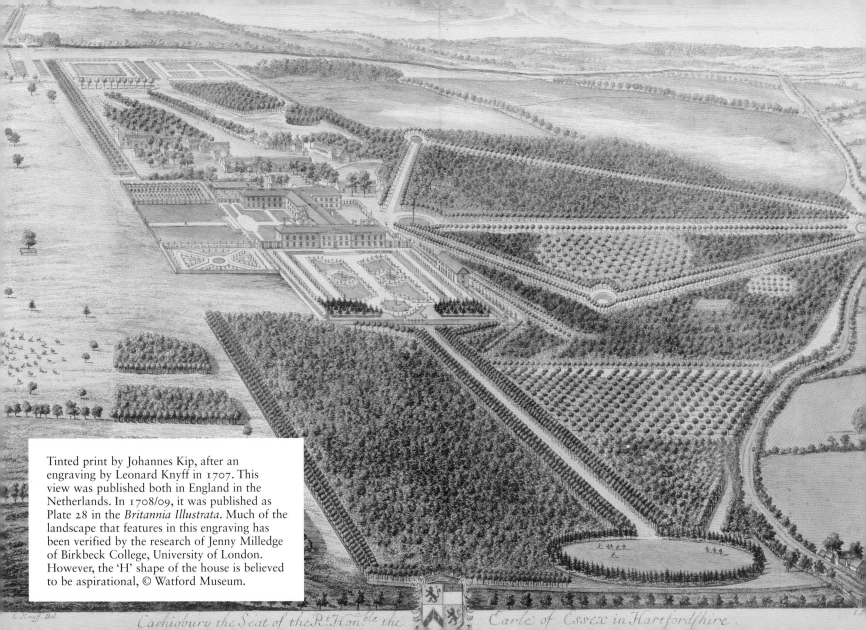

Tinted print by Johannes Kip, after an engraving by Leonard Knyff in 1707. This view was published both in England in the Netherlands. In 1708/09, it was published as Plate 28 in the *Britannia Illustra*. Much of the landscape that features in this engraving has been verified by the research of Jenny Milledge of Birkbeck College, University of London. However, the 'H' shape of the house is believed to be aspirational, © Watford Museum.

L. Knyff, Del.

Cashiobury the Seat of the Rt. Honble the Earle of Essex in Hartfordshire.

engraving. Slightly sunken, it lay on the east side of the house, and was very formal and symmetrical in plan, containing mounts planted with trees, gravel walks, grassed areas and a proposed fountain. On its north side, at the top of the slope facing south, stood an orangery, which may have predated Cook's work, as he implies in his preface that it was already in existence by 1669. This was a substantial building, and clearly shown in Kip and Knyff's engraving and also on Lady Essex's drawing of 1778. To the south of these gardens and the house lay the Home Park which were stocked with deer, and from which the pleasure grounds required protection. In the Kip and Knyff engraving, the Wood Walks and garden areas can be seen to have stout fences around them. There are two features which are worth noting in relation to the deer park. Firstly, the open nature of the landscape, unlike the more functional deer parks of earlier centuries, with those created in the sixteenth and seventeenth centuries, were not for the most part very densely wooded, so that open aspects could be enjoyed, both towards and away from the mansion. Secondly, some of the trees within the park are shown growing in marked lines. Evidently, hedges had been grubbed out when the park was created, but the timber within them allowed to grow on. This was normal practice when parks were created in the seventeenth, eighteenth and nineteenth centuries. In addition to creating new landscape features at Cassiobury, Moses Cook gave Lord Essex a great deal of practical advice on laying out his grounds, managing his extensive and valuable woods, and raising new trees, both native and exotic.

In April 1680, John Evelyn visited Cassiobury and recorded his much-quoted response in his diary. Interestingly, there are both descriptions of the gardens, along with detailed views of the house itself, and its setting, with considerable praise for Cook's work in the gardens;

> The house is new, a plaine fabric, built by my friend Mr Hugh-May; there are in it divers faire and good rooms, excellent carving of gibbonss, especially the chimny of his library. There is likewise a painting in the porch or entrance of Signor Virrios, Apollo & the liberal arts: one roome parquetted with yew which I liked well. The chimny mantles are some of them of a certaine Irish Marble (which his Lordship brought with him when he was Lieutenant of Ireland not long before) not much inferior to Italian. The Tympanum or Gabel at the front is a *Bass-relievo* of Diana hunting cut in Portland stone handsomely enough. The middle dores being round I did not approve of: but when the hall is finished as his Lordship designs it, being an oval cupol'd, together with the other wing, it will be a very noble palace: The library is large, & very nobly furnish'd.[9]

Evelyn goes on to describe the gardens and grounds in greater detail,

> Having spent our time in the mornings in walking or riding about the grounds & contriving.[10] No man has been more industrious than this noble lord in planting about his seate, adorn'd with walkes, ponds, & other rural elegancies; but the soile is stonie, churlish & uneven, nor is the water neere enough to the house, though a very swift & cleare streame run within a flight-shot from it in the vally, which may fitly be cald cold-brook, it being indeede excessive cold, yet producing

faire Troutes. In a word, 'tis pitty the house was not situated to more advantage; but it seems it was built just where the old one was, & which I believe he onely meant to repaire at first, which leads men into irremediable errors, & saves but little. The land about it is exceedingly addicted to wood, but the coldnesse of the place hinders their growth: onely black-cherry trees prosper even to considerable timber, some being 80 foote long. They make also very handsome avenues. There is a pretty oval at the end of a faire walke, set about with treble rows of Spanish firr trees. The gardens are likewise very rare, and cannot be otherwise, having so skillfull an artist to governe them as Mr Cooke, who is as to the mechanic part not ignorant in mathematics, & pretends to astrologie. Here is an incomparable collection of the choicest fruits.[11]

The reference to 'Spanish firr' has caused debate over the years, as to whether they are Spanish chestnuts or even Scots Pine. In Cook's own words, as planter of the said trees, they were in fact spruce firs – Norway Spruce, already a well-established introduction in Britain at that date. Cook was still active at Cassiobury as late as 1680 as he was still receiving payments, but by 1681, he had left to join George London and others as founding partners of the Brompton Nursery.

It is interesting to hear of Evelyn's descriptions and views of the house and gardens but what of Essex himself? 'As for my Lord, he is a sober, wise, judicious and pondering person, not illiterate beyond the rate of most noblemen in this age, very well versed in our English histories and affaires, industrious, frugal, methodical, and every way accomplished.'[12] The Earl of Essex was, according to Cook, an active participant in the garden developments and skilled at raising seedlings, but he was about to prove himself far less fortunate in handling affairs of state. With others, he became involved in discussions aimed at either preventing the succession of the Duke of York (James II), or in limiting his powers if he did come to the throne. Essex came under suspicion of complicity in the Rye House plot, to assassinate both the duke and Charles II. In 1683, Arthur was arrested at Cassiobury House, and taken to the Tower of London. Legend claims that he was held in the very rooms where his father had awaited execution for the same charge of treason. Arthur's case never came to trial. On the 13 July, he was found dead with his throat cut in what was held to be a suicide by his detractors, but some evidence indicates this may well have been otherwise and that he was murdered.[13] His body was, however, released by Charles II and buried in the crypt of the Essex Chapel in St Mary's parish church, Watford. His spirit is also said to return to Cassiobury Park, where his ghost appears on horseback each year on the day of his death, each July. In the event, Cassiobury remained in the Capel family's hands, with the first earl's son, Algernon, succeeding to the title and estate the same year.

Algernon was to have a distinguished career at court and in the military. He was only thirteen when he succeeded to the earldom. In 1688, with the accession of William III, he was appointed Gentleman of the Bedchamber, and entered the army, where he gained recognition for his part in the Battle of Landen in Flanders. Algernon was betrothed to Mary Grimston, but she died in 1684. In 1691, he married Mary Bentinck, daughter of the Earl of Portland, a close advisor of King William III, and had three children, of whom the eldest son, William, would succeed him as the 3rd Earl of Essex.

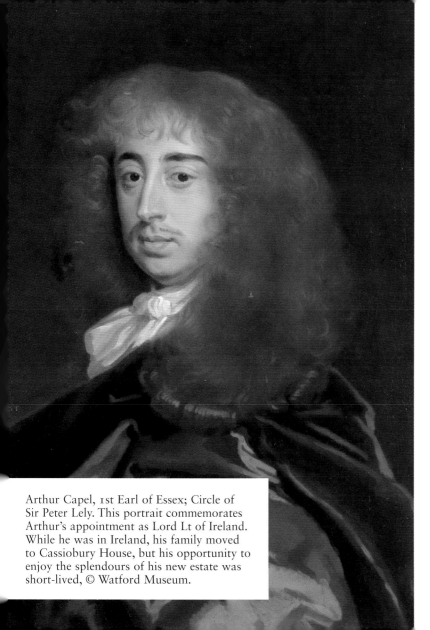

Arthur Capel, 1st Earl of Essex; Circle of Sir Peter Lely. This portrait commemorates Arthur's appointment as Lord Lt of Ireland. While he was in Ireland, his family moved to Cassiobury House, but his opportunity to enjoy the splendours of his new estate was short-lived, © Watford Museum.

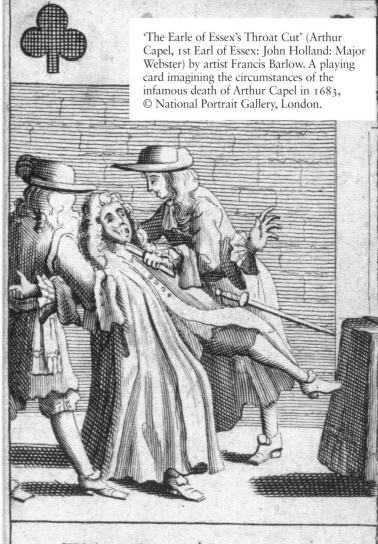

'The Earle of Essex's Throat Cut' (Arthur Capel, 1st Earl of Essex: John Holland: Major Webster) by artist Francis Barlow. A playing card imagining the circumstances of the infamous death of Arthur Capel in 1683, © National Portrait Gallery, London.

The Earle of Essex's Throat Cut

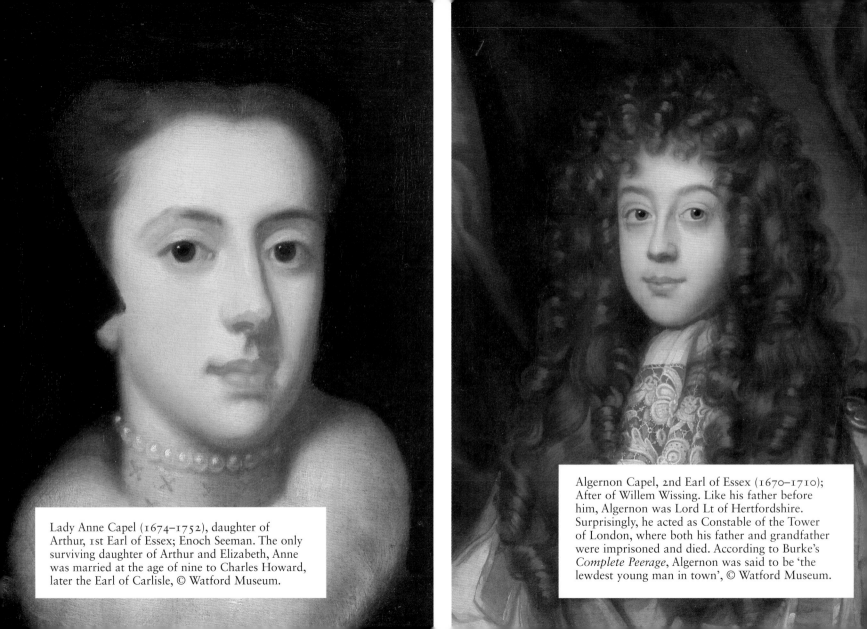

Lady Anne Capel (1674–1752), daughter of Arthur, 1st Earl of Essex; Enoch Seeman. The only surviving daughter of Arthur and Elizabeth, Anne was married at the age of nine to Charles Howard, later the Earl of Carlisle, © Watford Museum.

Algernon Capel, 2nd Earl of Essex (1670–1710); After of Willem Wissing. Like his father before him, Algernon was Lord Lt of Hertfordshire. Surprisingly, he acted as Constable of the Tower of London, where both his father and grandfather were imprisoned and died. According to Burke's *Complete Peerage*, Algernon was said to be 'the lewdest young man in town', © Watford Museum.

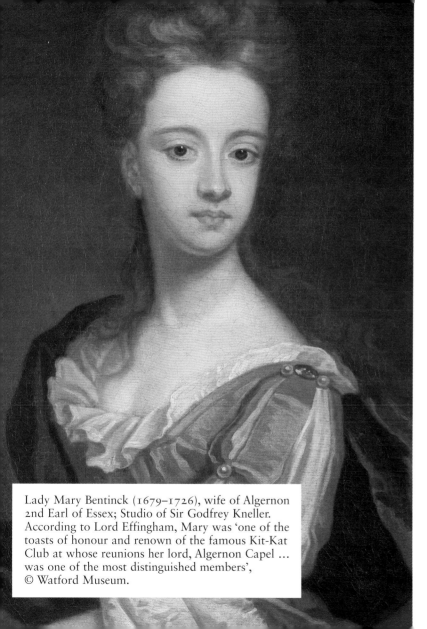

Lady Mary Bentinck (1679–1726), wife of Algernon 2nd Earl of Essex; Studio of Sir Godfrey Kneller. According to Lord Effingham, Mary was 'one of the toasts of honour and renown of the famous Kit-Kat Club at whose reunions her lord, Algernon Capel … was one of the most distinguished members', © Watford Museum.

In the reign of Queen Anne, the 2nd Earl was rapidly promoted to Maj.-Gen. and, in 1707, to Lt-Gen. of Her Majesty's forces. Like his father before him, he was Lord-Lt of Hertfordshire and acted as Constable of the Tower of London, where ironically both his father and grandfather had been imprisoned. The 2nd Earl is probably best known for his membership of the celebrated Kit-Kat Club, and he was, at the same time, said to be the 'lewdest young man in town', as quoted in Burke's *Complete Peerage*. It was also about this time that Little Cassiobury was built, probably as a dower house for his mother Elizabeth.

During this time, an extremely detailed valuation of Cassiobury was carried out, and a copy of it supplied to the Earl of Elgin. The 3rd Earl of Elgin was on the opposite side of the political fence to Essex, being a strong supporter of the Stuart succession. It may be that, after Essex's tragic death, during the turbulent years of King James II's brief reign (1685–88), Elgin saw himself as a likely candidate for receiving some sequestrated property. This valuation of Cassiobury, in 1685, not only provides a picture of the landholdings and the distribution of wood, meadow and arable land, but also gives an insight into the contents and management of woodlands, enumerating and categorising as it does nearly every tree, and giving the age and acreage of coppice. The home park, covering 213 acres, contained over 2,000 timber trees (oak, ash and elm) and also underwood – implying that some of the trees were in fenced clumps or small plantations – pollards, and hedgerows. The Wood Walks (16 acres) consisted mostly of oak, ash, beech, and cherry, 8½ acres of coppice. Across the River Gade, the High Park (282 acres) was similarly rich in timber trees, while areas just to the north of it – Fox Dell, Deer Spring, and

Whippendell – were described as 'wood ground and deer park', suggesting that, although primarily woodland, they were also grazed by deer and probably included some clearings. They contained some timber and a good deal of coppice; of the 200 acres in Whippendell Woods, 90 acres consisted of coppice at various stages of growth. Leavesden Wood, an outlying part of the estate, was managed almost entirely as coppice. Other interesting features of the valuation are the recorded presence of the lodge in High Park, a hop ground, 'New Mills', and values Watford's parsonage and its farm as the single most valuable property on the estate – at £7,200, exactly twice the value of the mansion and its curtilage.

Further changes were made to the gardens under the 2nd Earl. He employed George London, who had been trained by John Rose, presumably the same Rose who was for a time gardener at the Capel's town house, and who had studied in France.[14] This may perhaps explain the oft-repeated notion that Le Nôtre and Rose had a part in designing Cassiobury. Also, London had been in partnership with Cook at Brompton, and he therefore had all the credentials for continuing the work at Cassiobury. The 1697 state accounts show that Mr London was paid £88 18s 8d for 'work done in the gardens', and other entries mention clearing ponds and filling a pond in 1699, unspecified work in the Wood Walks (1698–1701), and watering trees (1702) – suggesting new planting had taken place. It was also likely that London was asked to address Evelyn's criticism of insufficient water features near the house, and did so by creating the ponds and fountains, as shown in the Kip engraving. This may have included finishing off Cook's *parterre*, by installing a pair of pools rather than the central one proposed, and creating a large pond and several smaller ones in and around the Wood Walks. To the west of the house, the engraving shows walled areas of cultivation, probably the kitchen garden, and some rectangular pools that may have acted as reservoirs for the fountains. There are later references to waterworks, and the existence of a reservoir above the house to which water was pumped from the river by means of an engine at the mill.[15] In front of the south entrance is a formal pattern of lawns, beds, and orchards, perhaps also the work of London, and there also appears to be a large greenhouse within the Wood Walks. Moses Cook had always regretted the lack of such a greenhouse in which to raise exotic trees. As for George London, he worked all over England (as Capability Brown was to do) creating formal gardens at great houses such as Longleat, Chatsworth and Burghley, and his role as an early exponent of the naturalistic style has only recently begun to be fully appreciated. By 1700, Thomas Ackres was head gardener at Cassiobury, being paid £140 for work in 'the Wildernesse'. His name was linked with further works in the woods just east of the house, formerly part of the Wood Walks. It appears Cook's design of rigidly straight avenues was already being modified, to create areas of contrived wildness and irregularity.

The 2nd Earl of Essex died in 1710, and his son, William, succeeded at the age of thirteen. The new 3rd Earl followed in his father's steps, holding a number of important posts at court. He did not however, take his seat in the House of Lords until he reached adulthood. From 1719, he served as Gentleman of the Bedchamber to the Prince of Wales (duties included assisting the king at his dressing, waiting on him when he ate in private, guarding access to him in his bedchamber and closet and providing noble companionship, generally) and, following his

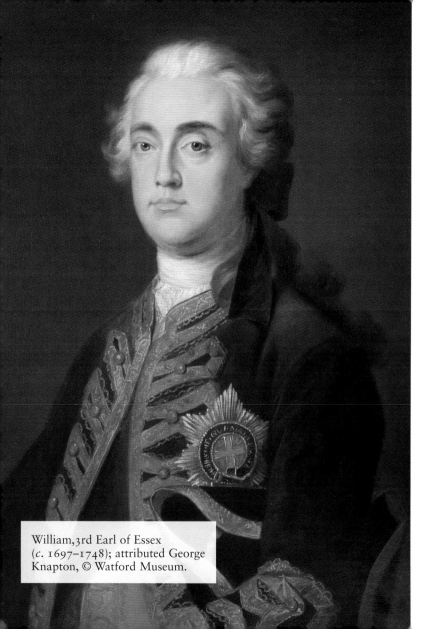

William, 3rd Earl of Essex
(*c.* 1697–1748); attributed George
Knapton, © Watford Museum.

ancestors, he served as Lord Lieutenant of Hertfordshire, from 1722 until his death. From 1724, he was Knight of the Thistle, until 1737, when he received the Garter. Among his other titles were: Ranger of St James's Park and Hyde Park, Ambassador Extraordinary and Plenipotentiary to the King of Sardinia, and Envoy Ambassador to Turin. After returning to England, he became Captain of the Yeoman of the Guard. He first married Jane Hyde, daughter of the Earl of Clarendon, and had four children. Lady Jane was much admired for her good nature and her beauty, and in his *Journal to Stella*, Jonathan Swift, Dean of St Patrick's, Dublin, described her as 'A Top Toast'. In 1724, at the age of thirty, she tragically died of fever in Paris.

In 1726, William then married Elizabeth Russell, daughter of the 2nd Duke of Bedford, producing several children, but only one surviving son, in 1732.

During the twenty or so years that William Capel was master of Cassiobury, he made further alterations to the grounds. John Wootton's *A View of Cassiobury Park* gives us some insight into the world of the 3rd Earl of Essex. It depicts in the foreground members of the Essex family, and their friends, set against a vista of Cassiobury Park. The painting is significant, as it shows Cassiobury House and the park with the 3rd Earl of Essex, his family, friends and servants. Among those portrayed on the painting are Lady Clarendon; Lady Mary Forbes; Dr Johnson, Bishop of Worcester; Elizabeth, Countess of Essex; William, Earl of Essex; Lady Caroline Egerton, sister to the Duke of Bridgewater; the Duke of Bridgewater; Lady Anne Capel; Lady Diana Capel; a black servant and a gamekeeper.

Throughout its history, Cassiobury has employed many servants, and in particular a number of black servants. At the

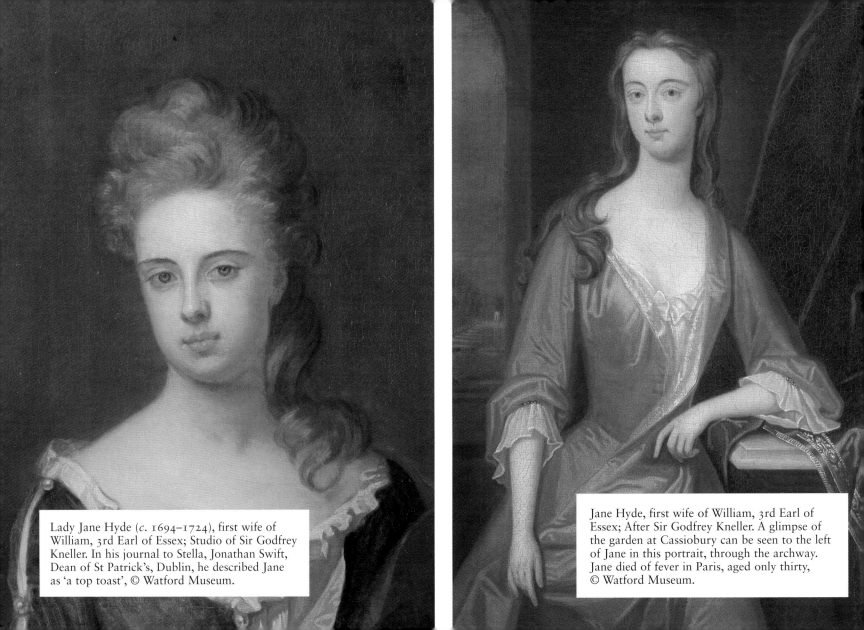

Lady Jane Hyde (*c.* 1694–1724), first wife of William, 3rd Earl of Essex; Studio of Sir Godfrey Kneller. In his journal to Stella, Jonathan Swift, Dean of St Patrick's, Dublin, he described Jane as 'a top toast', © Watford Museum.

Jane Hyde, first wife of William, 3rd Earl of Essex; After Sir Godfrey Kneller. A glimpse of the garden at Cassiobury can be seen to the left of Jane in this portrait, through the archway. Jane died of fever in Paris, aged only thirty, © Watford Museum.

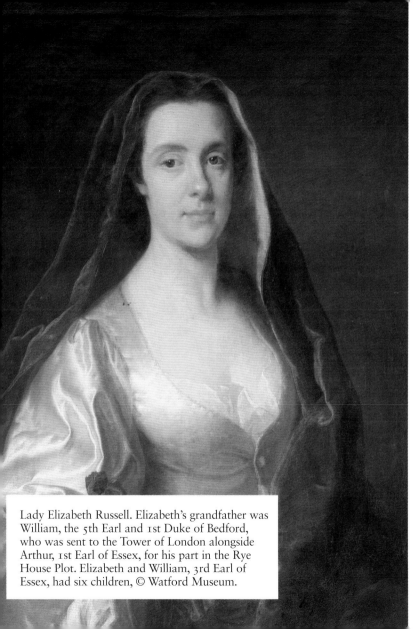

Lady Elizabeth Russell. Elizabeth's grandfather was William, the 5th Earl and 1st Duke of Bedford, who was sent to the Tower of London alongside Arthur, 1st Earl of Essex, for his part in the Rye House Plot. Elizabeth and William, 3rd Earl of Essex, had six children, © Watford Museum.

beginning of the eighteenth century, there was a great expansion in Britain's black population. At the time, many wealthy plantation owners were returning to London with their fortunes and personal slaves. Black servants were flaunted as evidence of wealth. At Cassiobury, black servants were employed, and are recorded in paintings, gravestones and parish records. A gravestone in St Mary's churchyard still marks the resting place for one of Cassiobury's black servants, George Edward Doney (c. 1758–1809). George, known as Edward, worked for forty-four years for the 5th Earl of Essex. The inscription on his gravestone reveals that he was originally captured from Gambia as a child and sold into slavery.

> Poor Edward blest the pirate bark which bore
> His captive infancy from Gambia's shore
> To where in willing servitude he won
> Those blest rewards for every duty done –
> Kindness and praise, the wages of the heart;
> None else to him could joy or pride impart,
> And gave him, born a pagan and a slave
> A freeman's charter and a Christian's grave.

A significant number of paintings of black people in the eighteenth century show them as servants, including the painting by Wootton in 1748. In the bottom left hand corner of the picture, is a black servant who may well have been Othello, formerly called Donas, servant to the Earl of Essex at that time and baptised at 'Cashiobury', in 1730. Artists frequently placed black people on the edge of the painting, gazing in awe at their masters and mistresses.

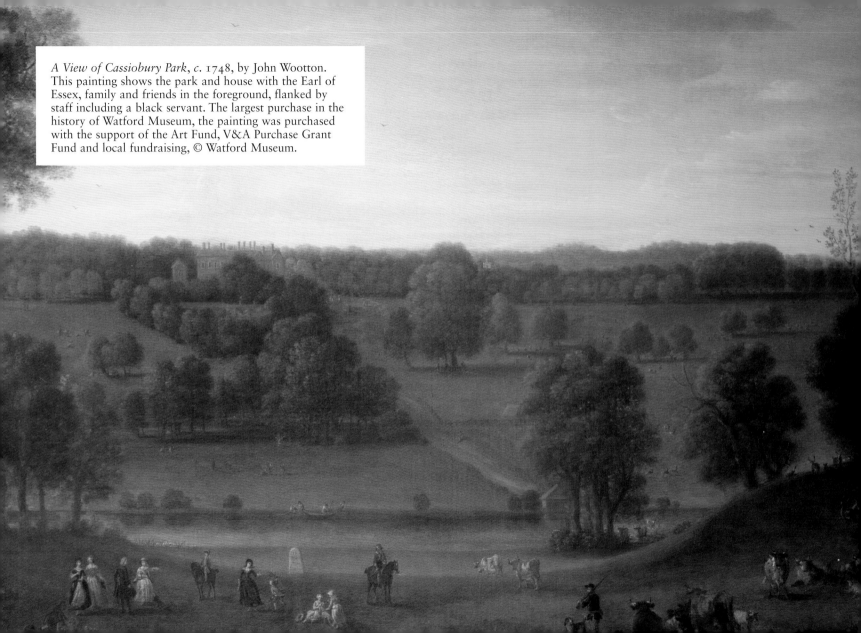

Harvest Home was painted by Turner on his second visit to Cassiobury. The unfinished painting shows a harvest dinner in one of the barns, with a black servant as one of the key figures. Turner's painting gives an entirely different perspective to the usual depiction of black servants in the art of the time. Instead of positioning the servant at the edge of the canvas, the picture gives a sense of how important he was in the hierarchy of staff at Cassiobury. The black servants of Cassiobury were not slaves, but high status members of the household, recruited as freemen in London. No portion of the wealth of the Earls of Essex was ever earned from the proceeds of slavery.

It is known that Charles Bridgeman, the royal gardener and a former pupil of London, was also employed at Cassiobury, and was held in such high regard that his bust stood in the house, but no record of what he actually changed or brought to the gardens and landscape at Cassiobury exists. Walpole states that Bridgeman had 'laid out the wood.'[16] Dury and Andrews' map, from 1766, shows several features not previously recorded, including a pattern of straight rides criss-crossing Whippendell Wood, and three avenues in High Park. One of these ran from the eastern side of Whippendell towards the house and, according to a later visitor, was aligned to the summer sunset. 'On a distant rising ground you look along a very broad avenue of limes, exactly at the end of which, during a part of the summer, the sun sets…'[17] The lime avenue may also have been aligned to a very striking obelisk, located north-west of the house, which is very clear in the painting of 1748 by Wootton, but is unrecorded anywhere. Another avenue, parallel to the first but shorter, ran east by south-east from the lodge, while the third ran roughly north–south through High Park. This last one was

known as Mile Walk, and was an avenue of limes which certainly post-date the 1685 valuation of High Park, as none are recorded. Dury and Andrews' map also shows a much denser network of walks in the Wood Walks than existed in 1707, and a large cleared area within them. At the northern edge of the park is a new circular feature, while to the north-west of the house the walled gardens are clearly seen.

There were further embellishments added to the grounds by Thomas Wright, an astronomer and mathematician who liked to design grottoes and follies.[18] He was a regular visitor to Cassiobury between 1741 and 1746, having first been engaged as a tutor to the earl's daughters. Wright made drawings of a temple and associated walk leading north from the house to Cook's oval clearing. The extent of his contributions is unclear, but he may well have been responsible for both building the temple, and softening the vista to it by thinning the woodland edges. No other illustrations of the temple are known, though it appears on later maps from 1766 and 1798. The site of the temple was later occupied by a lodge known as Temple Cottage. Wright may also have advised on, or even executed, other garden improvements, but again no record of them remains. Nor is there any reason to believe that the cascade and Triton grotto designed by William Wrighte for Cassiobury were ever constructed.

A grotto, canal, and cascade, decorated with rock work, tritons, Sibyls, etc. pouring forth fountains of water. The author hopes he may be indulged with observing that he hath with great pleasure seen a fine piece of water in the park of the Earl of Essex, at Cashiobury, near Watford, Herts, and flatters himself that if the arch in this design, on which the Triton is placed, was to be

executed there in the nature of a bridge, it would have a very magnificent and pleasing appearance.[19]

In 1743, the 3rd Earl died and was succeeded by the second son of his second marriage, William Anne Holles Capel. He was Lord of the Bedchamber to George II, and later to George III. He also succeeded his father as Lord Lt of Hertfordshire, and served as Master of the Royal Staghounds from 1776. The new Earl of Essex broke with the political and family tradition of marrying daughters of earls and dukes, by taking as his wife a wealthy, but untitled, heiress – Frances, daughter of Sir Charles Hanbury Williams, of Hampton Court, Herefordshire. Around the time of their marriage, in 1754, the Dowager Lady Essex moved into the dower house at Russell Farm, probably built in 1718 on the site of Tooley's farm, by the date on its weathervane. In April 1758, Lord Essex engaged William Lapidge to carry out work in the grounds. Lapidge was relatively unknown, and it was an unusual appointment from such an important client. Lapidge's son Samuel would go on to later work as a surveyor for 'Capability' Brown.[20] Over the next eighteen months, the estate accounts show continued payments to Lapidge, and for a variety of works, including many simply called 'great work'. Beginning in April 1758, there are repeated references to work on the 'New Waters' and 'Broad Water'. Such work has often been attributed to Humphry Repton, but this work was actually begun more than forty years earlier, by Lapidge. One would have also expected the lake to have been placed so as to be visible from the main rooms of the house, making the obvious choice of a site a broad flood plain to the south-west at Pheasant Meadow (later occupied by watercress beds). The present course of the river

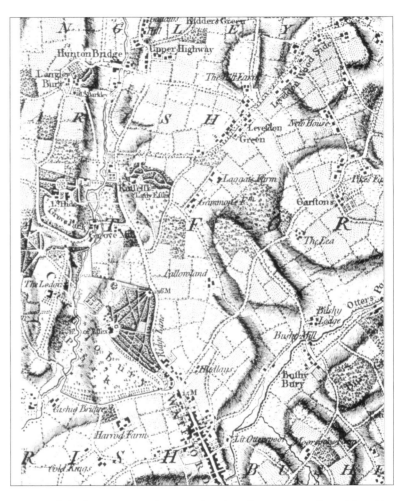

Dury and Andrew's map of 1766, showing the pattern of straight rides criss-crossing Whippendell Wood, and tree avenues in High Park Cassiobury, © Watford Museum.

here, along the eastern edge of the flood plain, is perhaps a legacy of Lapidge's waterworks; the Wootton view of 1748 shows that its earlier course lay farther west, roughly on the line of the canal. The disappearance of the lake can be attributed to the building of the Grand Junction Canal, at the end of the eighteenth century.

Lapidge may also have been responsible for the construction of the ha-ha wall shown on the drawing made in 1778 by the earl's second wife, although it is possible, it could have been adapted from an earlier structure, perhaps made previously by Bridgeman. Its smooth curving line suggests that it was purpose-built, as part of a scheme to bring fashionable informality to the setting of the house, by removing visible barriers between the gardens and the Home Park. The ha-ha wall was marked as a strong feature on Kent's map of 1798, and on the first edition 1 inch 1822 Ordnance Survey, and was still extant at the time of the 1871 Ordnance Survey. In Lady Essex's drawing, all trace of rectangular parterres and lawns has gone, and the ha-ha wall encloses a naturalised east lawn, planted with young conifers. On the far side is a greenhouse, seemingly on the same site as Cook's orangery, and in front of this, according to the legend, is a 'skittle ground'.

Frances died in 1759, in childbirth, and the earl was married for a second time, in 1767, to Harriet Bladen, with whom he had five sons. Harriet, an amateur artist, produced the drawing *View of Cassiobury*, which was later engraved. Changes to the estate, towards the end of the eighteenth century, were, it appears, few and far between. Certainly, in 1767, building work was going on in 'the Garden'[21] – almost certainly the kitchen garden, and a new plantation was being prepared.[22] Lord Essex also considered having the old wing

of the house rebuilt, and commissioned an architect to draw up a plan for it, but evidently he decided the expense could not be justified. This may have been in response to criticism received in particular by Defoe in 1748.[23] The biggest impact on the park however was the building of the Grand Junction Canal, in 1796. The earl was heavily praised for his public-spiritedness in permitting it to cross his land.

> Cashioberry Park, is where we first fall in with the Grand Junction Canal. Ready permission was granted by the present Earl of Clarendon, and the late Earl of Essex, to allow this great national undertaking to pass through their respective parks; and when we find the opposition that the late Duke of Bridgewater was continually receiving, from parties, through whose premises he was unavoidably often obliged to pass his navigable canals, it must stand as a monumental record, and example, of the urbanity and *amor patrice*, these distinguished noblemen exhibited for the weal of their country.[24]

Shortly before its construction, in 1795, it was suggested that the canal company build the earl a reservoir, and should,

> readily accord with the patriotic views of the Honourable Board, in forwarding by every means in their power the watering of meadows along the line thereof ... The water may be guided to every part of it in plough furrows, from a reservoir made next the London road and highest part on this side of the park. The carpet would be refreshed, the beauty of the place and value of the feed increased thereby, in the course of a month's watering; and to prevent the rot, the deer may be confined to another

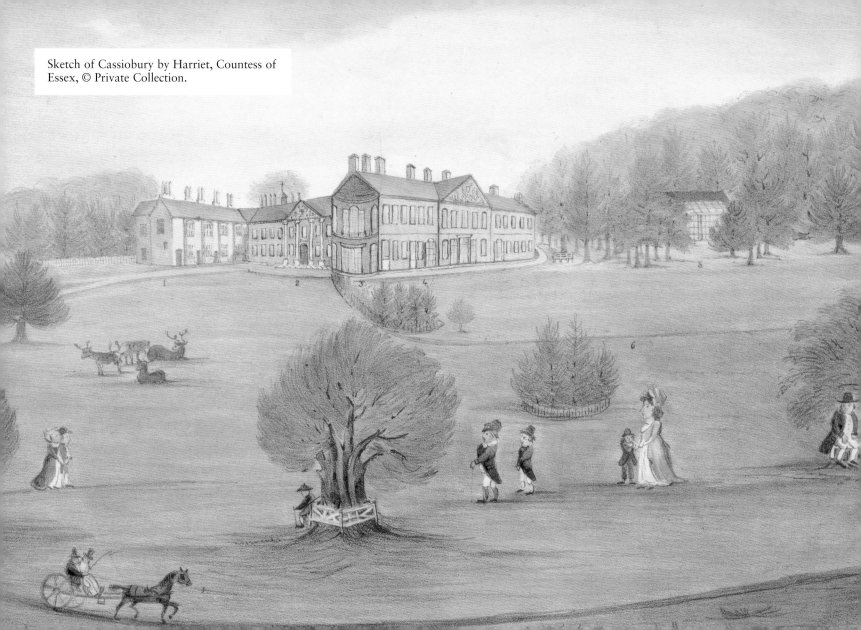

Sketch of Cassiobury by Harriet, Countess of Essex, © Private Collection.

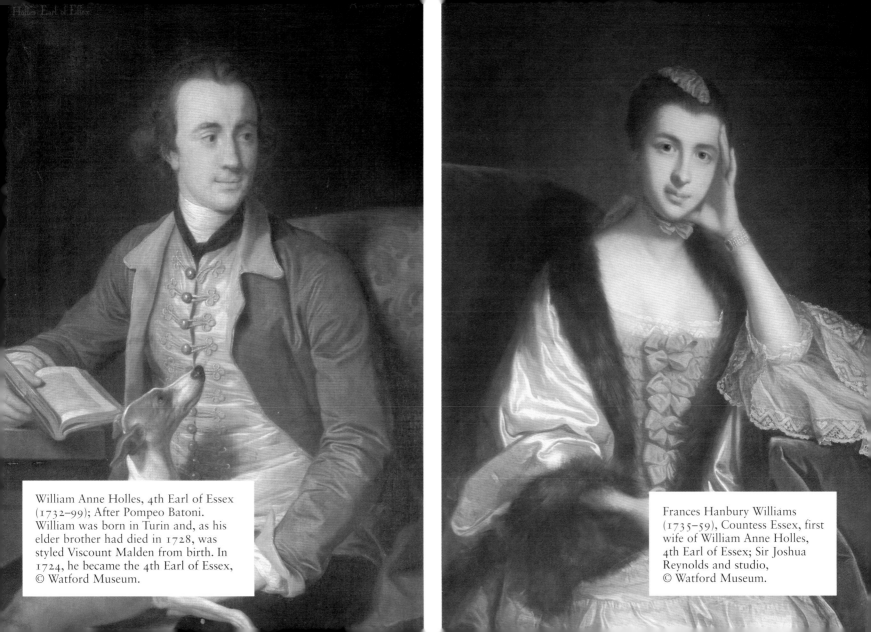

William Anne Holles, 4th Earl of Essex (1732–99); After Pompeo Batoni. William was born in Turin and, as his elder brother had died in 1728, was styled Viscount Malden from birth. In 1724, he became the 4th Earl of Essex, © Watford Museum.

Frances Hanbury Williams (1735–59), Countess Essex, first wife of William Anne Holles, 4th Earl of Essex; Sir Joshua Reynolds and studio, © Watford Museum.

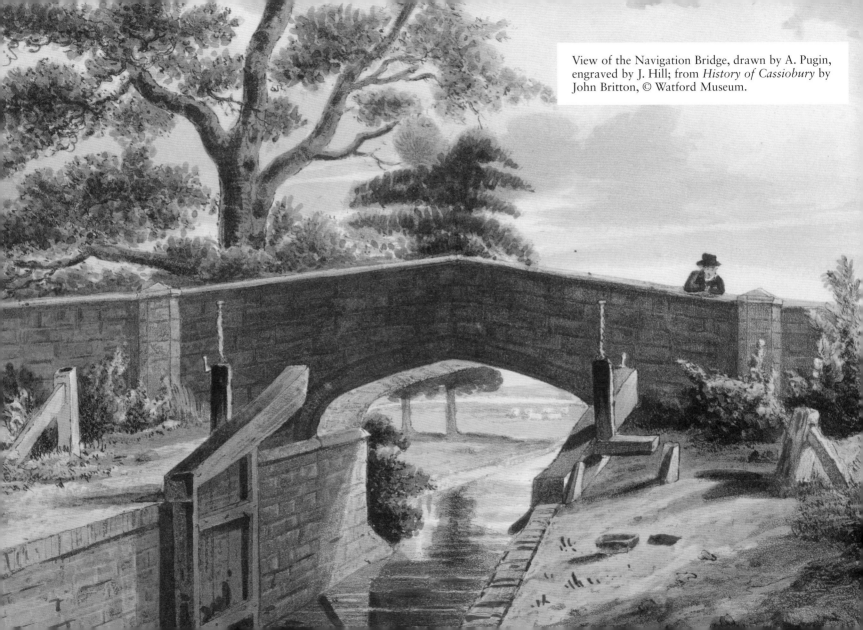

View of the Navigation Bridge, drawn by A. Pugin, engraved by J. Hill; from *History of Cassiobury* by John Britton, © Watford Museum.

quarter of this extensive park, till a month after this part has been flooded.[25]

Still, no evidence exists that this was ever built. The canal was always viewed as a visual asset to the park, often animating the scene with draught horses and colourful craft, though the 'depredations' of watermen had to be guarded against.[26] In 1810, Nash was having less luck with the Regent's Canal proposals, which was proposed traversing the north-west angle of Marylebone Park, especially as he thought it a 'grand and novel feature of the Metropolis' and because 'many persons would consider the circumstances of boats and barges passing along the canal as enlivening the scenery provided the bargemen or people from the boats were prevented landing in the parks'. Sadly, the commissioners did not agree, and decided that barges were best kept out of the royal parks, and the canal was compelled to take its present route, skirting the north boundary of the present Regent's Park.[27]

Both the canal and River Gade entered the park from the north as separate streams; there were two locks and a private wharf on the canal, below which the river rejoined it. They parted again above the mill, near the Ironbridge Lock and two bridges carrying the drive that linked Home Park with High Park. There were weirs above and below the mill, one of which was visible from the house;

Adjoining the Grove is a very superb mansion, situated in an extensive and noble park, called Cashiobury. This is the seat of the Earl of Essex, and has lately been repaired and beautified at a considerable expense. The river Gade likewise runs through this park. The scene is much enlivened, by a beautiful waterfall,

formed from the waste water, which forms a pleasing object from the house.[28]

The whole scene was much brightened, and a favourite view for artists was from a seat in High Park, looking over the river and canal as they crossed Pheasant Meadow, with the house on higher ground in the distance.

Towards the end of the eighteenth century, Lord Essex commissioned a survey of the park and in-hand farmland from Messrs Kent, Claridge and Pearce.[29] Nathaniel Kent, an estate agent, had recently been employed by George III to make improvements at Windsor, while John Claridge was Essex's own steward. The plan shows the fields of Grove Mill Heath and Kings Land farms, in some cases giving their use such as clover, turnips, wheat etc., and also the layout of the woods and avenues. Most of the straight rides in Whippendell and the Wood Walks are still intact, though Cook's bowling-green has gone, and the east lawn and ha-ha wall are present. The stables, yards, orchard, and a series of gardens are arranged to the north and west of the house. Wright's temple survives, and is referred to in the survey. Listed is a double lodge at the main entrance and a small cottage, Cowman's Lodge, described as being at the north end of the park. Also listed are an 'elegant summer room called the fishing house and bath' – presumably near the river but not marked on the plan – ornamental seats, an 'engine house with as small water grist mill', and a variety of utilitarian structures including stables, kennels, lime and brick kilns, a greenhouse, a hothouse, cottages for the gardener and carpenter, and the first mention of the existence of an ice house.

By now the lodge in High Park is described as a farmhouse, while there are also two other farmhouses at Kings Land and

Grove Mill Heath. The survey was not merely a record of the estate at that time, but came with a series of recommendations from Kent. These stated, firstly, that 50 acres of land next to the river in Home Park should be hurdled off and used for hay; that 100 acres of High Park, west of the Mile Walk, should be converted to a tillage; that the numbers of deer should be increased, and a flock of at least 600 sheep built up; that Little Cassiobury should be let; and lastly, that 'an entire new system of management' should be introduced in the woods, by dividing them up into sub-plots to establish an annual rotation of felling work and regrowth, removing old stunted timber, and replanting with oak and ash to provide a succession of new timber.

The 4th Earl died in 1799, and the title passed to his son George Capel, who took the surname of Coningsby, the family name of his maternal grandmother through whom Hampton Court, Herefordshire, had come into Capel's possession. George may have had plans for this property, having not long before commissioned the young J. M. W. Turner to make paintings of it, but, in 1808, he sold it to help fund his improvements at Cassiobury.

It was the ancient seat of the Coningsby's who had possessed it from the time of Henry IV. It came to Lord Essex by his mother ... This noble estate yielded Lord Essex a very small income compared with its value, owing to the mismanagement of agents. Lord Essex's mind was set upon making Cashioberry a fine place...[30]

Right: The 1798 survey, carried out by Nathaniel Kent, HRO, © Hertfordshire Archives and Local Studies.

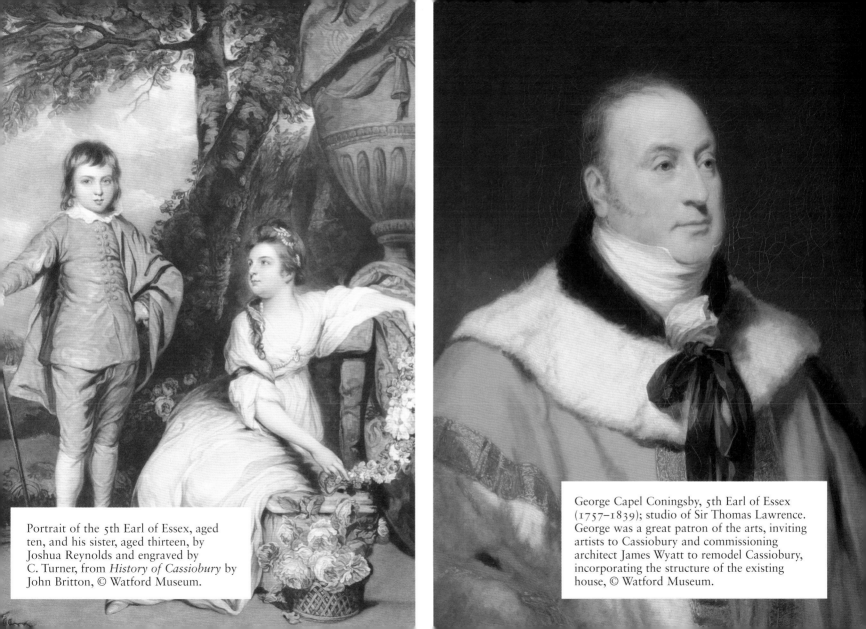

Portrait of the 5th Earl of Essex, aged ten, and his sister, aged thirteen, by Joshua Reynolds and engraved by C. Turner, from *History of Cassiobury* by John Britton, © Watford Museum.

George Capel Coningsby, 5th Earl of Essex (1757–1839); studio of Sir Thomas Lawrence. George was a great patron of the arts, inviting artists to Cassiobury and commissioning architect James Wyatt to remodel Cassiobury, incorporating the structure of the existing house, © Watford Museum.

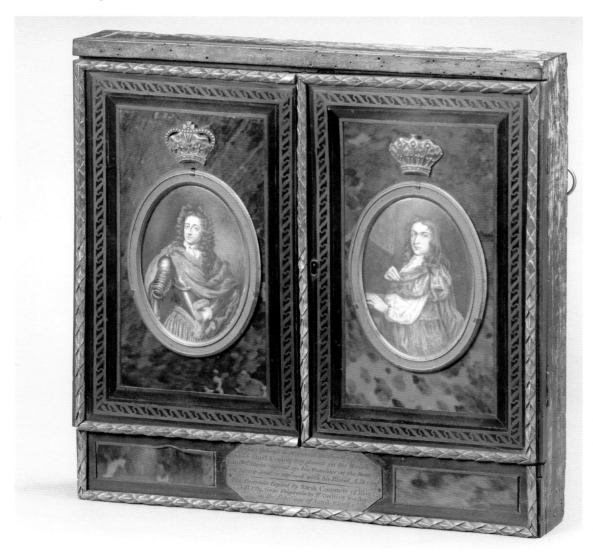

Left: Wooden casket with miniatures painted by Sarah, Countess of Essex. The casket contains a stained handkerchief, reputed to have been used to stem the blood of William of Orange on sustaining an injury at the Battle of the Boyne in 1690, © Watford Museum.

Right: Catherine Capell-Coningsby (née Stephens), Countess of Essex, by John Jackson,
© National Portrait Gallery, London.

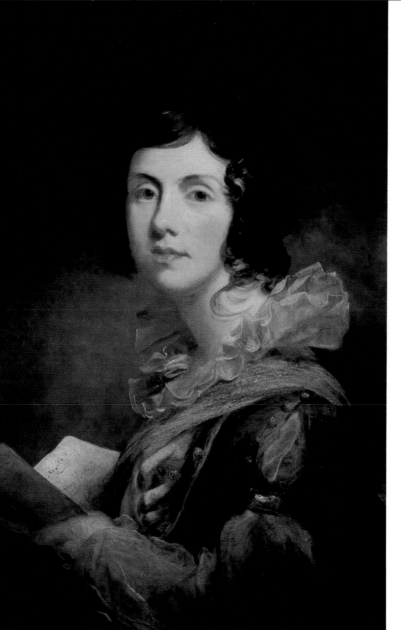

George had been educated at Corpus College, Cambridge where he gained an MA. He also took on the roles of Lord Lt of Hertfordshire, Lord High Steward and Recorder of Leominster, Doctor of Civil Law, and Fellow of the Society of Antiquaries. As the earl's first marriage, to Sarah Stephenson, was an unhappy one, the couple lived separately, until her death in 1836. Two years later he married Miss Catherine 'Kitty' Stephens, a singer and comedy actress. A portrait of her in the role of Diana Vernon, from Sir Walter Scott's *Rob Roy*, was installed by the earl in the Dramatic Library at Cassiobury. She survived him by forty-three years, living in her own home at No. 9 Belgrave Square, where she and the earl had been married. Her obituary in the *New York Times* on 17 March 1882 pays a tribute to her.

By the death of the Dowager Countess of Essex, in her eighty-eighth year, on Feb 22, another link is severed between the present and the past. Kitty Stephens was essentially a vocalist of an age long past and gone. It is doubtful, indeed, whether many persons now living can truthfully say they recollect publicly hearing a lady who made her first appearance at Bath no less than seventy-one years ago, and who, for nearly half a century, has lived in retirement from the stage. Tradition states that Lady Essex had a high soprano voice extending up to D in alt, and that she was chiefly celebrated as a singer of ballads ... The Earl of Essex had been barely three months a widower when he, in 1838, led Katherine Stephens to the altar; and he died within a year of his wedding. For forty-three years the gilder's daughter has continued the earl's widow, respected and honoured by many friends.

George Capel Coningsby was a major patron of the arts, taking Cassiobury to its zenith during the first decade of the nineteenth century. Immediately upon his becoming the 5th Earl, George had engaged the fashionable architect, James Wyatt, to remodel Cassiobury House in a Gothic style.

> The 2nd, 3rd and 4th Earls of Essex do not appear to have made any essential alterations or improvements at Cassiobury; but the fifth and present earl has not only given a new character to the house, the park and gardens, but has rendered the whole picturesque, elegant, and interesting.[31]

The appointment of Wyatt was a significant part of the continuing development of Cassiobury, not just for the changes he made to the house, but because his reputation was at that time highly regarded. James Wyatt was the most celebrated English architect of his time. From the moment he returned from Rome, in 1768, and embarked on the Pantheon, the finest Neoclassical interior in London, until his death in a dramatic carriage accident in 1813, he was regarded as 'the first in his line'.[32]

Wyatt was engaged at Cassiobury until his death in 1813. The old west wing was demolished, as was the south-west projection of Hugh May's east wing, and a new north range was built, enclosing a courtyard and cloister. This layout may well have been favoured by the earl as a reflection of the similar plan of the old family house at Hadham Hall.[33] The main entrance was moved from the south to the west front, and the whole was given a Gothic aesthetic with the addition of turrets, pinnacles, painted windows, a chapel-like dining room, and an octagon kitchen (the latter much admired by Repton). However, some of the old rooms and their rich carvings,

including the Grinling Gibbons/Edmund Pearce staircase, were retained. One of the most detailed descriptions of Cassiobury at this time was by John Britton, FSA who was responsible for *The History and Description, with Graphic Illustrations of Cassiobury Park, Hertfordshire: The Seat of the Earl of Essex*, published in 1837, thirty-eight years after Britton first met Lord Essex at Hampton Court, Herefordshire. Britton was no admirer of Wyatt, describing his efforts at Windsor as 'flimsy, weak, and ill suited' and his works at St Stephen's chapel and his designs at the House of Lords as 'defective and inappropriate'. Likewise, at Cassiobury, Britton 'cannot compliment the architect for his designs of the exterior', but he,

> Finds much to be pleased with in the arrangement of the interior. As a suite of rooms, adapted for a noble family, and for varied companies, their disposition and sizes are calculated to afford every domestic comfort, combined with luxury; but there are neither finishings, nor fittings, to correspond with the exterior character of the building.[34]

Britton's descriptions include a range of engravings, to display the arrangement of rooms on the ground floor, as well as the exterior features of the mansion. His descriptions are as follows:

> The whole surrounds an open courtyard, the entrance being to the west, the chief rooms to the south, the private or family rooms to the east, and the kitchen, servant's offices, to the north. A small porch screens the entrance doorway, which opens into a narrow cloister, on the right of which is a small vestibule and enclosed staircase. Eastward of these is the great cloister, having

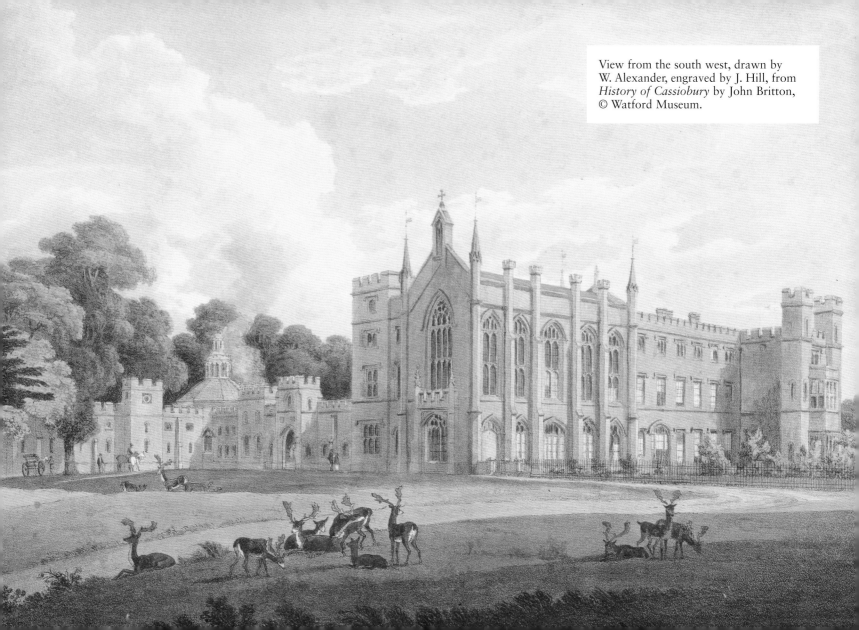

View from the south west, drawn by
W. Alexander, engraved by J. Hill, from
History of Cassiobury by John Britton,
© Watford Museum.

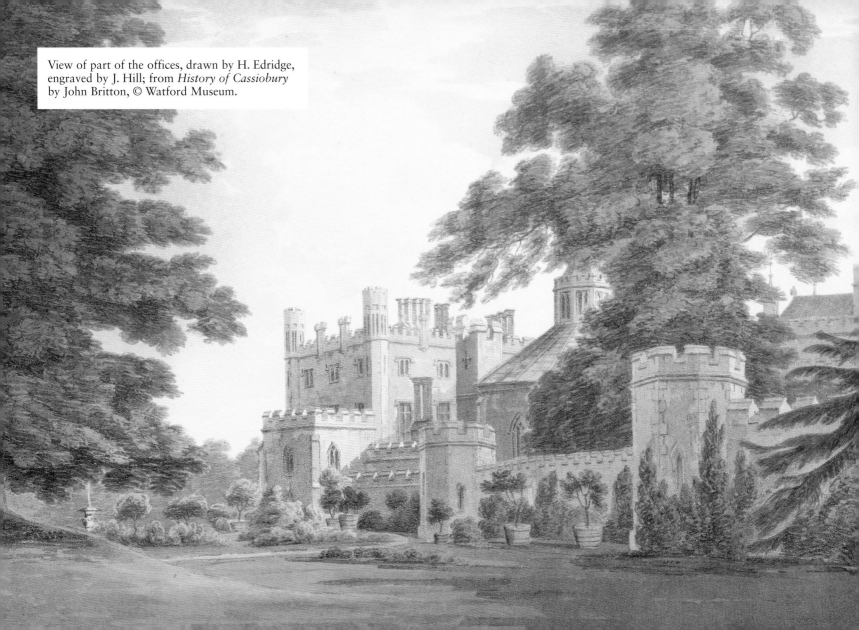

View of part of the offices, drawn by H. Edridge,
engraved by J. Hill; from *History of Cassiobury*
by John Britton, © Watford Museum.

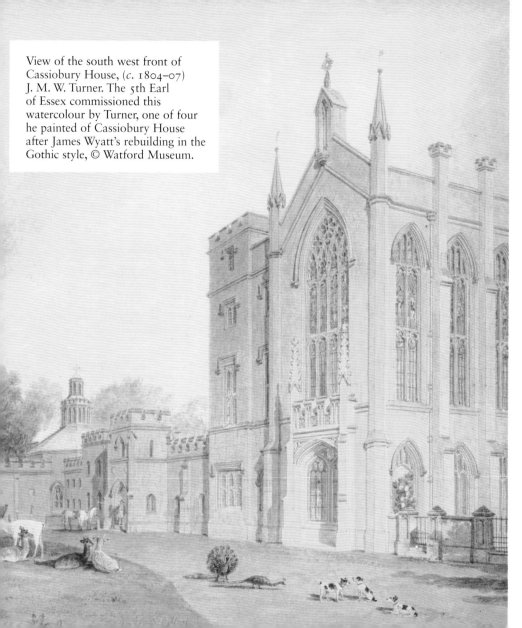

View of the south west front of Cassiobury House, (c. 1804–07) J. M. W. Turner. The 5th Earl of Essex commissioned this watercolour by Turner, one of four he painted of Cassiobury House after James Wyatt's rebuilding in the Gothic style, © Watford Museum.

five windows, partly filled with stained glass, and its walls adorned with four full-length family portraits, and a head of King Henry IV. Branching off from the cloister is the saloon, intermediately placed between the dining and drawing rooms. Its ceiling is adorned with the painting which Evelyn mentions as belonging to the hall of the old mansion. The dining room commands a fine view through the large western window, of the distant park and its long and lofty vista. The principal drawing room is a handsome apartment, adorned with cabinets and other rich furniture. On its walls are six fine and very interesting pictures by Turner, Calcott, Collins, and B. Barker. The great library is a noble room, and most admirably stored with those treasures of never-dying philosophy and learning which men of talents have, through the medium of the printing press, bequeathed to all the world. The library of Cassiobury is extensive, and judiciously arranged. It is divided into four classes … is disposed in as many separate, but adjoin rooms, *viz.* 1. The classics, history, travels, and philosophy; 2. Topography and archaeology; 3. Poetry and novels; 4. Dramatic and miscellaneous. A series of bookcases extend round the room, over which are fifteen portraits of so many personages of the family. The small, or inner library, appropriated to books on topography and antiquities, is ornamented with portraits and other enrichments, particularly some fine carvings by

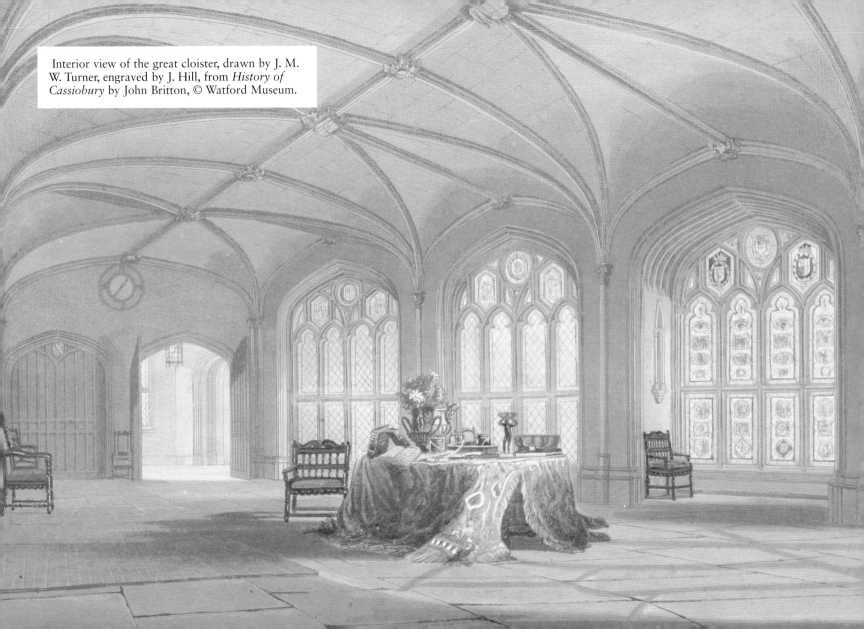

Interior view of the great cloister, drawn by J. M. W. Turner, engraved by J. Hill, from *History of Cassiobury* by John Britton, © Watford Museum.

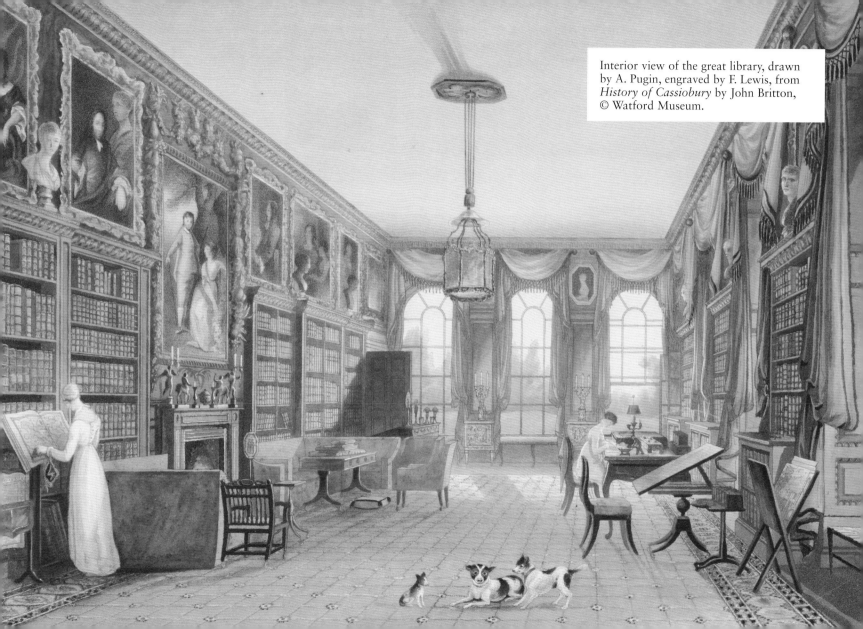

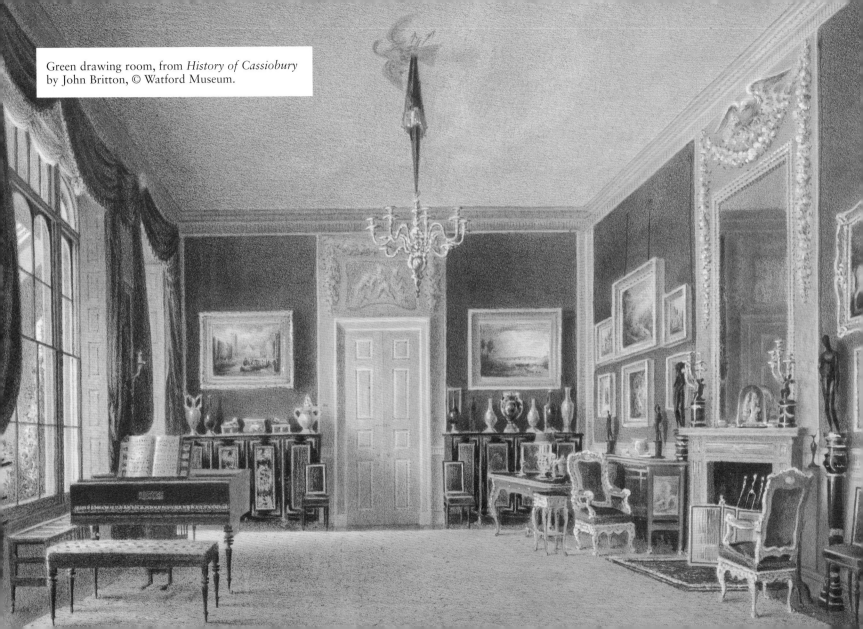

Gibbons. The dramatic library is a small cabinet room, adorned with miniatures, small bronzes, ivory, and other carvings, and a collection of plays. Another library contains a collection of novels and numerous other volumes of miscellaneous literature. The other apartments, to the north of the former, contain a collection of pictures by modern artists, which at once reflect honour on the patron and the painters.[35]

Hassell, in 1819, also provided a detailed insight of the remodelled house, as part of his *Tour of the Grand Junction.*

> The Earl of Essex's mansion at Cashiobury, is a spacious building, situated on an elevation, in an extensive park. The house has been much improved by its present noble owner, who has added, at the west end of the building, the external appearance of an ancient hall. The deception is so complete, that when withinside, you are naturally led to enquire for the great hall or the chapel, for either of which it may be taken. It is a long pile in imitation Gothic architecture with a number of pointed turrets, and deep window frames in which are double compartments painted with the scriptural subjects of the twelve apostles.[36]

Hassell describes in further detail areas that Britton has omitted and includes,

> The state bedroom … decorated with blue and white furniture, and hung with Gobelin tapestry, displaying a village feast, from Teniers, the subject that of making wine, etc. The roof of this apartment is painted azure, and the upper part gilt, with a coronet. In King Charles's room is a full length of Charles I by Vandyke, Charles II by Lely, and two female portraits by the same artist.[37]

A year after engaging Wyatt, Humphry Repton had been brought in to improve the setting of the remodelled house. Repton had already done some work for the late earl, although what was done, or whether it was at Cassiobury or Hampton Court, is not known. From Repton's own writings, he was responsible for thinning out the trees at the edge of the Wood Walks, to provide a more open aspect beyond the lawns. He also created a straight gravel walk, the Mall, north-east of the house, on which he was complimented by the Prince Regent. 'HRH the Prince told me at Brighton, that he was so much pleased with the good taste of the Mall I had made at Cashiobury, that he resolved to consult the person who had in these times dared to advise a straight gravel walk.'[38] Repton, from the amount of correspondence that was generated, may well have had a much greater impact at Cassiobury, but became increasingly bitter at the lack of credit accorded to him. In 1796, he is said to have widened the river, to create the illusion of a lake, and it could be that this was the project on which the fourth earl had consulted him, coinciding with the construction of the canal.[39] Repton, or his son, John Adey Repton, probably designed the new orangery, erected on the northern edge of the north lawn, described as being of an old-fashioned design with an opaque roof.

> The plants in the conservatory are chiefly orange trees, which are particularly appropriate to this kind of building: they are not, generally, in tubs, but planted in the free soil; and they looked far better than could have been expected from plants kept perpetually

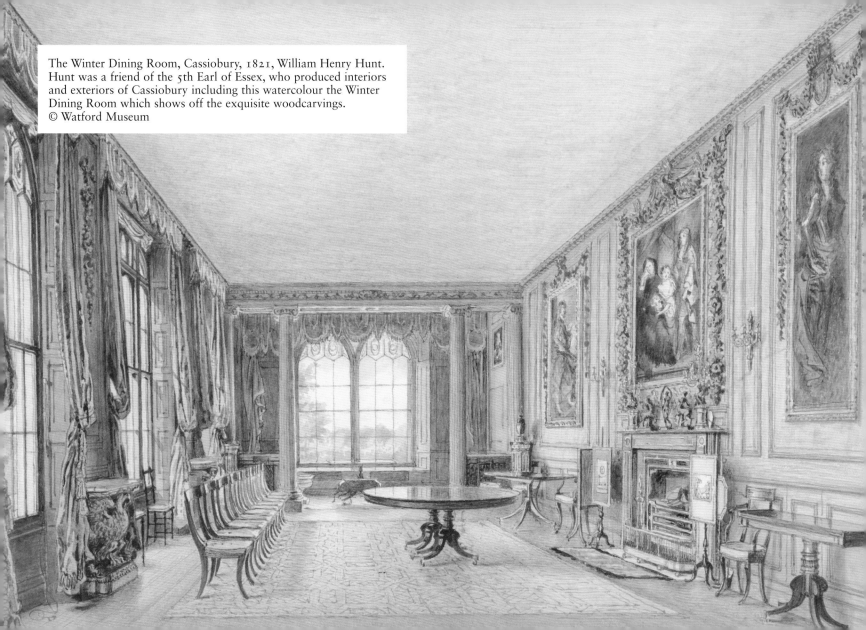

The Winter Dining Room, Cassiobury, 1821, William Henry Hunt. Hunt was a friend of the 5th Earl of Essex, who produced interiors and exteriors of Cassiobury including this watercolour the Winter Dining Room which shows off the exquisite woodcarvings.
© Watford Museum

under an opaque roof … There are two other conservatories, of a modern character, with glass roofs. The plants they contain have for many years been too large for them, so that they are annually obliged to be cut down.[40]

A new area of lawn and shrubbery, surrounded by a wall, was made outside the south front on what had been the old approach to the house. It has also been suggested that Repton was responsible for the design of the Chinese garden. If true, this would indicate that he was still working at Cassiobury after 1804, as in the same year he also proposed to make a Chinese garden at Woburn 'the first specimen of a Chinese garden in England'.[41] Repton must also be given the credit for the overall layout of the Flower Gardens, with their 'devious walks, avenues, arches, lawns, alcoves, groves, orangeries, etc',[42] covering 8 acres of ground to the north-east of the house. They are referred to in 1816 and, by 1820, sufficiently renowned to be described as the 'lion of the place'.[43] Repton may also have helped establish the new kitchen garden, in the midst of the woods by the Hempstead Road, near the then turnpike gate (moved north to Ridge Lane when the road was straightened). A clearing is shown here on Dury and Andrews' map of 1766 and Kent's of 1798. By the time of the first edition *Ordnance Survey* of 1822, it appears as a walled garden.

Repton's work at Cassiobury was without doubt influential, as he refers to it on several occasions. Though he was clearly concerned at the lack of credit he received, and his relationship with Lord Essex was, at times, strained,

although I have never envied any man for his riches or his title, I have sometimes felt it hard, that those who possessed both should wish to deprive me of my fair share of the only merit I did possess … and if this should ever meet the eye the noble lord (No. 73) who boasts that everything that was done at his place was his own tastes and design let him recollect that after writing fifty letters with the most trifling queries about a line of fence, or a gravel walk etc., and after denying that he had ever taken my opinion – and referring me as a common tradesman … Of fie! My lord! How can you tell everybody that Mr Repton never did anything for you?[44]

The Cassiobury gardens were described in detail by three visitors of the 1820s: Robert Havell in 1823, Prince Herman Puckler-Muskau in 1826, and J. C. Loudon who visited in 1825. Described in 1820, the gardens were clearly the 'lion of the place', and the descriptions by these three visitors confirm their high profile.

Havell describes the gardens and pleasure-grounds as,

particularly interesting from their arrangement, decoration, and contents. Besides almost every species of deciduous and exotic trees, plants, and shrubs that will live in the English climate, several hot houses and greenhouses are appropriated to rear and preserve the more delicate and tender shrubs and fruits. In one spot we recognise a Chinese garden, with analogous buildings, inscriptions, rocks, and plants, while in another, the visitor is surrounded by an American nursery. A third spot carries him to the frozen regions of the North, while a fourth scene is adorned and perfumed with the flowers and fruits of a tropical climate … an endless variety and intricacy, although by a closer examination we discover order, science, and taste to pervade the whole.[45]

Prince Herman Puckler-Muskau goes into further detail;

The flower gardens occupy a very considerable space. Part of them are laid out in the usual style; that is, a long green-house at the bottom, in front of which are several *berceaux* (a series of arches on which plants are trained) and shady walks around a large grass-plat, which is broken with beds of all forms, and dotted with rare trees and shrubs. But here was also something new – a deep, secluded valley of oval form, around which is a thick belt of evergreens, and rock-plants planted impenetrably thick on artificial rockeries; a background of lofty fir trees and oak, with their tops waving in the wind; and, at one end of the grass-plat, a single magnificent lime tree surrounded by a bench. From this point, the whole of the little valley was covered with an embroidered parterre of the prettiest forms, although perfectly regular. The egress from this enclosure lay through a grotto overgrown with ivy, and lined with beautiful stones and shells, into a square rose garden surrounded with laurel hedges, in the centre of which is a temple, and opposite to the entrance a conservatory for aquatic plants. The rose beds are cut in various figures, which intersect each other. A walk, overarched with thick beeches neatly trimmed with the shears, winds in a sinuous line from this point to the Chinese garden, which is likewise enclosed by high trees and walls, and contains a number of vases, benches and fountains, and a third greenhouse – all in the genuine Chinese style. Here were beds surrounded by circles of white, blue, and red sand, fantastic dwarf plants, and many dozens of large China vases placed on pedestals, thickly overgrown with trailing evergreens and exotics ... The park, gardens, and house cost £10,000 a year to keep up. The earl has his own workmen in every department: masons, carpenters, cabinet-makers, etc., each of whom has his prescribed province.[46]

John Claudius Loudon, writing in the *Gardeners Magazine* (Volume 12, 1836) about visits made to Cashiobury in 1825 and 1836, similarly describes a succession of different sorts of flower garden which contained exotic trees and shrubs, including magnolias, rhododendrons and azaleas. These were each displayed in separate groups, contained by basketwork or stonework, in the style later described by Loudon himself as 'gardenesque' – each different species was displayed for its individuality, rather than being used as part of some overall design.

These various walks, shrubberies and hornbeam arbours with groupings of plants by climate – from the cold zones and from the Tropics, with assemblages of American plants – came under James Anderson, head gardener. He had considerable influence on the design and planting, as he had been on plant collecting expeditions to Africa and South America.[47] Horseshoe Dell, a secluded valley which was described by Puckler-Muskau, can be attributed to Sir Uvedale Price. Price was one of the leading exponents of the Picturesque movement, and a major influence on John Nash, who was laying out Regent's Park in 1825, as well as being a friend of Lord Essex. Visiting Cassiobury in July 1824, Price explored the grounds and spotted the potential of a secluded, overgrown hollow surrounded by banks, close to the house. It may have been an old marl pit or gravel pit, or possibly a remnant of some earlier landscaping. With the earl's permission, and some labour supplied, Price cleared and replanted it creating 'a deep secluded valley of oval form' that Puckler-Muskau clearly was enthralled with.

View of the flower garden, drawn by A. Pugin,
engraved by J. Hill; from *History of Cassiobury*
by John Britton, © Watford Museum.

A. Pugin delt. CONSERVATORY SCENE FROM BERCEAU WALK. Hill aquatinta

A follower of Price's Picturesque doctrine, William Sawrey Gilpin, also had influence at Cassiobury in the 1820s. Gilpin is rather an elusive character in the panoply of great garden makers. For such an important designer, whose career reached its height less than 200 years ago, surprisingly little is known of him. As a garden maker, Gilpin was the greatest exponent of the Picturesque style of landscaping, and is the man who provides the historical link between Humphry Repton and Sir Charles Barry. Gilpin set himself up as a landscape gardener very late in life. He was fifty-eight when he started out, and he worked well into his seventies. Gilpin set up business at just the right time. Humphry Repton had died in 1818, leaving no obvious heir to his practice. The essence of the Picturesque style was founded on a belief that the eighteenth-century English landscape style, introduced by Capability Brown, was too sweeping, shapeless, smooth, tidy and monotonous, and needed to be improved in two specific ways. First, the landscape should be laid out irregularly. This meant, for example, that clumps of trees should not be symmetrical, but open out in different directions on all sides. Some of the clusters that Gilpin planted look like an amoeba in their irregular outlines, although he maintained that they were compositions that grouped well together. They created both harmony in their tints, and unity of character within themselves. This desire for asymmetry was also promoted by architects of the time. Gilpin flourished just as the Gothic style became fashionable.

Left: Conservatory, seen from the Berceau Walk at Cassiobury, drawn by A. Pugin, engraved by J. Hill, from *History of Cassiobury* by John Britton, © Watford Museum.

The other fundamental precept of Picturesque was that the picture should, in effect, be properly framed. This had many implications but, above all, that the landscape should not sweep right up to the house, and the view from each of the principal rooms' windows should be considered and improved. Gilpin asserted that 'composition in landscape embraces three distinct parts: the distance, the middle distance, and the foreground' but, as 'the first of these is out of the reach of improvement in itself', the most important was the foreground, because it frames the others and should be properly dressed. The art of improvement consisted of uniting all three into one harmonious whole. It is known that Gilpin certainly advised on plantings and views at Cassiobury and, in particular, on varying the size and shape of tree groupings within the Home Park. He opened up a view of the canal that had been deliberately and ill-advisedly obscured by a conifer plantation – presumably by Repton.

> Cassiobury forms a striking instance of this mistaken planting. The Grand Junction Canal passes through the park close under a high and finely wooded bank. Under such a circumstance, the improver, conceiving the canal an unsightly object, made a plantation of Larch, Fir, etc. to hide it. Not perceiving that the consequence of hiding the canal would be the exclusion of the wooded bank beyond it – the finest feature of the scene. The plantation is now removed, and the occasional passing of the boats is a source of cheerfulness rather than deformity.[48]

The earl's remodelled house at Cassiobury was completed in 1805. Yet, well before this, the earl was already entertaining artists there and commissioning some to paint the mansion and

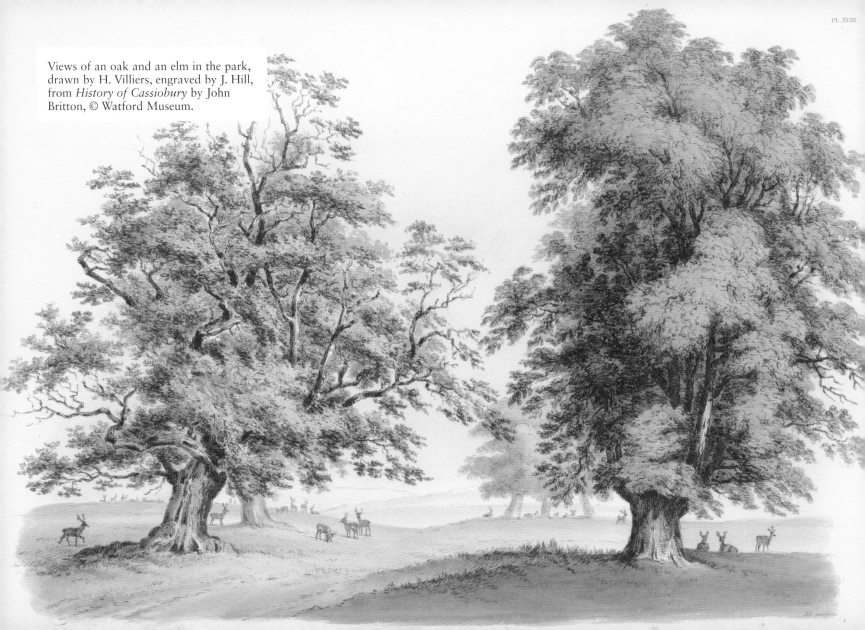

Views of an oak and an elm in the park, drawn by H. Villiers, engraved by J. Hill, from *History of Cassiobury* by John Britton, © Watford Museum.

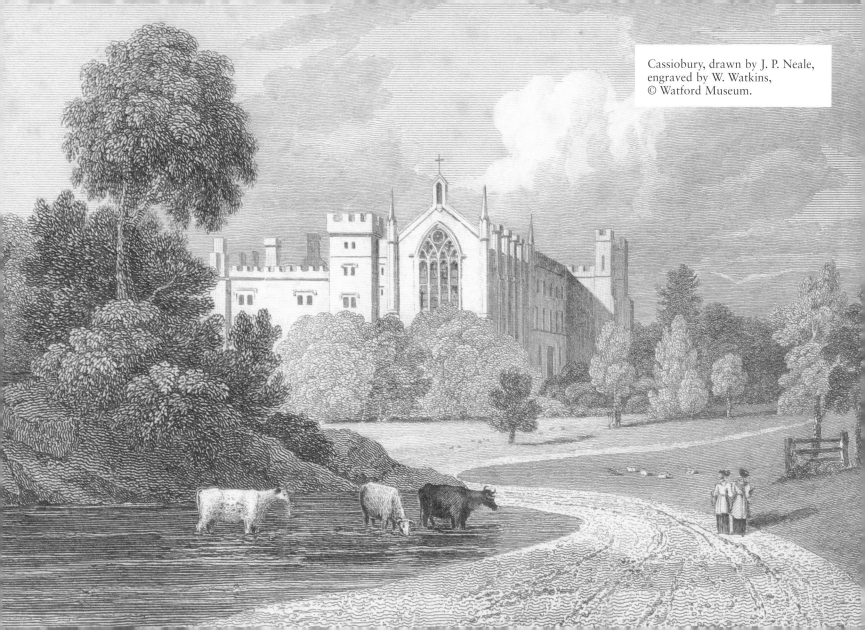

Harvest home, *c.* 1809, Joseph Mallord William Turner (1775–1851). Harvest celebrations are depicted in a barn of shadowy, but cathedral-like proportions. Turner's drawing shows an outdoor setting, with notes about 'men half drunk', and those waiting to be served as 'eager and cunning'. The painting is unfinished – a story abounds that Turner took offence at a comment during its execution and refused to complete it, © Tate, London, 2014.

Gravestone of George Doney in St Mary's churchyard, Watford, © Watford Museum.

park. Most were acquainted with each other through attendance at Dr Thomas Monro's academy in London. Monro was also known as a patron to numerous artists (including Peter De Wint, Thomas Girtin, John Sell Cotman and William Turner). The group of artists around him was known as 'The Monro Circle', and included students from his academy in London, where evening classes were given. Other painters who visited his home included J. M. W. Turner, Joseph Farington, Thomas Hearne (1744–1817), James Bourne, Henry Edridge, William Henry Hunt, John Laporte and John Varley. Most of these artists continued to visit him when he moved to Bushey and, through him, obtained introductions to Lord Essex. J. M. W. Turner, who had already impressed Essex with his images of Hampton Court, was at Cassiobury making sketches in 1802–04. He is known to have produced four watercolours of the house and park, and these in turn were used as the basis for aquatints to illustrate both John Britton's (1837) and Robert Havell's (1823) books. His final visit to Cassiobury was in 1809, when he is thought to have made the oil painting *Cassiobury, reaping*. Henry Edridge, William Hunt and Thomas Girtin, all members of Monro's academy, received commissions from Lord Essex. Only Thomas Hearne, the most senior member of Monro's circle, failed to convince the earl to employ him at Cassiobury.

Several architects were engaged in work at Cassiobury during this period. James Wyatt continued working there until his death, in 1813, and his son Samuel and nephew Jeffry Wyattville were also employed by Essex. It was at this time that many of the delightful lodges and cottages were built, though who was responsible for which building is unclear. Wyatt and his son may have designed the castellated lodge, dated 1802, at the main

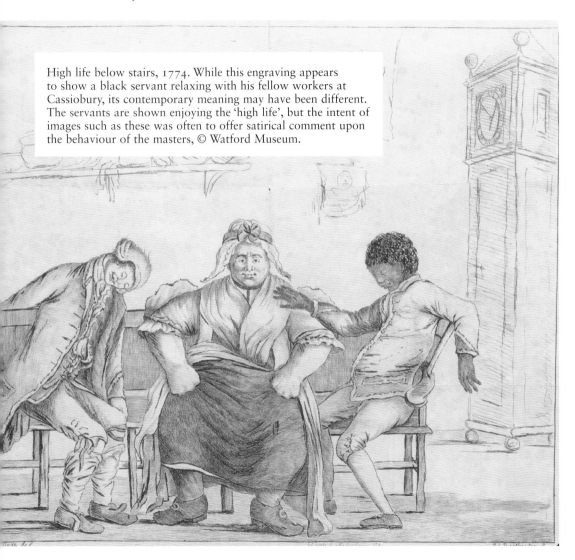

High life below stairs, 1774. While this engraving appears
to show a black servant relaxing with his fellow workers at
Cassiobury, its contemporary meaning may have been different.
The servants are shown enjoying the 'high life', but the intent of
images such as these was often to offer satirical comment upon
the behaviour of the masters, © Watford Museum.

entrance. Wyattville may have done some
alterations and decorative work to the
mansion, and sketches in his hand, dated
1812, suggest that he designed some of the
lodges. These buildings clearly show the
strong influence of the rustic style of *cottage
ornés*, pioneered by John Nash at Blaise
Hamlet in Bristol, and who was soon to
be working on Regent's Park for the Prince
Regent.

Britton describes them at length;

In different parts of the park and
grounds are various cottages and lodges,
which are distinguished at once for their
exterior picturesque features, and for the
domestic comfort they afford to their
humble occupants. Unlike the ragged,
wretched sheds and hovels which are too
often seen by the roadside, and even in
connection with some of the large and
ancient parks of our island, the buildings
here delineated are calculated to shelter, to
console, and gratify the labourer after his
daily toil, and to make his wife and family
cleanly and diligent ... The cottages at
Cassiobury have been designed with the
twofold object of being both useful and
ornamental. They are occupied, exempt
from rent and taxes, by men and women

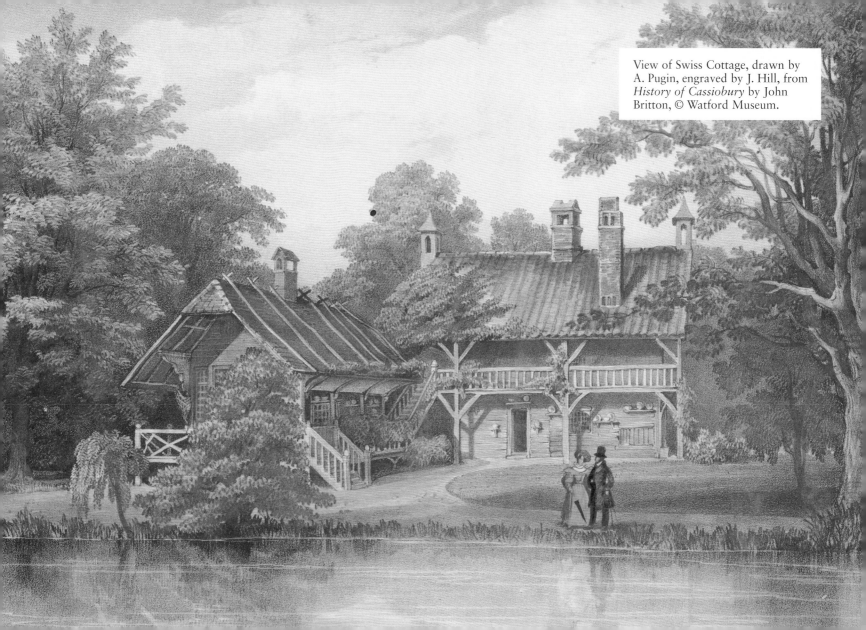

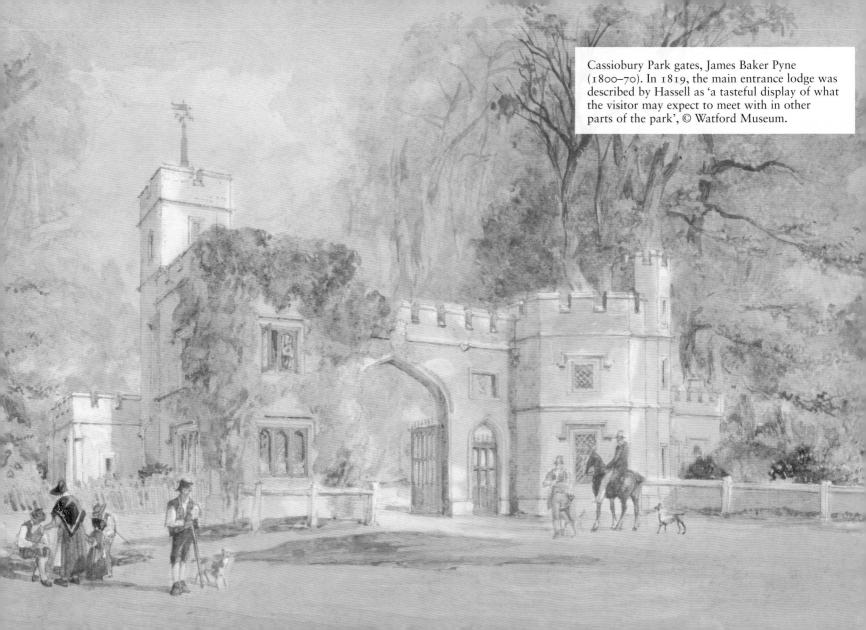

Cassiobury Park gates, James Baker Pyne (1800–70). In 1819, the main entrance lodge was described by Hassell as 'a tasteful display of what the visitor may expect to meet with in other parts of the park', © Watford Museum.

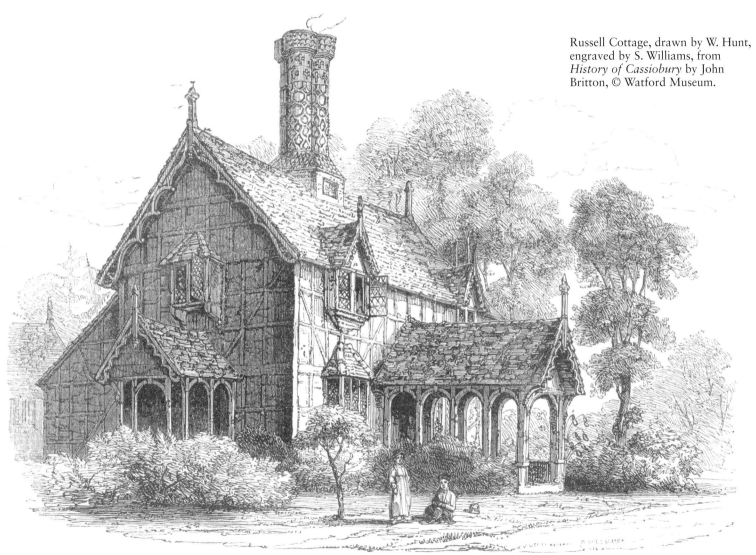

Russell Cottage, drawn by W. Hunt, engraved by S. Williams, from *History of Cassiobury* by John Britton, © Watford Museum.

W. Hnnt, del.

RUSSELL COTTAGE.

who are employed by the noble landlord in various offices about the park, the gardens, and the house; thus the park keeper, a gamekeeper, a shepherd, a lodge keeper, a gardener, a carpenter, a miller, a lock keeper are accommodated.[49]

Britton further describes them as mostly having a porch, a sitting room, one or two bedrooms, and a wash house, with an oven and a copper. These included Park-keeper's Cottage, Thorn Cottage, Shepherd's, or Keeper's Lodge, Entrance Lodge, Ridge Lane Cottage, Great Beech Cottage, Russell Farm Lodge, Russell Cottage and the Cassio-bridge Cottage. The latter is the most elaborate in execution, with its whole exterior being covered, or 'cased with pieces of sticks of various sizes split in two'. The Swiss Cottage, on the bank of the River Gade, was frequently subject to many paintings, and was intended for the occupation of a family, and also for the accommodation of parties, during the summer, to take refreshment.[50]

In 1819, Hassell describes many of the lodges, and specifically their settings, as part of his *Tour of the Grand Junction*.

Cashioberry Park is entered by a gate at the lodge, a short distance from Watford ... The lodge at this entrance is a tasteful display of what the visitor may expect to meet with in other parts of the park; it is an octagon building one-storey high, with a profusion of ivy, honeysuckles and roses covering its top and sides, while its back is embowered among lofty trees. From this entrance both a path and carriage road lead to the mansion, which stands on an elevated part of the park. Nearby in the front of the entrance to the great house is the carpenter's cottage, which is partly embowered in trees, with a vine over its front and to its very summit, interwoven

with other flowering shrubs and creepers, with still greater profusion of roses, lilies and flowers of every description than that at the lodge gate has. From this, we take an immediate south-west direction across the park to the shepherd's residence, which forms an opening to the road on the south side, and is called Thorn Cottage. This habitation is a mixture of the Swiss and English style of cottage building, and like the carpenter's residence has its sweet and blooming accompaniments. It is peculiarly well adapted for a herdsman's retreat, as the cattle can be received in, and out of the park; without annoying the company passing along the high road to the lodge.[51]

The approach to the Swiss Cottage is via a 'rusticated and monastic-like gate, with a bell placed at its top' and is described as a 'charming place' and 'towards the extremity of the grounds on the left, a rustic bridge is thrown over the river, which answers the double purpose of a weir and dam.' A pretty retreat is found along the banks of the Grand Junction Canal, and is 'an excellent station for checking the depredations of the boatmen, who navigate the vessels on that stream.' Nearby is the mill with a waterfall, where the scenery 'is very picturesque, having an abundance of wood, embowering the mill and cascade, which are continually enlivened, by the herds of cattle and deer.' A cottage called Sparrowpot Lodge is inhabited by one of his lordship's keepers 'at the termination of the Cashioberry woods'. The Canal Company also have a watchman's cottage, 'to prevent the navigators from committing depredations in their passage through the park'.[52]

The references to deer in the park at Cassiobury are frequent throughout its history. Until the end of the fifteenth century,

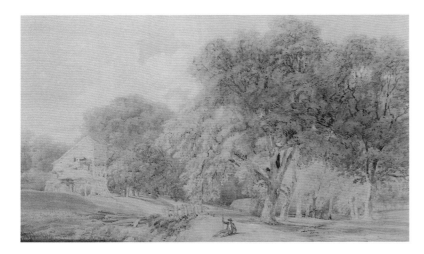

In Cassiobury Park, *c.* 1801, Thomas Girtin. A peer of J. M. W. Turner, Girtin was commissioned by the 5th Earl of Essex to paint views of Cassiobury Park. This picture shows the River Gade, lined by trees, with a horse-drawn treadmill to the left, © Watford Museum.

a park was simply an enclosed parcel of land, the purpose of which was to retain the beasts of the chase, which included deer. Domesday, in 1086, records that there were then thirty-five parks in England. The growth of the medieval deer park coincided with the expansion of the royal forests and the rigorous enforcement of the Forest Laws. They were a device which enabled the nobility, the Church and wealthy landlords to own their private hunting grounds, stocked with deer, without breaching the Forest Laws. The park provided better opportunity for a successful chase than did the forest, because the quarry was more readily available within its confines. In the later Middle Ages, there was an emphasis away from hunting and towards amenity,

with a new generation of parks directly associated with a major residence, occupying what was once arable or pasture land. Tree-lined avenues and other features were introduced, and a certain amount of formality gradually became apparent.[53] Throughout the successions of the various Earls of Essex and the Morisons who preceded them, it is unlikely that Cassiobury was used as a hunting ground. Certainly, Charles II never appeared to visit Cassiobury, even though he was a keen hunter and enjoyed the thrill of the chase. From the various descriptions of Cassiobury, the deer were there as part of the local amenity. 'The Park, with its splendid trees, beautiful verdure, and the river meandering in a circuitous course through the valley in the foreground, is exquisite, and the beauty of the scene is enhanced by the numerous herds of deer which group themselves about, apparently with a view to effect.'[54] In the early 1900s 'when pedestrians had been granted access to stroll in the park … the first noticeable event was the tame deer [which] were to be seen grazing within 50 yards of the Rickmansworth Road.'[55] This is emphasised further by an article in the *London Journal*;

the lover of nature would rather indulge pleasurable emotions in viewing the laughing landscapes of Cashiobury Park, diversified and enriched as it is by countless trees of ever varying colour and forms, by herds of deer and of cattle and by flocks of sheep, by a running stream and a broad canal.'[56]

That Essex was no lover of hunting is best perhaps seen when, on July 26 1809,

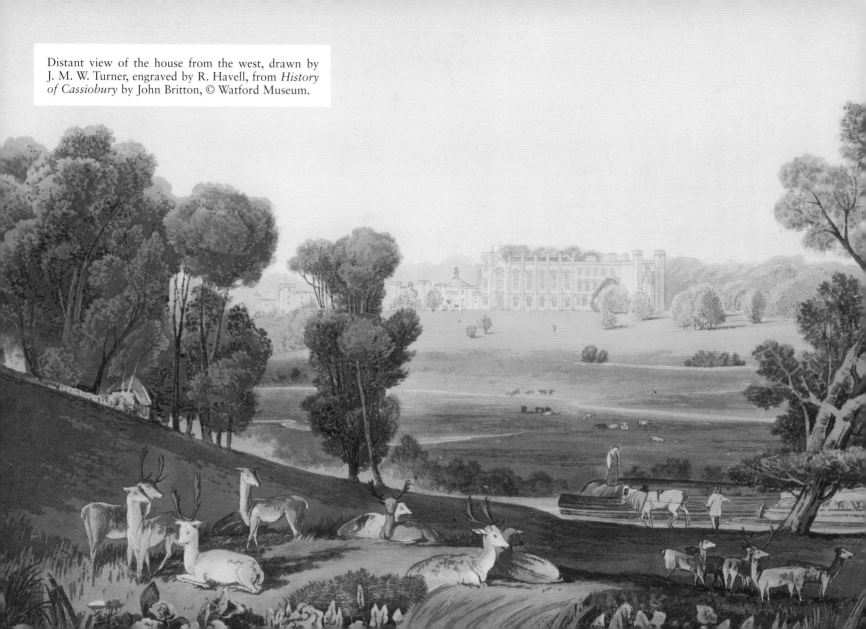

Distant view of the house from the west, drawn by J. M. W. Turner, engraved by R. Havell, from *History of Cassiobury* by John Britton, © Watford Museum.

At Hertford Assizes on the 24th the Earl of Essex obtained a verdict of one shilling damages against his brother, the Hon. Revd. Mr Capel, for a trespass committed on his lordship's park at Cashioberry, by the Berkeley hunt, club of fox hunters, of which Mr Capel put himself at the head – his lordship only wished to have the point of law decided. The defendants pleaded that their object in hunting was to destroy a noxious animal. But Lord Ellenborough supported his lordship's council in saying, their object was pleasure and not merely to kill the fox – besides, to kill the fox they were not justified in committing great depredation.[57]

The 1770 accounts of George Bennett, gamekeeper, include 'beer for fishing … killing a bustard … killing a cat in Wheping dell … expenses curing some venison that was sold to Kits inn … expenses sending venison to Norfolk'.[58]

Deer were also exchanged with the royal parks. Richmond Park, Bushy Park and Windsor were all struggling with their stocks and with declining numbers, especially as all royal hunting grounds were heavily used and had to satisfy the Royal Venison Warrant. In 1833, deer were exchanged with Woburn and Cassiobury Park. Richmond Park keeper James Sawyer noted in his diary that Friday 1 March 1833 was 'a very fine morning', part of which he spent catching 'three brace of deer sorels and sores for Woburn Park'. Tuesday 16 April that year started with 'a dull morning' and saw John Lucas, the second or under keeper returning from Cassiobury with 'eight brace of deer in exchange'. On Saturday 20 April, it was again a 'fine morning', and Sawyer 'caught three brace of deer for the exchange. They ran amazingly and we had some rare galloping.'[59] Management

of the deer herds was always not straightforward. Stocks were diminished in many of the royal parks but also in many others too. The Agricultural Department of the Privy Council were concerned about losses of deer, particularly in the royal parks, and inspectors Cope and Horsley established the presence of rabies at Richmond Park. In their official report of the Richmond Park outbreak, they conjectured that 'the distemper' which had destroyed a large number of deer in Cassiobury Park in 1798 and 'which remained so long in Windsor Great Park' may well have been rabies. Whether it was rabies was debated for a considerable while, and whether sheep were the cause of it. Either way, many deer were destroyed at Cassiobury.

In 1839, the 5th Earl of Essex had died without legitimate issue from his first two marriages. However, the 5th Earl had a biological daughter. She died at the age of twenty-nine, predeceasing him by two years. A memorial tablet, situated in the Essex chapel at St Mary's church, Watford, reads, 'To the memory of a most beloved and lamented daughter this tablet is placed here by her affectionate father George Earl of Essex. Harriet/ Oby. May 14th 1837 Aged 29'. As he left no heirs, his estate therefore passed to his nephew, Arthur Algernon Capel (born in 1803). The 6th Earl had many interests, including agriculture and engineering and was also a talented water-colourist. He also had a real passion for croquet, becoming an enthusiastic promoter of the game. With his interest in farming, and the vogue at the time among landowners for creating model farms, it is probable that he built the new Home Farm, north of the mansion. It was set around a square yard, with a fountain in the centre and a farmhouse on the south side, with a description of it in the 1922 sales catalogue.

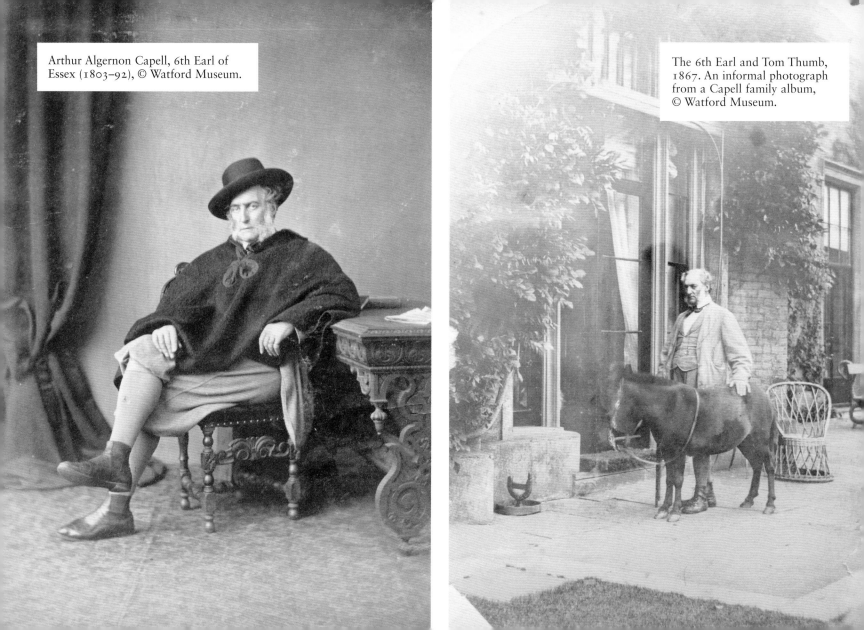

Arthur Algernon Capell, 6th Earl of Essex (1803–92), © Watford Museum.

The 6th Earl and Tom Thumb, 1867. An informal photograph from a Capell family album, © Watford Museum.

The 6th Earl was also active in improvements, with the orangery completely refurbished. It was subsequently destroyed by fire, but replaced in time for a royal visit in October 1846. That year, Lord Essex rented Cassiobury to Queen Adelaide, widow of William IV, and it was during her tenancy that a visit by Queen Victoria and Albert took place, 'the carriages entered the park by the Cassio Gate at a few minutes past five o'clock … thence to the mansion, where the royal party arrived at about twenty minutes past five o'clock.' The following day,

> Her Majesty and the Prince Consort rose at an early hour this morning, and walked in the pleasure grounds adjoining the mansion. Shortly before ten o'clock, the Queen, accompanied by Prince Albert, and attended by the Countess of Gainsborough, the Earl of Howe, and the youthful Ladies Adelaide and Emily Curzon, proceeded to inspect the extensive gardens, and subsequently visited the orangery. The royal party then went to the dairy at the Home Farm.[60]

On his return in 1848, the earl and his third wife, Louisa, began to institute a number of changes to the gardens and estate. The gardens, already magnificent, became among the most celebrated in the country, and at their height gave employment to twenty-eight gardeners. Lady Essex added a number of 'incidents', including a statuary, fountains, summerhouses, and a trellised walk. The horseshoe dell, with its sheltered microclimate, was stocked with a collection of sub-tropical plants by Mr Fitt, head gardener. The kitchen garden comprised not only the 4 acres within its walls, but a further 4 acres of slip gardens and glasshouses outside. Access to both the kitchen garden and the farm was facilitated by two new entrance drives, each with its own lodge, and there were workmen's cottages within the garden area and the park. The description of the gardens, from the 'Gardener's Chronicle' of 29 May 1886, are detailed and extensive.

> Trees and shrubs of priceless value such as time imparts are among the heirlooms of Cassiobury, and the delighted visitor sees at once that the gardens are historic. Some noble cedars of Lebanon on the lawn are fit memorials of the year 1675, and of the improvements referred to by Evelyn … I traversed the pleasure grounds and other gardens under the guidance of Mr Fitt, the head of staff which till lately comprised twenty-six gardeners – a number which has been in these bad times somewhat reduced, though the diminished forces are of such a quality and so well led that the horticultural prestige of the place is not likely to suffer. Large numbers of bedding plants are used. In the first warm days of May this year, 3,000 tulips might be seen in full blossom, arranged, of course, with skill according to their colours. Presently 30,000 pelargoniums will be planted in the flower garden, while the total number of plants turned out into beds for summer decoration is 100,000. The lawn and shrubbery of 16 acres, enclosing two sides of the house, are delightfully arranged on a rather complex plan, which is, I believe, partly due to the foreign taste of a former proprietor. Several wildernesses formed, by short and curved hedges of hornbeam, have proved most welcome in hot summers for the shade they afford. They were probably French in their origin … You will hardly find such another garden for shady nooks and pleasant arbours, such cool retreats and sheltered places, and so many convenient seats for rest … The bright colours of the beds of tulips and violas, and clumps of aubrietia, attracted us to the front of the orangery, a good spot

for a general view of the grounds immediately connected with the house … It is not an orangery in name only, being full of large trees in boxes, which will presently be wheeled out upon the lawn, together with several species of standard rhododendron, also in tubs … Among other curiosities, Mr Fitt, the gardener, showed me some shoots of a bay tree which had grown from a cutting brought by Mr James Forbes from the tomb of Virgil at Naples. In another part of the garden is another commemorative tree, a willow, brought as a cutting from the grave of Napoleon, and planted by a fountain among flags and bulrushes … A rose garden with a 'temple' of roses and honeysuckles in the centre, forms one of the divisions of this delightful 16 acres of pleasure garden. Another spot, a little combe or hollow, surrounded and sheltered by rhododendrons and hornbeam arbours, and forming in itself a natural division, has been set apart by Mr Fitt as a sub-tropical garden.[61]

Country Life, in 1910, adds to this description of the gardens;

Many delightful garden incidents have been added by the present Lady Essex, who is keenly interested in her garden. Such is the great grass semicircle bounded by a tall yew hedge, in front of which stand busts of the twelve Caesars on stone pedestals flanking an alcove, wherein a dolphin spouts water into a great shell. A wall pierced by roundels and faced with trellis, on which roses grow luxuriously, ends in a seat shaded by a pergola of stone columns and oak rafters.[62]

The park was still well stocked with deer, and was freely open to the public during the 6th Earl's time. 'To see the house

Caroline, Countess of Essex, © Watford Museum.

an introduction is required; but the park is always open, and the gardens may generally be viewed on application to the gardener. They are very beautiful, and have always been famous.'[63] Visitors were able to walk right through the grounds to the north-west entrance at Sparrowpot Lodge, stopping on the way to have a picnic at Swiss Cottage, where they were provided with utensils.[64]

Lord Essex took a keen interest in the management and improvement of the estate farm and was, according to the *Herts Mercury*, 'one of the best practical farmers of the county'. After the repeal of the Corn Laws by Sir Robert Peel's government in 1846 (which allowed hitherto excluded cheap foreign corn to flood into the land), many landowners adopted a policy of heavy investment in farming, known as high farming. Essex had very much opposed the repeal of the Corn Laws, and joined the Herts Agricultural Protection Society, which campaigned for their return. Though it seems that his enthusiasm for protectionism waned, after he obtained a loan of some £3,000 from the state to modernise his farm. The earl invested in machinery and new technology, emphasising that this should help protect the economy and farm jobs in the future. An 1864 article published in the Journal of the Royal Agricultural Society of England notes that,

> The Home Farm of the Earl of Essex is remarkable for an extensive experiment on sewage brought from the adjoining town of Watford. The pipes were laid down eight years ago. The population from which the sewage is derived is about 4,500; this does not include the whole parish. Pipes are laid under 96 acres of land, comprising 35 acres of permanent pasture, 7 to 10 acres of Italian rye grass, and the rest arable.

Another experiment was the collection of urine from some thirty short-horned cows which, when diluted with river water, was spread over 4 acres of Italian rye grass, thus helping to keep those same cows fed. The 6th Earl was a keen croquet player. The *Herts Advertiser* of 5 October 1889, recounted a visit to Cassiobury, stated, 'as the inventor of Cassiobury croquet, he realised a small fortune by manufacturing some 3,000 sets a year'. Photographs of the lawns at Cassiobury in the latter half of the nineteenth century are seldom without their quota of croquet hoops, and members of the Capel family, clad in flowing dresses or tweed jackets, clinging to their mallets. The sport became a significant craze at the time, and was played at country houses all over the country. He had many other interests, noted by visitors to his clematis, wisteria and magnolia-covered mansion. He collected briarwood pipes; he was a very competent watercolour painter and amateur chemist; he had an extensive stable, and he enjoyed riding his Icelandic pony, Tom Thumb, to have tea at the estate dairy, or to visit his neighbours at the Grove or at Moor Park.[65]

The earl married three times, and had several children. He married his first wife, Lady Caroline Janetta Beauclerk, in 1825, but she died in 1862. In 1863, he married Lady Caroline Elizabeth Boyle, who died in 1876. In 1881, he married the widow of Lord George Paget, the Lady Louisa Elizabeth Heneage, who died in 1914. One of his children was Lady Adela Capel who, at the age of thirteen, was beginning to question some of the practices of those around her, through her very detailed diary, which she kept between the years 1841 and 1842. Her diary provides delightful insights into the lives

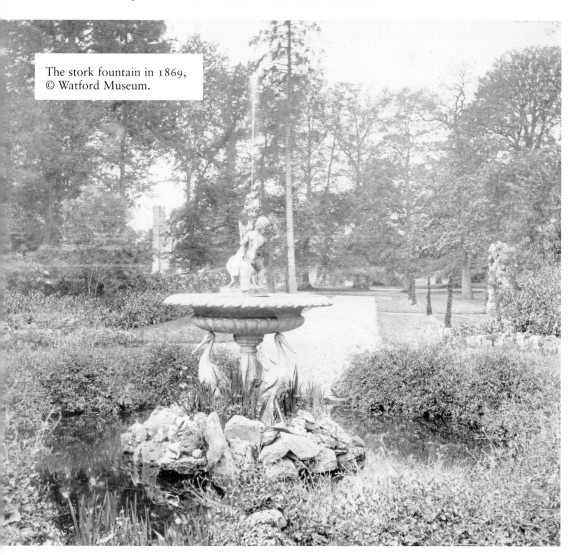

The stork fountain in 1869,
© Watford Museum.

of the family, and some of the servants at Cassiobury House at this time. The young diarist was the only daughter of the 6th Earl, by his first wife, Lady Caroline Jeanetta Beauclerk, daughter of the 8th Duke of St Albans. Adela was born on 4 March 1828, and spent much of her early life in London with frequent visits to Cassiobury to see the 5th Earl. On his death, in 1839, Cassiobury House became their home. Half a mile from Cassiobury House on the earl's estate, at Little Cassiobury – one of the family's dower houses – lived Uncle and Aunt Bladen. They were both involved in various ways in helping to develop the interests and skills of their young great-niece Adela, and she often visited them. Uncle Bladen, Admiral Bladen Thomas Capel, was a distinguished naval officer who had acted as Nelson's signal officer at the Battle of Trafalgar. Adela spent time with them both, whether for piano lessons or looking through the telescope given to her by Uncle Bladen. At the same time, Revd William Capel, one of her father's uncles, was the vicar of St Mary's church in the centre of Watford, and was also a chaplain to Queen Victoria. A colourful and controversial character,

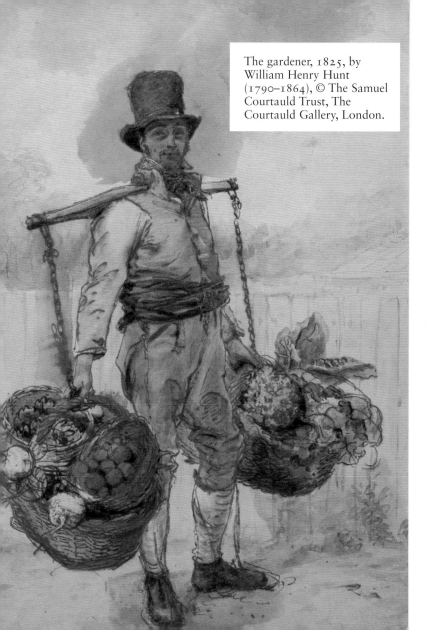

The gardener, 1825, by William Henry Hunt (1790–1864), © The Samuel Courtauld Trust, The Courtauld Gallery, London.

he was a very keen sportsman, loving the hunt and playing billiards, which often left him open to criticism. In London, Adela's grandmother, Lady Caroline Capel, lived with Amelia and Mary, her younger unmarried daughters. Grandmama was Adela's special confidante and friend, with many references to her in her diary. Despite the many frequent visits to London, in Adela's opinion, life in the countryside was preferable to living in London. Her relationship with her father, the 6th Earl, was clearly a positive one as she writes of their walks together, of his interest in her pets, and of accompanying him on a visit to London.

The earl's interest in his daughter, and his family, may have stemmed from the pain of his own separation from his parents, brothers and sisters during childhood. Arthur's father, John Thomas Capel, had so reduced the family fortunes through gambling that he was forced to live with his family on the continent, where housing and living costs were more affordable. As the 5th Earl, George, had no sons, he paid for part of Arthur's education but placed every obstacle in the way of him rejoining his parents, even for the holidays. Adela had three brothers, with the eldest referred to as 'Malden,' as he was already titled as the Honourable Arthur de Vere Capel, Viscount Malden. He was already being groomed for his position in the aristocracy with military training at Sandhurst. On his return for holidays, the other children's lessons were rearranged to accommodate his interests. Malden did not live long enough to succeed his father. He died at the age of fifty-two, on 10 March 1879. The two younger brothers, Reginald and Randolph, were great friends and spent much of their time on the earl's estate shooting, playing and fishing.

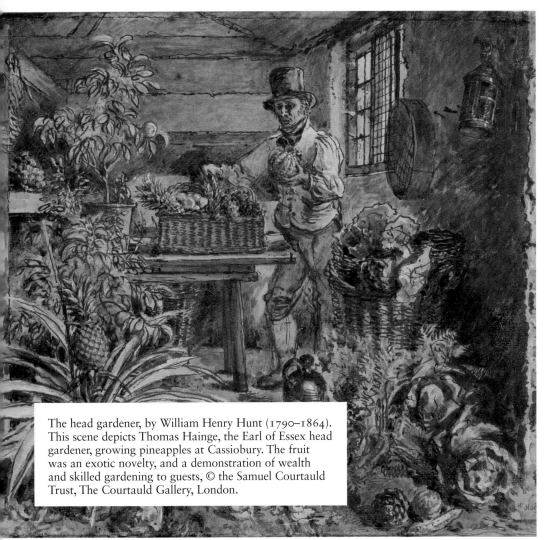

The head gardener, by William Henry Hunt (1790–1864). This scene depicts Thomas Hainge, the Earl of Essex head gardener, growing pineapples at Cassiobury. The fruit was an exotic novelty, and a demonstration of wealth and skilled gardening to guests, © the Samuel Courtauld Trust, The Courtauld Gallery, London.

A rifle range was on the estate and was well used by the brothers. Their later lives differed greatly. Reginald went from Harrow to Trinity College, Oxford, and was then appointed a Queen's Messenger from 1849 to 1858. He was a captain in the second Hertfordshire Rifle Volunteers, became a JP for Hertfordshire and a director of the Great Northern Railway. He eventually married and, for a while, lived at Little Cassiobury and was heavily involved with matters in Watford. He died at the age of seventy-nine in 1906. Randolph however entered the navy at the age of sixteen, serving on board the *Britannia* in the Black Sea and was in the naval brigade in the trenches at Sebastopol. In 1857, he went to Rio de Janiero as flag-lieutenant to Admiral Wells on the Cumberland, but died of yellow fever at Rio de la Plata, Brazil, at the age of twenty-five. After Randolph's death, his sword and commission were returned to Cassiobury, where his father kept them on the wall of his study (now in Watford Museum).

As mentioned previously, Adela was close to her Grandmama. The references to her in her diary are frequent. Grandmama, Lady Caroline Capel, had married the 5th Earl's brother, John Thomas Capel. The many letters written from Europe became known as the 'Capel letters' describing their life in Brussels during and after

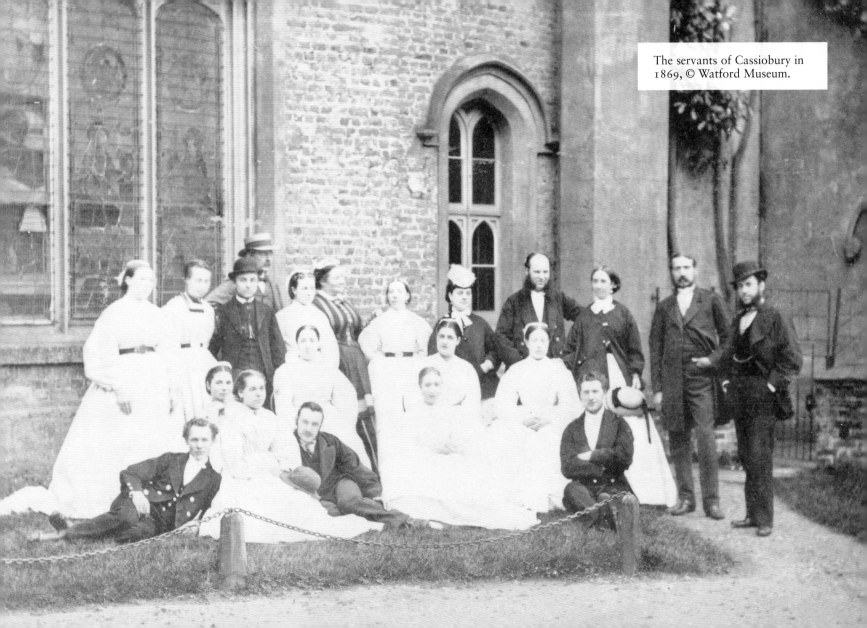

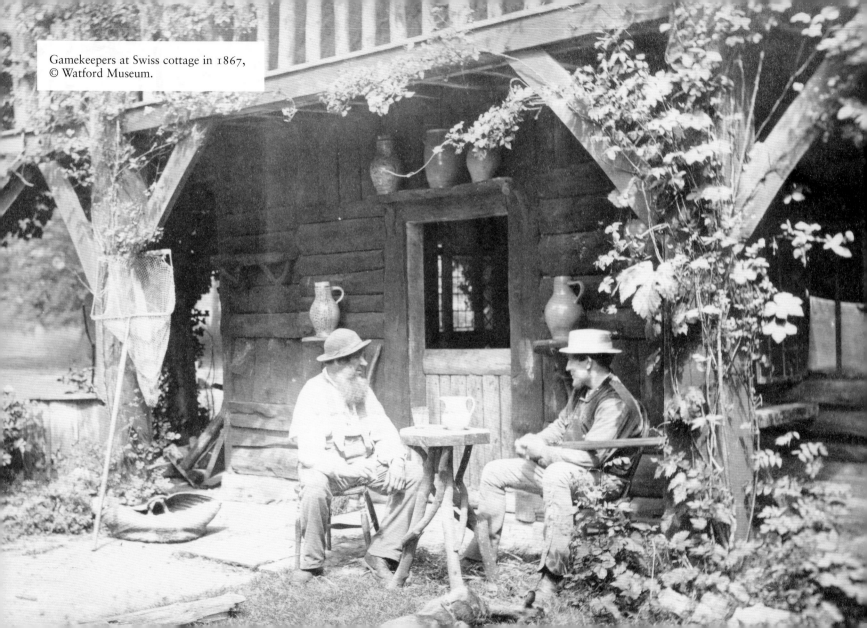

Gamekeepers at Swiss cottage in 1867,
© Watford Museum.

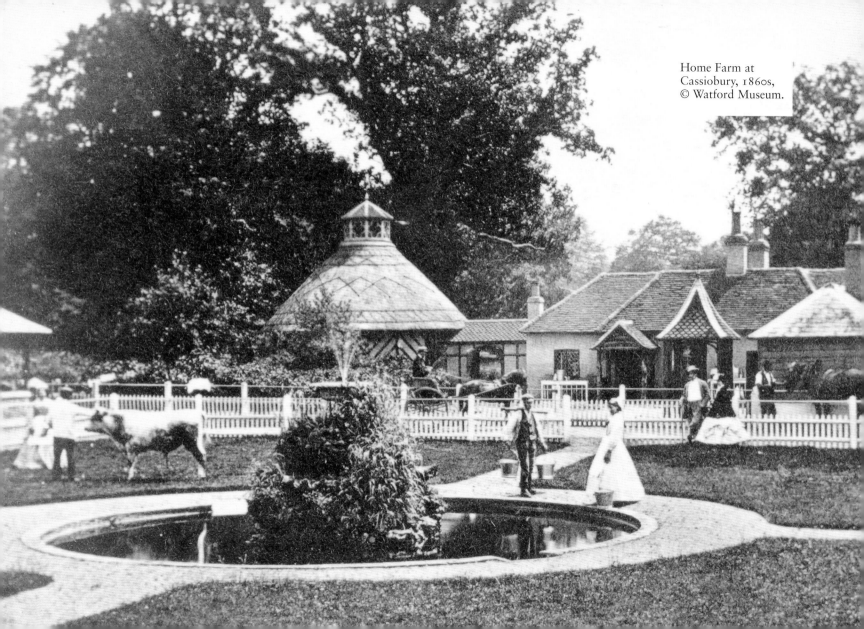

Home Farm at
Cassiobury, 1860s,
© Watford Museum.

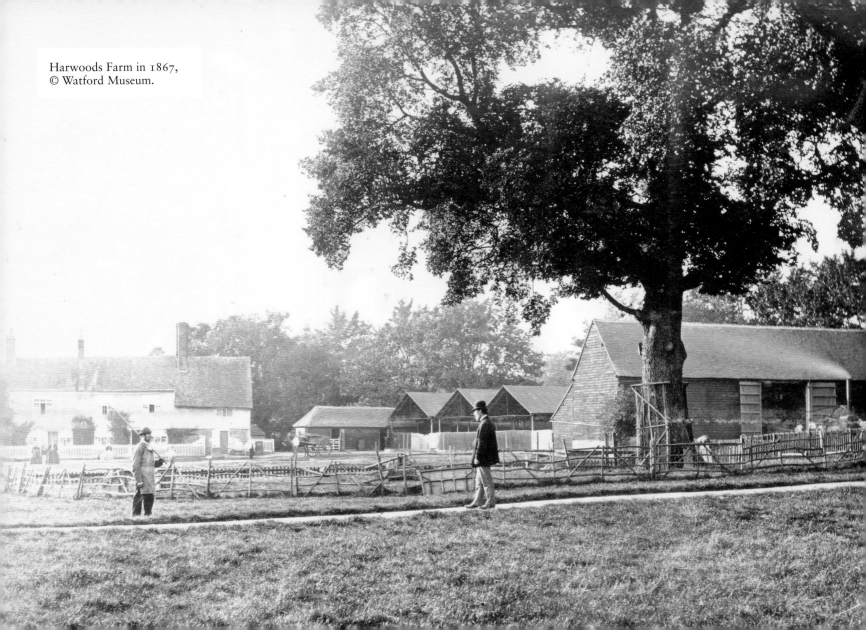

Harwoods Farm in 1867,
© Watford Museum.

the Battle of Waterloo. Lady Caroline's husband died in 1819, and she later moved to London, where, as we know, Adela was a frequent visitor to No. 23 Chester Square. Amelia was also a frequent visitor with her mother to Cassiobury. Lady Caroline Capel appears to have been a much loved mother and grandmother. She had given birth to thirteen children, though some had died at an early age. When she died in 1847, she was survived by five sons, five daughters and seventy-five grandchildren.

When Adela began her diary, Miss Smart was her governess. Adela refers to her often, and walked regularly with Miss Smart on the earl's estate, to the nearby farms and into Watford. They rode to local villages, visited Adela's pets, read to each other, and Miss Smart accompanied Adela to London, or collected her from there. The governess fished occasionally with Reggie and Randolph, and even accompanied Mama, the Countess of Essex, on shopping expeditions to Watford. At Cassiobury, there were a number of servants, some of whom are referred to in Adela's diary. According to the 1841 Census, the earl employed seven men and sixteen women, who worked and lived at Cassiobury House to support him and his family, and to care for the mansion.

According to Adela, it had eighty-four rooms, discovered after a spending one wet day in November counting them as 'it rained so hard'. A further four male servants, one having a wife and daughter, were resident at the stables. Caroline Ravenhill, a thirty-year-old servant at the time of the 1841 Census, was involved closely with Adela and is referred to as 'Ravenhill', and may well have been a nanny or lady's maid. Other members of the earl's staff who were important to Adela included Balie the gamekeeper, Buckingham the gardener, who lived at Cassiobury Garden Cottage; and Mr Fellows the agent and his wife. Adela made many visits to Mrs Roberts at the Home Farm, to the Balies, and also the Barkers of Cashiobridge Farm, who, in 1842, were farming over 200 acres. Adela was passionate about her pets, and animals in general. Balie found Adela a fawn, which she named 'Fairy', who is frequently mentioned in her diary. Adela's diary leaves us with a picture of herself as a curious mixture of a young girl engrossed in her pets, and an emerging young woman who passionately expressed her thoughts on cruelty to animals and a love for the countryside, in preference to the attractions of London society. Adela remained unmarried until twenty-eight, when she was introduced to one of Scotland's most popular earls, Archibald William Montgomerie, the 13th Earl of Eglinton and Winton, of Kilwinning Castle in Ayrshire. Their marriage was a very happy one, but sadly she died at the age of thirty-three, having never fully recovered from the birth of her second child, in December 1860. Within a year, on 4 October 1861, though he seemed in good health, the earl unexpectedly died. The diary kept by Adela though is a fascinating insight into life at Cassiobury in the middle of the nineteenth century, with Cassiobury in its absolute prime.[66]

During Adela's time, a terrible tragedy was occurred at Cassiobury House, in 1846. Taffeta dresses were at the height of fashion during the Victorian era. These dresses, with hoops, layers and corsets, made dressing hard work and the fine ladies of Cassiobury would have been assisted in dressing by a maid. In 1846, Lady Horatia Capel was visiting her brother at Cassiobury House. At 10.15 p.m. one Saturday evening, Lady Capel retired to her rooms after dinner. In those days there was certainly no electricity and Cassiobury House was still lit by candles and lamps. Lady Capel accidently set fire to her dress, and as she admired herself in her mirror, she saw the flames. She

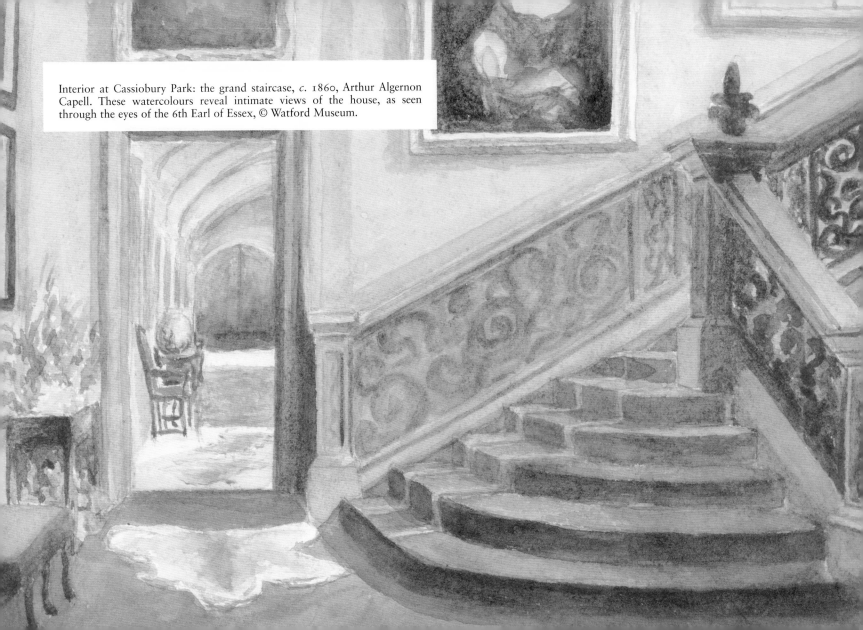

Interior at Cassiobury Park: the grand staircase, *c.* 1860, Arthur Algernon Capell. These watercolours reveal intimate views of the house, as seen through the eyes of the 6th Earl of Essex, © Watford Museum.

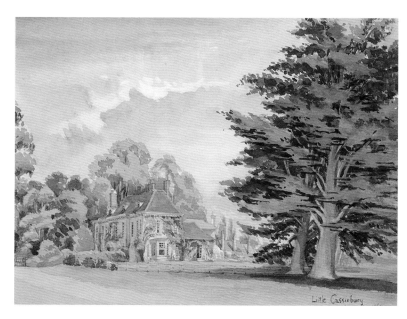

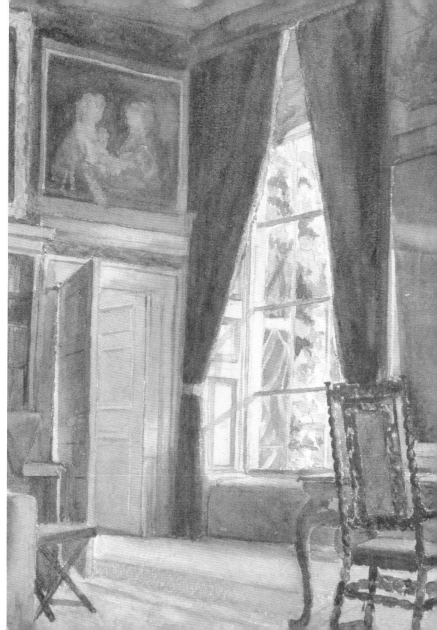

Above: Little Cassiobury, 1863, by Caroline Vernon. Little Cassiobury was built in the late seventeenth century, as a dower house for the Capel family. Rarely depicted in art, this charming painting of Little Cassiobury was purchased for Watford Museum by the Mayor of Watford, © Watford Museum.

Right: Interior at Cassiobury Park: private library with writing desk, *c.* 1860, Arthur Algernon Capell, © Watford Museum.

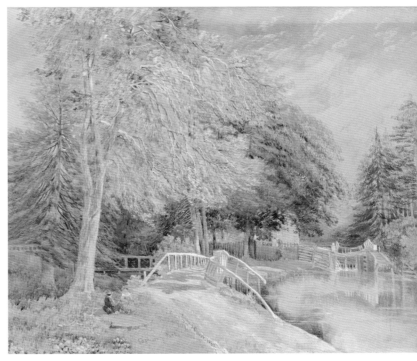

Left: Watford Horticultural and Floricultural Show in Cassiobury Park, *Illustrated London News*, 1855, © Watford Museum.

Right: Cassiobury Park, 1862, Emma Oliver. It is likely Emma Oliver knew the 6th Earl of Essex through her second husband, the Watford solicitor John Sedgwick. This watercolour shows two footbridges over the River Gade, and the lock on the Grand Union Canal, the two separating and joining as they pass through central rural Watford, © Watford Museum.

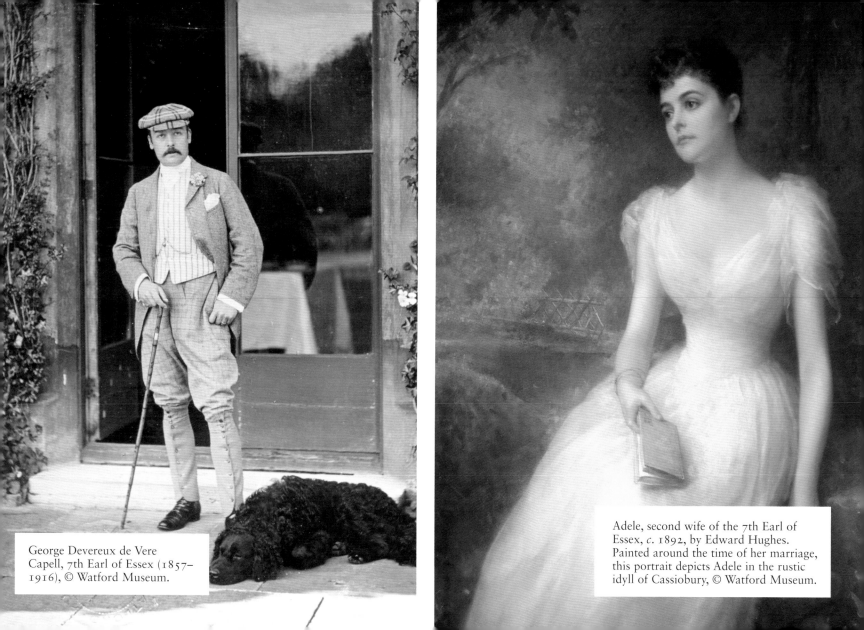

George Devereux de Vere
Capell, 7th Earl of Essex (1857–1916), © Watford Museum.

Adele, second wife of the 7th Earl of
Essex, *c.* 1892, by Edward Hughes.
Painted around the time of her marriage,
this portrait depicts Adele in the rustic
idyll of Cassiobury, © Watford Museum.

tried to free herself, but with her clothes too tight, the flames spread. Her screams were eventually heard by her brother, but it was too late, and she died a slow and terrible death from her burns.

Significant changes were about to sweep through Cassiobury. On 23 July 1880, George changed the name from Capel to Capell by Royal Licence. In 1892, the 6th Earl died, leaving his family and the population of Watford grieving. His extensive list of instructions for his funeral was fascinating and included his 'desire … that my funeral be of the plainest and most inexpensive character as may consist with perfect decency. No scarves or hats and no plumes or trappings to horses.'[67] As the earl was predeceased by his eldest son Arthur, Viscount Malden, the title passed to his grandson, George Devereux de Vere Capell who became the new, and 7th, Earl of Essex.

Financial difficulties though, were becoming apparent. In 1893, Christie's sold nine pictures from Cassiobury, including Landseer's *Cat's-paw* and three Turners, for 15,670 guineas in total, and another sale that year fetched £24,402 for porcelain, bronzes and furniture. George inherited a house that reputedly had had no major repairs carried out for over fifty years. George was Vice Lt of Hertfordshire, and Aide de Camp to the king. He served with the Imperial Yeomanry in South Africa in 1900/01. He married twice, firstly in 1882 to Ellenor Harriet Maria, daughter of William Henry Harford, and secondly in 1893 to Adèle, daughter of Beach Grant of New York. He had one son by his first marriage, Algernon George de Vere, who later became the 8th Earl, and two daughters by his second marriage. Adèle became George's wife at a time when many wealthy American women were marrying into the peerage.

Her arrival in Watford was marked with great ceremony. The carriage was drawn by men, from Watford Junction along Queen's Road and the High Street, and a triumphal arch was erected at the Essex Hotel opposite the old market place. To mark the occasion, George gave fifty pairs of blankets to the poor. Adèle had lived almost entirely in England before her marriage, but had travelled widely. She reputedly enjoyed life in the country, where she spent time riding, gardening and walking with her seven collies. It was her money that helped to support Cassiobury's early twentieth-century swansong when *Country Life* recorded the place, lavishly maintained and full of flowers, and enthused about its seeming detachment from the busy modern world of the Edwardian age. The *Country Life* author effused about the 'delightful grounds' and 'grandly timbered park'. 'Therein is peace and quiet; the aloofness of the old-world country home far from the haunts of men reigns there still, and Watford and its rows of villas and its busy streets is forgotten as soon as the lodge gates are passed.' The earl and dowager countess were not always in residence and, from around 1900, Cassiobury Park was offered 'to let, furnished, for a few months or term of years with shooting and trout fishing.' It was 'thoroughly up to date with several bathrooms, central heating, electric light, telephone, etc.' and it attracted tenants. The first was Sir Matthew White-Ridley, the current Home Secretary, followed by W. R. W. Peel in 1904. In 1918, the Earl of Wilton leased it and drove about it in fast sports cars, one of which crashed into the fence on Rickmansworth Road. Another later tenant was Mr Leonard Albu, who entertained the Grand Duke Michael Alexandrovitch there, while the Essex's were living in the Duke of Westminster's house in Davis Street, Berkeley Square.[68]

Shepherds Lodge, Rickmansworth Road,
c. 1900, Charles Vickers, © Watford Museum.

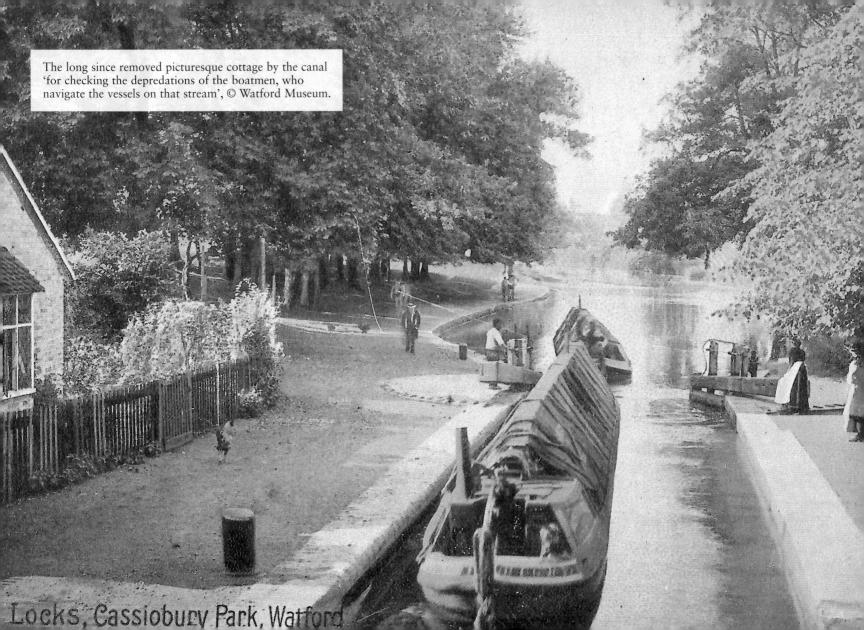

The long since removed picturesque cottage by the canal 'for checking the depredations of the boatmen, who navigate the vessels on that stream', © Watford Museum.

Locks, Cassiobury Park, Watford

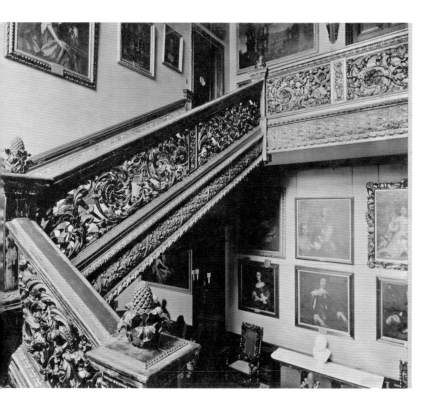

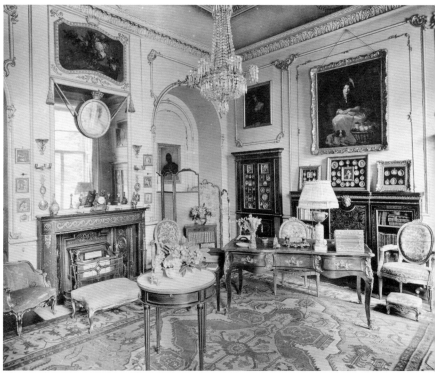

Left: The staircase of Cassiobury House, now housed in the Metropolitan Museum of Art in New York, © Watford Museum.

Right: The Yellow Room of Cassiobury House, © Watford Museum.

It was during George Devereux De Vere's lifetime that the significant break-up of Cassiobury began, starting with the outlying properties being sold or leased. Heath Farm (formerly Grove Mill Heath) had been sold to Lord Esher by 1890, and in that year Beech Lodge was also sold. By about 1900, farms to the east and south – Callowland, Harwoods, and Cassiobridge – had been sold to the developers, Ashby and Brightman.[69] In 1911, High Park was leased to the West Herts Golf Club after 184 acres, in the southern part of the park, had been sold in 1908, adjoining Rickmansworth Road, again to Ashby and Brightman for premium housing. The developers offered part of the land to the local council for use as a public park, and the cost implications caused a local furore. A poll by the council was held in September 1908, to find out what Watford residents thought of the idea of buying these acres. By a majority of nearly 3,000, they rejected the plan. In the end, after nearly a year's debate, Watford Urban District Council went against public opinion and bought 65 acres at a cost of £24,500, with an option on a further 25½ acres. They bought this for £7,000 in December 1912. After the town achieved borough status, further purchases followed. In 1923, Cassiobury Estates Ltd sold the council 33½ acres for £15,000, with further parkland in 1930, land to the West Herts Golf Course in 1932, and Whippendell Wood in 1935.[70]

Despite the beginning of the break-up of the estate at this time, some still viewed this period as 'the golden years of that lovely place'. This included Alice Herring, who was the daughter of one of the employees of the estate, who arrived at Cassiobury in 1898. Her memoirs have recently been shared with Watford Museum by the 11th Earl of Essex, and offer a detailed view of life at Cassiobury at the turn of the twentieth century. She describes 'all through the year there were house parties of people whose names ranked high in the annals of society, including many princes from foreign European courts.' Despite the changes and difficulties, the level of staff employed at Cassiobury was still significant. Alice writes of,

> a large staff to cope with all the work … lady's maids and valet, butler, three footmen, add on pantry man and boot boy, housekeeper, five housemaids, cook or chef and three kitchen maids and two girls for scullery work, a still room maid and four laundry maids and frequently wives of estate workers were pressed into service. At one time, there were 30 gardeners and three carpenters (house, garden and estate), three woodmen, a bricklayer, a plumber and a man to attend the turbines in the Old Mill for the private water supply from springs on the estate.

Other employees included a blacksmith as well as at Home Farm, a farm bailiff, a cowman, pig man, carter, dairymaid and a large number of labourers depending on the season. One of the more unusual roles was undertaken by a night watchman, who took up his duties at 10 p.m. each night and on occasions, was 'reinforced by the local police when very distinguished guests or very valuable jewels were in the weekend party'. Alice also talks of the occupants of the main lodge gate in the park with 'an ex-Guardsman on duty in a dark uniform, (blue-green), tall silk hat, a silver headed cane and his rows of medals across his coat, a most impressive figure to open the large gates.' Along with the lavish parties, on many occasions 'his lordship allowed the grounds to be used for open-air and promenade concerts in aid of charities.' The deer were also still present and, at times, causing havoc, often getting into the gardens but after one incident after devastating the vegetable garden, 'all

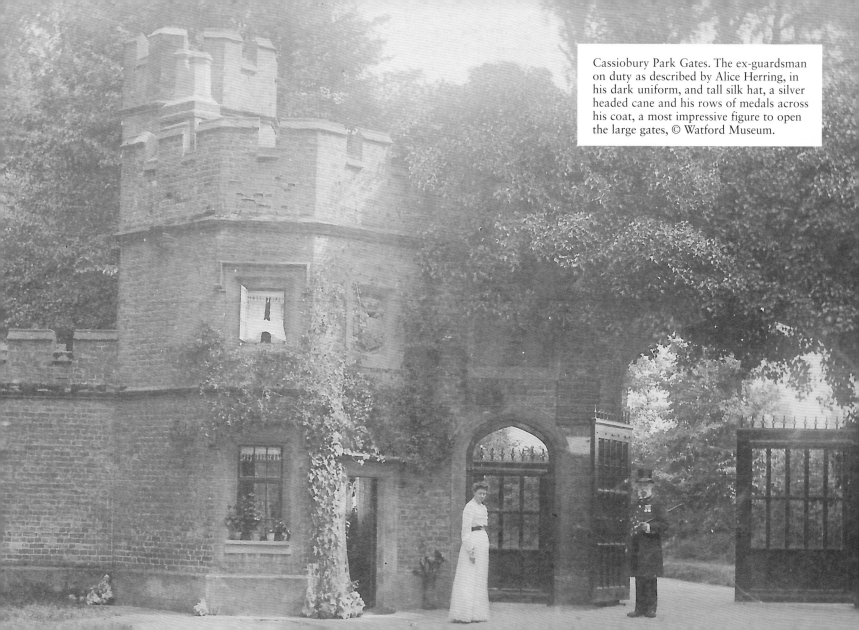

Cassiobury Park Gates. The ex-guardsman on duty as described by Alice Herring, in his dark uniform, and tall silk hat, a silver headed cane and his rows of medals across his coat, a most impressive figure to open the large gates, © Watford Museum.

Above: View of Cassiobury House from the west *c.* 1920–27, Kate Cowderoy. Painted in prior to the demolition of the house in 1927, this painting shows the western entrance with domestic quarters and kitchen behind, © Watford Museum.

Left: Part of Courtyard, Cassiobury Park, *c.* 1923, Kate Cowderoy. Cowderoy was a member of the Herkomer School of Art. Her watercolours of Cassiobury show unusual views of the neglected house just before it was demolished, © Watford Museum.

the deer disappeared.' The bandstand had also been erected in the now nearby public park, and was giving much pleasure to Watford residents but 'the Essex family and those who rented Cassiobury for long or short leases, did not appreciate its proximity as the music could be heard in the house.'[71]

Alice Herring's memoirs are a fascinating view of Cassiobury at a time when significant changes were occurring. The 7th Earl of Essex died very tragically in 1916, aged fifty-nine, as a result of being run over by a taxi, provoking a significant bill for death duties. Once the Wilton Lease had been ended after only three years, Cassiobury was left empty. The 8th Earl, Algernon George de Vere Capel and his stepmother, the Dowager Countess Adèle, organised the sale of the estate. There was a gigantic sale of the contents of the house lasting ten days and the core of the estate was put on the market by Humbert & Flint in association with Knight Frank & Rutley, in June 1922. The sales particulars announced, 'by direction of the Right Honourable Adèle, Countess Dowager of Essex' the 'Cassiobury Park Estate including the historical family mansion, Little Cassiobury, and the West Herts Golf Links, embracing in all an area of about 870 acres.' The sale of the contents consisted of 2,606 lots. The Capels had long been collectors of art, with their galleries containing works by Turner, Lely, Landseer, Wilkie, and much furniture, particularly French. Six English stained-glass windows from the great cloister of the house are now in the Victoria and Albert Museum in London. The house however, failed to find a new occupier, and was ultimately demolished for its materials in 1927, 'To lovers of the antique, architects, builders etc., 300 tons of old oak: 100 very fine old beams and 10,000 Tudor period bricks.' The Grinling Gibbons carvings, valued at £20,000, were sold mainly to American museums. The

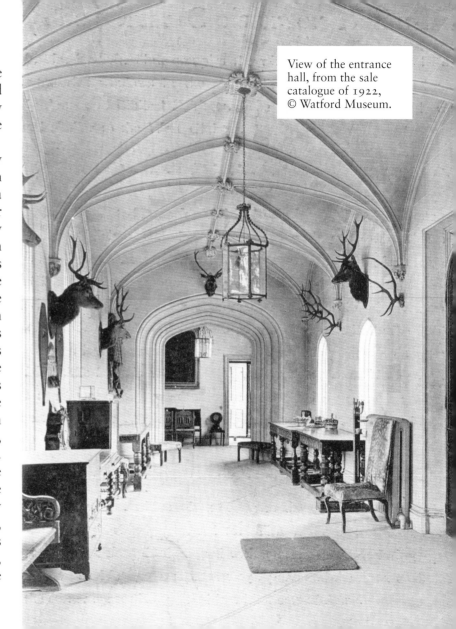

View of the entrance hall, from the sale catalogue of 1922, © Watford Museum.

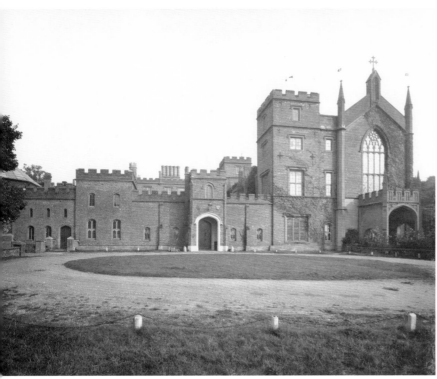
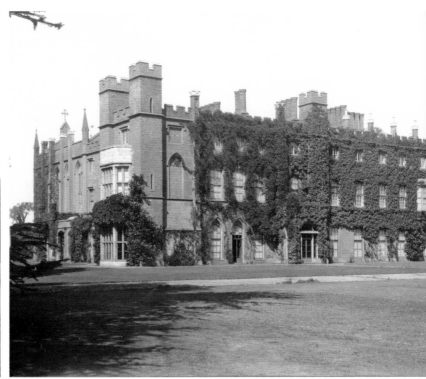

Photographs of Cassiobury taken around the time the house was put up for sale, in 1922, © Watford Museum.

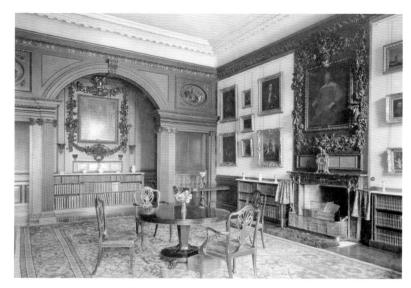

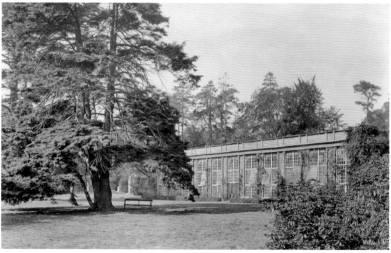

grand staircase (said to be designed by Gibbons but since attributed to Edmund Pearce) was removed to the Metropolitan Museum of Art in New York. Construction of the residential Cassiobury Estate soon began. The land was made subject to restrictive covenants, stipulating that only good quality detached or semi-detached houses would be allowed. Most of these were built in the 1930s, although building has gone on continuously ever since.

With Watford situated on the main line from London to Birmingham, growing rapidly and with new industry and spreading twentieth-century suburbs, Cassiobury's fate always seemed inevitable. Once Cassiobury had ceased to be an aristocratic country house, and with it being situated within minutes of Watford Junction railway station, its future was uncertain. With death duties impacting, and the previous poor condition of the house adding to the woes, the 8th Earl and the countess dowager had little choice but to sell. As *Country Life* had reported, the twentieth century certainly had been pressing hard at the gates. The *Estates Gazette*, in 1922, had declared unsentimentally that Cassiobury provided 'the best and most rational area for the expansion of Watford'. It was ripe for development and little survived. Along with the main house, Wyattville's orangery and *cottages ornées*, the Home Farm and the old mill also disappeared. James Wyatt's stable block remained and is now in Richmond Drive, renamed Cassiobury Court. The former dower house at Little Cassiobury was converted to the South West Hertfordshire Education Departments offices and, now owned by Hertfordshire County Council, remains empty.

Above left: Oak dining room, 1922 sale catalogue, © Watford Museum.

Below left: Orangery, 1922 sale catalogue, © Watford Museum.

GROUND FLOOR PLAN

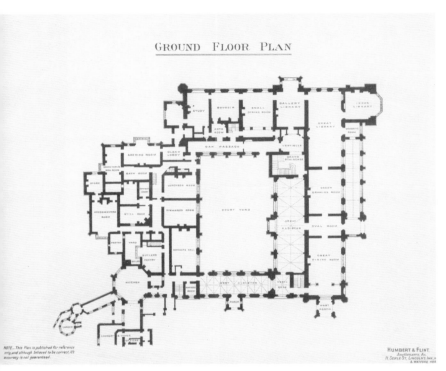

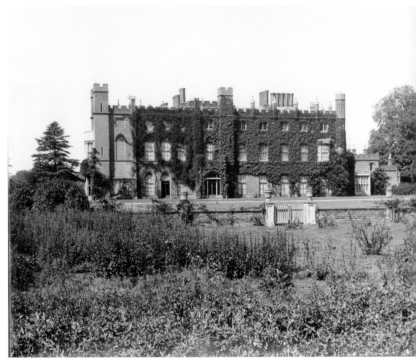

Above left: Floorplan of the house in 1922, © Watford Museum.

Above right: Late photograph of Cassiobury in the 1920s, © Watford Museum.

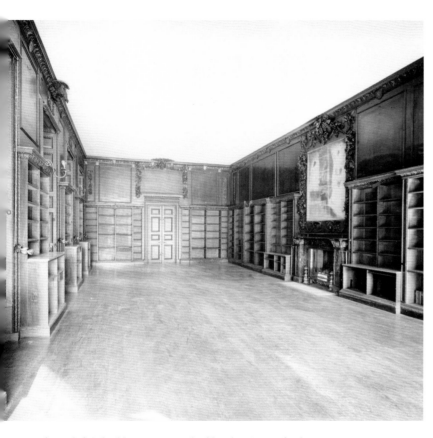

Above left: The library emptied of books, © Watford Museum.

Above right: The ceiling of the state bedroom at Cassiobury House, © Watford Museum.

James Wyatt's delightful castellated main entrance lodge of 1802 survived until 1970, when it was demolished by road engineers to make way for a road widening scheme. Some of the lodges do survive on the perimeter of the park. These include Cassiobridge Lodge which survives at No. 67 Gade Avenue; Garden Lodge (Garden Cottage), at No. 129 Hempstead Road; Home Park Lodge at No. 191 Hempstead Road; and Toll Gate Cottage (Ridge Lane Cottage/Lodge) at No. 235 Hempstead Road.[72] Others that did not survive were the popular Swiss Cottage which burnt down in the 1940s and the old mill, demolished several years later in 1956.

The Grand Union Canal was now winding its way past nearby 1930s semis. Street lights had replaced the ancient oaks and elms once recorded in fine aquatints based on watercolours by Turner and Pugin. The 8th Earl of Essex eventually emigrated to the warmer climates of the Caribbean and was apparently last heard of in the 1960s, living in a house called 'Little Cassiobury.'[73] It was the end of an era. The admiration for the gardens since the days Moses Cook was employed by the Earl of Essex was now a distant memory.

The house during demolition, with timbers marked up ready for sale, © Watford Museum.

It must not be surpassed by that Cassiobury, seat of the Right Hon. Earl of Essex, was one of the first places in England where the ingenious spirit of gardening made the greatest Figure. I must confess I never see that truly delightful place without being more than ordinarily ravish'd with its natural beauty.[74]

3

FROM COUNTRY ESTATE TO PUBLIC PARK

One mile south-east of Cassiobury House and the estate lies the medieval market town of Watford. As previously described, Adela Capel shopped in Watford occasionally, either with her governess or Ravenhill. She would also attend the parish church of St Mary's on Sundays with her family. Not only were Cassiobury and Watford close physically, they were also bound to each other historically. Henry I had bestowed on Watford the rights and privileges of a weekly market, and three fairs each year. Following the dissolution of the monasteries, the crown granted the tolls from the markets to various landowners. In 1770 these passed, together with the manor of Watford, to the 4th Earl of Essex and later to Adela's father.

The town of Watford is situated along a ridge, which slopes southwards towards the River Colne. During the 1820s and 1830s, Watford had been described by some as a well built, quiet and handsome little country town if not a little dull, while others, such as Hassell, had described it as 'a populous and busy town' by the middle of the nineteenth century. Still, like most towns in the early Victorian period, it had to grapple with insanitary conditions. It was not until 1849, when the Board of Health's report drew attention to the town's 'open cesspools and manure heaps' and the 'infected atmosphere', that the streets and drainage were improved.[1] Pipes were laid down, which provided the town with a constant supply of fresh water. Pigot's directory of 1839 describes Watford as having a main street nearly 1½ miles in length.[2] The bulk of the population lived in small tenements in the courtyards and alleys which ran off the main street. The Parliamentary Population Returns for 1841 indicate that there were 3,697 people living in the town of Watford, in 698 tenements and houses. Around 35 per cent of the population were employed in agriculture, while others found employment in the silk mills, straw plait and paper making, and the malting business. Rookery Mills were the largest of the silk mills, employing at one time 500 hands where the hours were long, conditions hard and accidents frequent.

Developments in transport were crucial to the growth of Watford. It was some 7 miles south-west of St Albans and 3 miles east of Rickmansworth, and only 15 miles by road from London. Several major roads passed through the town, in particular those from London to Aylesbury and from Uxbridge to St Albans. By

the 1840s Watford's transport facilities had developed and were beginning to bring increased interest in the town and a growth in population. Coaches from London passed through Watford twice a day. The Grand Junction Canal had been opened in 1796, increasing facilities for trade. But the most important development contributing to Watford's growth was the arrival of the railway. The London & Birmingham Railway Company opened a station in Watford in 1837, and by 1838 the line was complete and ready to carry passengers between London and Birmingham. George, the 5th Earl of Essex, used his influence in parliament to ensure that the railway did not follow the line of the canal through his land.[3] It was diverted over a viaduct to the south of Watford and through fields and a tunnel to the north-east of the town.

Throughout the latter half of the nineteenth century and into the early years of the twentieth century parts of Watford suffered appalling housing conditions. Dwellings without any form of sanitation or amenities had been built after the arrival of the railway to house those workers coming into Watford in the wake of the industrialisation of the town. By the end of the nineteenth-century, Watford was becoming much more varied in the make-up of its industry. Modern industry was making its mark. There were breweries, a steam laundry, and a cold storage company. The population growth that accompanied such industrialisation was phenomenal. In 1841, it was 1,940 but by 1891, the population was 9,775. Yet only ten years later in 1901, it had risen to 20,382.

Nationally, conditions in towns and cities were concerning national and local government. Early nineteenth-century reformers had become concerned about the consequences of enclosure and thought that public walks and gardens were the solution. Richard Walker, the Member of Parliament for Bury had spoken in Parliament about the lack of areas for recreation in his home town and in 1833 the Select Committee on Public Walks was set up to look at the problem. The committee noted that, owing to urban development and rising property values during the previous fifty years, 'many inclosures of open spaces in the vicinity of Towns had taken place, and little or no provision had been made for Public Walks or Open Spaces, fitted to afford means of exercise or amusement to the middle or humbler classes'. They gathered witnesses from many of the large manufacturing towns to try to establish remedies. One of their conclusions was that 'having a place to which they (the humbler classes) might resort on a Sunday Evening would tend to promote that self-respect which is so advantageous to all classes'. Although there were a number of parks in the country, most of them were royal parks or privately owned estates (at Cassiobury, the Earls of Essex certainly permitted access to the Home Park), and the landowners could exclude those they did not approve of.

In Watford, the conditions were certainly a concern. Between 1850 and 1894, Watford was governed by a Board of Health, which was then replaced by an Urban District Council under the aegis of the Local Government Board. On 18 October 1922 Watford was granted Borough status. It was something for which Watford had long campaigned, but the outbreak of the First World War had further delayed the arrival of Charter Day. Watford now had the right to make bye-laws and gain freedom from the Local Government Board.[4] It also now had the right to purchase land for public recreation.

One of the first parks to be laid out was Oxhey Park. One Saturday afternoon in January 1919 the Council's Estates

Committee met at 3 p.m. on Wiggenhall Bridge to view the adjacent estate of Wiggenhall House. By May 1919 the price of £14,000 had been provisionally agreed with the owners. Long drawn out negotiations followed because to buy it the Council had to have a loan sanctioned by the Ministry of Health. The actual conveyance document, with its map, is dated 26 April 1920. Gradually over the next four years the necessary decisions were made on land allocation, the finance was in place, and the groundwork put in hand. Once the areas set aside for housing and allotment had been agreed, the use of what remained for pleasure grounds and recreation could be planned. In January 1924 the Estates Committee of what was by now Watford Borough Council could recommend that the 'newly allocated public park be named and known as Oxhey Park'.

With the availability of land from the sale of the Cassiobury Estate, the Council were forward thinking having purchased land from 1908 up to 1935 when they purchased Whippendell Wood. The poll held in September 1908 to find out what Watford people thought of the idea of buying such land was significant. The Urban District Council had debated this over a considerable period of time with opposition even before the poll was held. Ashby and Brightman who were offering the land were keen to progress but were becoming impatient. Writing to the Council in July 1908; 'As four months have now elapsed since the question of the purchase by the Council of a portion of the Park was first mooted, and our plans for the development of the Estate cannot be completed until that question is disposed of, we think we must ask the Council to arrange that a final decision, subject to the approval of the Local Government Board be arrived at without delay. If the Council determine not to purchase we must at once proceed with the construction of a portion of the new road from the Lodge to the River and with the sites abutting upon and adjacent to that Road'.[5] The results of the poll were announced at the Council meeting of 5 September 1908 with a total of 3,644 against purchasing the land and only 679 for the proposal. Thankfully, the Council ignored the majority of nearly 3,000 who rejected the plan and bought 65 acres at £24,500, and took up the option on a further 25½ acres, which they purchased for £7,000 in December 1913. It is thanks to their vision and foresight that Cassiobury Park exists for the 2 million plus visitors to enjoy today. From the Council minutes of the time, the Council were certainly taking their role as landowner of their new public park seriously. In 1910, they were debating Sunday band playing in Cassiobury Park by the Watford Artizan Band and Watford Military Band and permissions to take collections while playing 'sacred and classical music.' Permission was granted despite objections from the Revd J. S. W. Wicksteed, who had written to the council 'protesting against the action of the council in permitting Sunday band playing.'[6] In 1913, further objections were received in relation to the timing of music being played in the park, with concerns 'such music is not provided by the rates during the hours of public worship on Sundays', but was however permitted by the council. Dancing in Cassiobury Park though, was one step too far, with a letter received on 22 July 1913 from the Watford Artizan Band asking the Estates Committee to consider. It was 'decided to defer consideration until next season'. A letter from Capt H. W. Downs was also presented to the council requesting permission for his son to cycle in Cassiobury Park, but permission was denied.[7] Yet requests by the first Troop B. P. Boy Scouts to drill in the park were granted[8] as were requests by D Company of the Herts Regiment Territorials in June 1909.

......................................**Ward.**

Watford Urban District Council.

CASSIOBURY PARK.

The above Council have had before them an offer by the Owners of a portion of Cassiobury Park shewn on the plan opposite to sell to the Town for a People's Park 75 Acres of Land (including the Two Entrance Lodges as indicated), for the sum of £24,000.

Before taking any further steps in relation to the matter, the Council have resolved to ascertain the views of the Town as to whether or not it is desirable to acquire such land.

JOHN ANDREWS, *Chairman.*

H. MORTEN TURNER, *Clerk.*

June, 1908.

Are you in favour of, or against this proposed purchase?

Make your **X** in one of the Spaces below.

FOR.	**AGAINST.**

IMPORTANT.—This paper will be called for on SATURDAY THE 18TH JULY, 1908, before 10 p.m., after which time no paper will be received.

THE OFFICIAL ENUMERATORS will wear a Badge and be in possession of their appointments, and no paper is to be given or shewn to any other person.

Voting paper from the public poll in 1908, © Watford Museum.

TO THE ELECTORS OF WATFORD.

The Park and the People.

Do not be DECEIVED by UNTRUE STATEMENTS.

IT IS UNTRUE
That its purchase would mean a 4d. Rate.

IT IS A FACT
That the purchase of 75 acres at £24,000 would only mean a 1½d. Rate which would gradually become less as the Rateable Value of the Town increased.

IT IS UNTRUE
That Workmen would have to pay 6d. a week more Rent because of the Park being bought.

IT IS A FACT
That in 1903 the District Rate was 4/6; To-day it is 3/9; and as New Sources of Income are available, it should not be necessary to raise this Rate for the purchase.

IT IS UNTRUE
That the People of LOWER HIGH STREET, CALLOW LAND, QUEEN'S WARD and HARWOODS ESTATE Do not Use the Park.

IT IS A FACT
That the Thousands of People who use the Park come from every part of the Town.

FELLOW TOWNSMEN! If called upon to **VOTE** on this Question, think of your **WIVES** and **CHILDREN**, to whom this **PUBLIC PARK** would be a **BOON**.

Have a place to walk in that YOU can call YOUR OWN.

VOTE FOR ITS PURCHASE and save the Town from becoming a SECOND WEST HAM.

Published by Cassiobury Public Park Committee—JOSCELINE F. WATKINS, Chairman; W. T. COLES, Vice-Chairman. Printed by EDWARD VOSS, Loates Lane, Watford.

Advertisement encouraging electors to vote yes to the creation of a public park, 1908, © Watford Central Library.

.IN.
WATFORD.

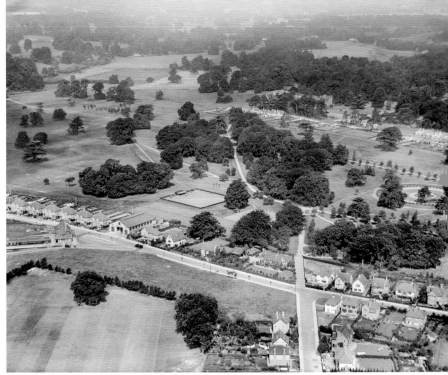

Above: Aerial view of Cassiobury Park and the surrounds, 1927, © English Heritage (Aerofilms Collection).

Left: In Watford, Edward McKnight Kauffer. A poster published by Underground Electric Railways in 1915, © TfL from the London Transport Museum collection.

However as described, the estate was finally sold off in 1922, and the house demolished in 1927. It was during the inter- and post-war years that Cassiobury was further developed into a town park. Introductions had already included a bandstand, but new features included a tea pavilion, *c*. 1926, the laying out of a paddling pool near the River Gade in the 1930s, and the creation of a model railway in 1959. The long northern drive, visible on the first edition *Ordnance Survey*, was straightened and planted with a double row of trees. Further plantings took place in the park, changing many aspects of its open parkland character. This occurred most notably in the old High Park, around the golf course fairways, absorbing the Mile Walk within the woodland. By 1933, along with the new tea pavilion, the park had shelters, a drinking fountain, a bowling green, hard and grass tennis courts, football dressing rooms, a convenience near the entrance lodge near Rickmansworth Road, new paths and significant planting along the western end of the new tree-lined avenue.

The cottage at Iron Bridge Lock had also been demolished, although no exact date exists when this occurred. During the Second World War, a large number of specimen trees were removed from Whippendell Wood, and later replaced with silver birch and ash. In the early 1940s, the Swiss Cottage was burnt down. Further tree planting was carried out along the avenue of sycamores and horse chestnuts, between the park gates on Rickmansworth Road and the paddling pool. The first tree was planted by the then Mayor of Watford. A major development in 1954 was the notification of Whippendell Wood as a site of special scientific interest. Only two years later, in 1956, the Old Mill was demolished. In 1957, filming began in Cassiobury Park for parts of the film *Yangtse Incident: The Story of HMS Amethyst*, the start of many filming sequences

in the park over the years. By the end of the fifties, and into the early sixties, ordnance survey maps illustrate the maintenance yard and buildings to the rear of the tea pavilion, which was then a day nursery. Car parking was accessed off Gade Avenue, and allotment gardens were present in the north-west corner of the public park.

Throughout the sixties, more areas of Whippendell Wood were cleared and replanted with beech and conifers. The conveniences near the entrance lodge were removed by 1964. The same year, 9½ acres were leased to Old Fullerians Rugby Football Club for ninety-nine years. By the end of the sixties, most of the shelters and the fountain had been lost, but byelaws were introduced and adopted for the public park for the first time.[9]

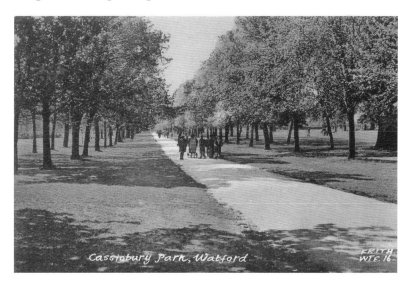

The new planting of avenues of trees along the western end of the park, © Watford Museum.

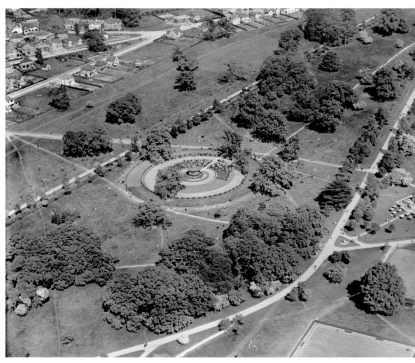

Above left: Digging of trenches in Cassiobury Park during the Second World War, © Watford Museum.

Above right: An aerial view of the bandstand and Cassiobury Park, 1928, © English Heritage (Aerofilms Collection).

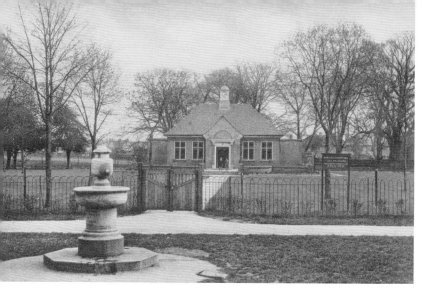

Above: The Art Deco tea pavilion, built *c.* 1926.

Right: The bandstand, prior to its decline and then removal in the 1970s, when bandstands and their popularity waned. The sound of the Watford Artizan Band is a long distant memory, © Watford Museum.

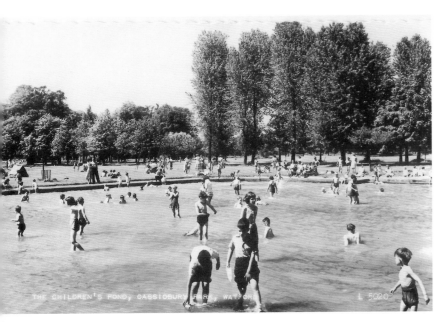

Above left: The paddling pools at the lower end of the park were fed by water from the river, and were immensely popular with park users, © Watford Museum.

Above right: Fishing in the River Gade, while park revellers enjoy the paddling pools in the background, © Watford Museum.

In 1970, the entrance lodge to the park, at the Rickmansworth Road entrance, was demolished for a significant road widening scheme. Wyatt's Gothic double lodge of 1802 was on the site of an earlier lodge of similar footprint, visible on Dury and Andrew's 1766 map. The lodge, although popular and loved by local people, was of little architectural value, but was important as it formed the terminal point of the grand carriage drive of 1802, and was the principal entrance to the estate from the town. It survived the break-up of the estate of 1908–22. Its loss was also significant, as it had the effect of disconnecting residents of Watford from the park's distant history and Watford's heritage in general. Its outline and remains are now mostly under Rickmansworth Road, as indicated by an archaeological excavation in 2014.

Above: Working horses were once a regular sight by the canal, © Watford Museum.

Left: Sparrowpot Lodge was named for the unusual sparrow pots on the gable end, © Watford Museum.

Above left: Swiss Cottage was a popular early twentieth century 'picture postcard' of the park, burnt down in the 1940s, © Watford Museum.

Above right: The mill in Cassiobury, demolished in 1956, © Watford Museum.

Demolition of Cassiobury Park gates in 1970. The gates were removed as part of the Rickmansworth Road widening scheme, the foundations now under the road, © *Watford Observer*.

The other significant removal from the park at this time was the bandstand. Central to the new park had been the introduction of an impressive bandstand within an enclosure. In September 1911, tenders were being invited 'for a bandstand to be erected in Cassiobury Park'. A number of tenders were received including one from the Scottish foundry of McDowall Steven and company for a No. 5 bandstand. It was a tender from Messrs Ensor and Ward that was accepted for the erection of a Hill & Smith, of Brierley Hill, bandstand in October 1911. The *West Herts Post* on 20 September 1912 reported,

Cassiobury Park bandstand – this structure now appears to be shaping up under the supervision of Messrs Ensor and Ward,

builders and contractors, Watford, who have got the work in hand [and] will shortly complete the whole structure. It is to be hoped the fine weather will prevail … The opening of the new addition to the park takes place on Wednesday afternoon at 4.30 p.m. when the Artizan Staff Band will render a nice selection of music.

It was formally opened on 27 September 1912 with screens later added in 1914, and there were proposals to extend the bandstand area between 1920 and 1923. Concerts were immensely popular, the *West Herts & Watford Observer* reported on 15 September 1923,

the season's band performances in Cassiobury Park concluded on Sunday, with two programmes by the combined bands of the Coldstream Guards and the Welsh Guards. In the afternoon the enclosure was full, but at the evening performance the accommodation was taxed to overflowing, and thousands congregated around the bandstand.

In 1930, sales brochures for local estate developments describe Cassiobury Park's natural amenities 'with a band enclosure with seating for 1,500 people. First class military bands give performances every Sunday'.

By the 1970s, the bandstand was a shadow of its former self and, in 1975, was in pieces in the council depot. Attempts to reach a decision to re-erect it caused local consternation, with one councillor complaining about its proposed new position next to the library. 'I never thought this was a suitable place for a bandstand but having got a stupid concrete base we have got to do something with it'. It was subsequently reassembled,

but was never intended 'to be used by a band or for musical entertainment' but as 'an architectural feature'. Its condition is poor, missing its soundboard and it has an unsympathetic felt roof. Its restoration and return to Cassiobury Park is long overdue.[10]

By the late 1970s, the tennis pavilions had been lost, as well as the last trees from the avenue comprising the Mile Walk in High Park. However, one of the most popular introductions to the park, during the twentieth century, was the new paddling pools and kiosks, which were introduced in 1983 at a cost of £250,000, replacing the original paddling pool by the River Gade. The *Watford Observer* reported,

> The new-look complex has three separate pools all at different depths to suit all ages of children … In keeping with the circular design, plans show a handful of hut-like buildings at the entrance end of the complex. These will house a kiosk, shelters, stores and lavatories. Council designers have also put forward attractive extras to decorate the pool area. Fibreglass animals at the pool's edges and other features within the water are just some of the decorations that could be added.[11]

The pools were, and continue to be, immensely popular with families from across Watford, Hertfordshire and North London enjoying them every summer. Another introduction, no longer present, was a pitch and putt course, laid out behind the bowling club pavilion. As in many public parks, they were initially popular but soon fell out of vogue, and most have been removed.

Two significant events occurred in 1987. Firstly, Cassiobury Park was listed in English Heritage's Parks and Gardens of special historic interest at Grade II. The entry is important, because it recognised the historic importance of the Cassiobury landscape through three centuries and not just of the current parkland, but also of the former High Park, Jacotts Hill and Whippendell Wood. The second event occurred in October 1987, which was the Great Storm that decimated historic landscapes across the south-east of England. Cassiobury Park and Whippendell Wood lost significant specimen trees, as did many other parks in the region. By the early nineties, active management of the last working watercress beds had ceased and they fell into disuse. The park's popularity with local filmmakers remained, and sections of *Star Wars: Episode I – The Phantom Menace*, released in 1999, were filmed in Whippendell Wood. In January 1999 the tea pavilion was significantly damaged by fire. Having previously operated for a while as a children's nursery, it was reopened in 2003 after a substantial rebuild, as the Cha Cha Cha Tea Pavilion.

The park remains popular with local people, with over 2.1 million visits a year (2014 figures). Despite the decline and loss of many features, the historic importance of Cassiobury Park is recognised through its listed status with English Heritage. It is also important because of its ecological value, with the area between the River Gade and the Grand Union Canal, designated a local nature reserve, and Whippendell Wood designated as a site of special scientific interest. Cassiobury Park has also been awarded a Green Flag Award every year since 2007, and continues to be well-used and valued by its many users to this day.

Above: The unveiling of a new playground in 2009, to mark the centenary of Cassiobury as a public park, © Watford Borough Council.

Right: Lowenna and friends in the Cassiobury park paddling pools.

4

CASSIOBURY TODAY

The landscape of Cassiobury is approaching 500 years, and is an excellent example of a palimpsest of landscapes, indicating the way generations have altered the landscape of their ancestors. Architects, archaeologists and landscape design historians sometimes use the word to describe the accumulated iterations of a design or a site, whether in literal layers of archaeological remains, or by the figurative accumulation and reinforcement of design ideas over time. The alterations over time by the successive Earls of Essex, and their advisors, has created a park today that in many ways bears no resemblance to the vast estate laid out by Moses Cook, but still consists of many remaining elements from each century. A walk in the park today still reveals a great deal and there is the sense that history abounds this place.

Approaching and entering Cassiobury Park from the Rickmansworth Road entrance, the northern section of the park is characteristic of a relict deer park with a number of fine veteran trees, including oaks, and areas of healthy grassland. It is now mainly parkland, with occasional recent plantings of azalea and rhododendrons. During the nineteenth century, this area previously described formed the prominent

approach to the estate, and included key picturesque open parkland features with good visibility to a number of mature tree specimens, still present in many places. Deer would have historically eaten up until the first 2 metres of vegetation from the ground, which Humphry Repton called the 'browsing line'. Trees with deadwood were also normally retained. However, during the twentieth century, new avenue plantings were introduced to form significant pedestrian routes with scrub and ornamental shrub islands. The open parkland character advocated by Gilpin and Repton has generally been lost. Another key feature of this area is the long carriage drive, which once led to the former house, now planted with a mature double line of sycamores from the 1920s.

The area is now overlooked by large houses from the Cassiobury Estate to the north, the former site of Moses Cook's Wilderness. In the summer, particularly during dry weather, remnants of the large circular area from the former bandstand enclosure are visible. This is a quieter area of the park, with the sight of dog walkers, joggers, cyclists and many workers heading into Watford's town centre every morning commonplace. Yet all pass by unwittingly within the

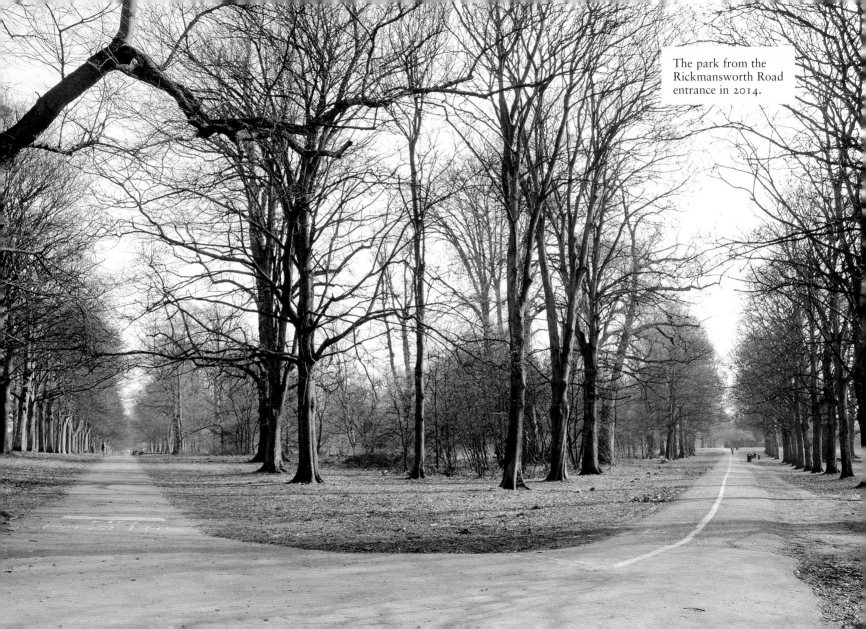

The park from the Rickmansworth Road entrance in 2014.

former shadow of Wyatt's Gothic masterpiece, and Moses Cook's magnificent Wilderness and Wood Walks.

The parkland to the south of the main curvilinear carriage drive includes many of the parkland features, introduced in the inter-war years and beyond, including the Shepherd's Road entrance, tennis courts, the impressive Art Deco Cha Cha Cha Tea Pavilion, and just behind, the croquet lawns, home of Watford (Cassiobury) Croquet Club. Cassiobury Park, then attached to Cassiobury House in the ownership of Arthur Algernon Capel, 6th Earl of Essex, was one of the first places in which croquet was played in this country. The earl became significantly obsessed with croquet in the early 1860s and never looked back. He was known as a leading entertainer of high society, an energetic entrepreneur who hosted lavish croquet parties for the glitterati of the age. The courts the club play on today were laid down by Watford Borough Council in 1936, where they have played ever since, only a few hundred yards away from where the 6th Earl entertained so many guests on his own croquet lawns.

Arriving into the central area of Cassiobury Park, one comes upon a large area of parkland, marked out with football and cricket pitches on the gently sloping valley side, falling away from the plateau on which the upper parkland areas are located. The views towards Whippendell Wood are impressive, and include a number of very fine, mature to over-mature parkland trees of significant stature, including oaks, beech and the isolated but iconic lone Cedar of Lebanon. The parkland here is much busier and livelier, whether hosting the annual fireworks display or other impressive events, or simply because of the facilities on offer – the pools, play areas and miniature railway. Many

The former carriage drive today.

local people still fondly remember the Rainbow Festival held annually in the park, until 2004. During the summer months, the area is vibrant, active and echoes to the sounds of families at play. Yet this central area retains much of the feel of the nineteenth-century open parkland landscape, even though it has been adapted for modern-day sports use. The lone Cedar of Lebanon dominates the skyline, and recalls the importance of the Lebanon cedars to the former design of Repton's landscape, many of which are still visible in the housing estate to the north.

As you pass the pools, the Gade Valley and Local Nature Reserve become apparent. The landscape changes entirely. A floodplain and much altered river valley floor, which has a strong riparian character, have remnants of the eighteenth and nineteenth-century designed landscape evolution. These include the altered course of the Gade, for the lost eighteenth-century lake and later watercress beds, which still remain but are disused, and a series of now much overgrown designed vistas to the lost Cassiobury House, across Pheasant's Island. Another feature is the now lost estate watermill with its cascades, race, leat, vaults and decorative flint-faced abutments often visually obscured due to the density of the riparian vegetation. The area also includes a number of walks of varying accessibility, through the wet woodland, and leads to the former site of the Swiss Cottage, which burned down in the 1940s. The route then leads to the extant Cassiobridge Lodge, which is often mistaken for the Swiss Cottage. Upstream is the rustic bridge on the site of the original delicate structure of the same name, the scene of many Victorian picture postcards. This entire area is of considerable historic significance, due to the visible relics of some of the working parts of the former estate, notably the watercress beds, old mill remains and weirs, and also

Overgrown watercress beds today are a reminder of the agricultural heritage of Cassiobury, © Watford Museum.

for the remains of designed views to the former house. It is also of considerable significance due to its biodiversity value, and the range, and quality, of lowland riparian habitats represented.

Beyond the nature reserve is the corridor and tow path of the Grand Union Canal, which was cut through the park in 1796. Remaining is the site of the former estate lock keeper's cottage, demolished in the early twentieth century, as well as the existing Iron Bridge lock and the Gothic Iron Bridge, which carries the historic western approach to the former house over

Above: The lone Cedar of Lebanon, overlooking Whippendell Wood.

Left: Chilterns League Cross Country in Cassiobury Park.

the canal (the bridge is so called because of the former iron cage and estate rail which enclosed it, of which traces are still visible). The canal is lined to the east by the historic watercress beds. The area also includes the terminal point of the lime avenue, and associated vista to the house. Though now overgrown, it is still legible as the eighteenth-century limes survive towards the edge of the canal. The canal and towpath is now popular with cyclists, narrow boats, some moored permanently, and pleasure boats passing through on their way, perhaps without any awareness of the importance of the surrounding historic landscape. Whether the 'pretty retreat found along the banks of the Grand Junction Canal' described by Hassell in 1819 as 'an excellent station for checking the depredations of the boatmen, who navigate the vessels on that stream' still remains, is however, unknown.

To the north and south of the lime avenue is the densely wooded 18-hole golf course, which was laid out on the eastern part of High Park and Jacotts Plateau in the early twentieth century. The area still incorporates a number of remnants of the seventeenth- and eighteenth-century landscape design – notably the Mile Walk – of which fragments and a number of veteran trees survive, immediately west of the present access road to the club house. This area also includes the site of the former hunting lodge in the High Park. Despite how much this area has changed with the impact of the golf course, there are remains of fragmented relics of the seventeenth- and eighteenth-century formal design of bosques and walks – as well as the remains of the Mile Walk.

The next area we come across is formed by the monumental early eighteenth-century lime avenue attributed to Bridgeman. The avenue largely survives in its entirety (cut in the middle by

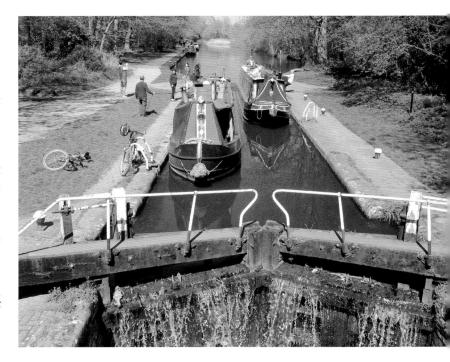

The Iron Bridge Lock, and the Union Canal as it quietly passes through Cassiobury Park.

a fairway of the West Herts Golf Course) although the trees are extremely outgrown, having last been pollarded early in the twentieth century. Historically, the lime avenue would have been pollarded and deer would have formed a browsing line of 2 metres from the ground. The lime avenue frames the northern stretch of the carriage drive, which still follows its original route from Grove Mill Lane and the former Sparrowpot Lodge to

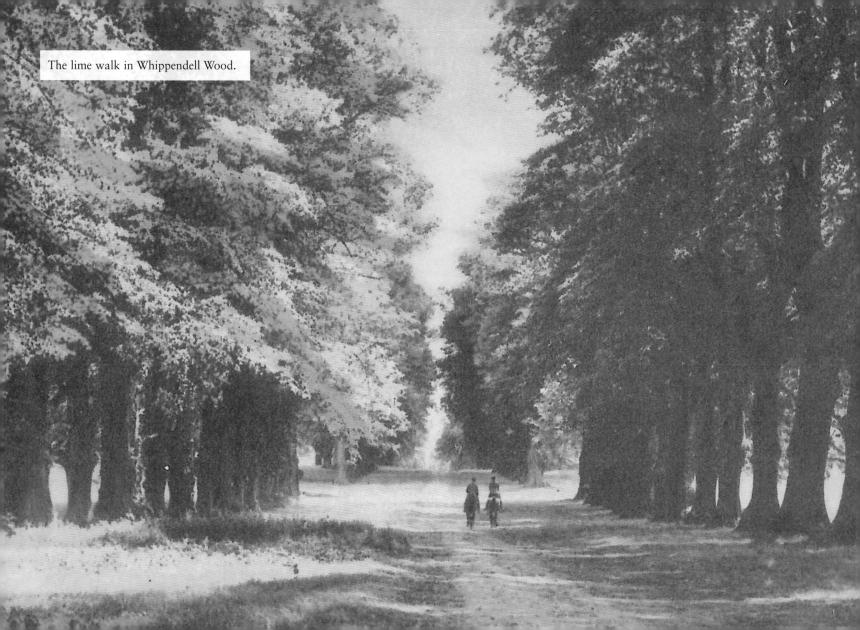

The lime walk in Whippendell Wood.

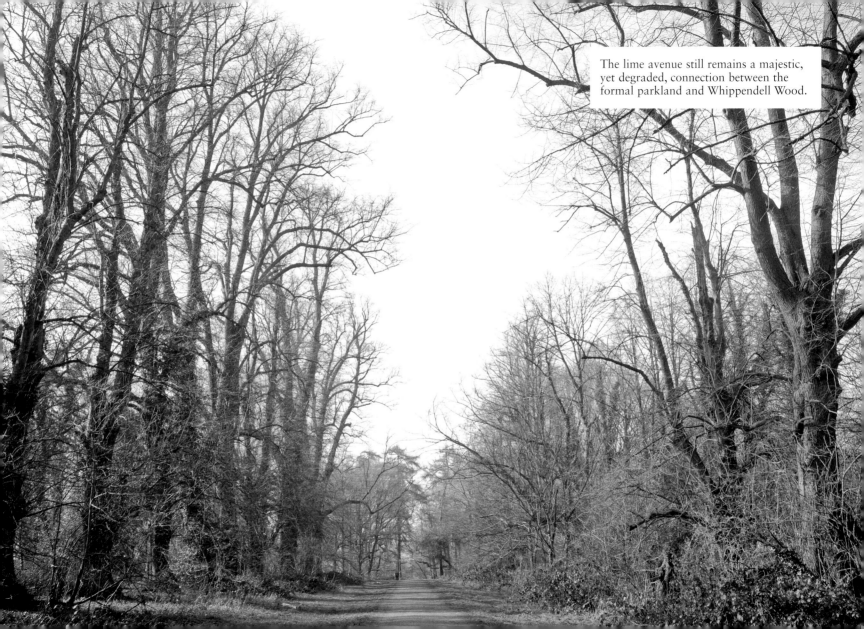

The lime avenue still remains a majestic, yet degraded, connection between the formal parkland and Whippendell Wood.

the north. At the western end of the avenue, the roundel which formed the node connecting to the other rides in the High Park and wood is still just visible, as are the secondary rides radiating from this, as shown on the estate survey plan of 1798.

The roundel connects to the many other rides which traverse the wonderful, yet more remote, Whippendell Wood. A living and ancient landscape, the wood contains a diverse array of historic landscape features and habitats. These include deciduous plantations on the site of the former open parklands of High Park, a relict network of rides which formed part of the purported Bridgeman landscape design, as seen on the estate survey of 1798, and an extensive tract of ancient bluebell woods in the great dell to the west, adjacent to Rousebarn Lane and Grove Mill Lane. There is much evidence of management of the woods, both now and in former times. As none of it is original woodland it is assumed to be of secondary growth; even in the older unmanaged parts of the wood it has not reached uniform climax, which in this case would be mixed deciduous wood dominated by oak. In the days when it was part of a large estate, the timber would have been used for many purposes, such as deer park railings, hurdles, firewood, building of huts, farm shelters, fencing etc. The woods are enhanced by the topography, which includes a scarp and old marl/chalk pits, plus many mature trees, including a double avenue of beeches in the north, which are part of the designed landscape, and much standing and fallen deadwood.[1] In 1985, a detailed study was carried out on the natural history of Whippendell Wood; *A Wood in Watford: Wildlife of Whippendell Wood – Secrets of its Natural History: An introduction for the student, layman and conservationist*'. The study revealed an array of fungi, as one would expect in a woodland, and especially in autumn,

when the humidity favours their growth, before the ground frosts set in. Mosses and liverworts are commonplace, with thirty-three kinds of mosses and three liverworts in the area of the woods. The flora of Whippendell Wood varies from the northern side of the valley, where the soil is more or less neutral, to the southern side, where it is sandy and acidic. In the valley bottom the soil is alkaline, as indicated by the presence of lime-loving plants. Along with the spring profusion of bluebells, a number of interesting flowers are found and include coralroot bittercress, grass vetchling, wild strawberry, small balsam, musk mallow, lesser periwinkle, twayblade and violet helleborine. Surveys have also revealed what the dominant trees were in Whippendell Wood, dating back to 1954: 31 per cent were silver birch, 23 per cent beech, 12 per cent were oak and 16 per cent sycamore.

The fauna of Whippendell Wood was also captured in this study. Butterflies were once very common but have declined in recent years. Familiar ones still found include Small Skipper, Large Skipper, Red Admiral, Small Tortoiseshell, Peacock and Meadow Brown. Moths are likewise widespread throughout the woods. Amphibians are also regularly seen, although some are quite rare. Common frogs and toads are found in damp parts of the wood but are not frequent. Slow-worms are commonplace, as are grass snakes, with occasional sightings of adders and common lizards, particularly on Jacotts Hill. The birdlife of Whippendell Wood is typical of many such woods in southern England, but has changed over many years. The effect of days when they were 'managed' as part of the Earls of Essex estate has significantly decreased. As a result, the bird life has changed to some extent, with the absence of some species or increase of others. The woodcock has been lost, whereas jays and magpies have increased.

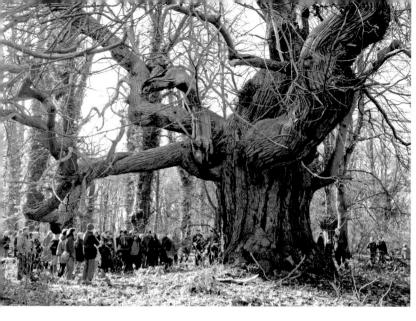

Above: A veteran sweet chestnut, popular with local people, schoolchildren and tree lovers.

Right: Whippendell Wood and the wonderful displays of bluebells each spring, © Ben Howard.

Mammals are a rare sight and are generally only seen at night. The red fox is occasional, as are badgers, stoats and a rare sight of a weasel is a pleasure. Fallow deer, which were once prolific in 1881, are much rarer, with thirty in the woods in 1976, and fifteen in 1980. Muntjac deer are also occasionally spotted, and on very rare occasions wander into Cassiobury Park towards Rickmansworth Road.[2]

The status of Whippendell Wood in relation to its classification by Natural England as a Site of Special Scientific Interest (SSSI) is classed as 'favourable'. The SSSI is notified for the variety of woodland invertebrates it supports, as well as its ancient woodland habitat. Many woodland invertebrates develop in standing or fallen deadwood, or the fungi growing on it, but feed on nectar as adults, hence the need to retain over-mature veteran trees and dead wood, a diversity of fungi (several of which are rare in their own right) and to maintain a network of sunny, flower-rich glades and rides.[3]

With the loss of the house and other landmarks including the park gates, it would be easy to assume the history of Cassiobury has gone forever. Yet physical evidence is all around us in Cassiobury and in Watford itself, as well as in the collections of Watford Museum and other museums around the world. This is most definitely not a lost heritage. A major part of heritage of Cassiobury was the built landscape and the house itself but it also included the lodges and buildings from the former estate, some of which are still extant.

The former dower house to Cassiobury, which remains as Little Cassiobury, is the most significant remnant of the former estate and described as 'the best classical house in Watford'. It is now Grade II listed, and is likely to have been built in the

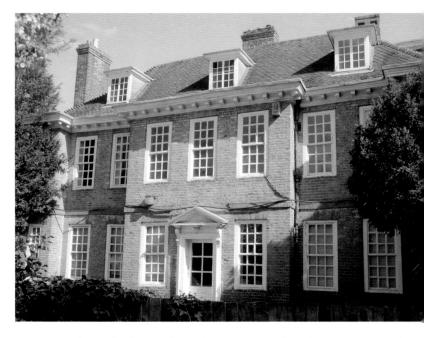

Little Cassiobury, the former dower house, is a Grade II listed building and the finest example of Cassiobury's surviving architecture.

late seventeenth century by the Earl of Essex to accommodate widowed and unmarried members of the Essex family. The residence originally consisted of the neoclassical frontage, a kitchen and an outhouse built in the vernacular style to the rear, as well as other subsidiary buildings. In 1930, the house was renovated by renowned architect Clough Williams-Ellis, and eventually sold under a compulsory purchase order to Hertfordshire County Council and used as offices until the 1980s.[4] The house and its setting are now much compromised

The former stables of Cassiobury, now the Grade II listed Cassiobury Court, © Watford Borough Council.

by the modern West Herts College, the adjacent Lanchester building and the Central Leisure Centre. With the Friends of Little Cassiobury established, one can hope for a more certain future. It is still a wonderful reminder of a once great estate.

The former stable block from the old house still remains (now called Cassiobury Court), and is found on Richmond Drive and is a Grade II listed building. It is the most substantial surviving vestige of the estate buildings relating to Cassiobury House. As an outbuilding, it survived the demolition of the

main house in 1927 and has had varied uses, including as a riding school in the 1930s. In 1951, it was partly rebuilt as an old people's home. However, it has since come into alternative use. The block has been altered in conversion. It is in red brick and castellated, flanked by three-storey blocks. The arched doorway, some arrow-slits, along with another arched doorway and battlemented carriage entry with brick buttresses all survive. Technical analysis in 2010 suggested that the historic core has much earlier origins than its national listing description would suggest, with brickwork and a roof structure indicative of an early eighteenth century date. This period is poorly documented, but the work is of the highest quality and possibly by a notable architect. The building was later extended and modified in the Gothic style by James Wyatt, from 1799, when the mansion was remodelled and other estate buildings were constructed in like style.

There has often been confusion over the identity of some of the Cassiobury cottages, due to the fact that in many cases, a lodge may have been known by two or even three different names. At the southern tip of the site, the most unusual lodge that remains though is the Grade II listed Cassiobridge Lodge (now at No. 67 Gade Avenue), described by Britton in 1837 as 'the most elaborate in execution; its whole exterior being covered, or cased with pieces of sticks of various sizes split in two.'[5] Built in Picturesque style with the original ornamental timber cladding and a prominent ornamented brick chimney stack, from here a path leads north alongside the east bank of the river into the park. The former drive extended north across the park to join the network of drives leading to the house. Grade II listed Toll Gate Cottage, also known as Ridge Lane

The picturesque, Grade II listed, Cassiobridge Lodge, with the gable end 'cased wit pieces of sticks of various sizes split in two'.

Cottage, remains (No. 235 Hempstead Road) and marks a former entrance to the park to the north, from Hempstead Road, the drive, now lost, having extended south-west to the house. However, it was not actually a toll house. Tolls were collected by the Sparrow's Herne Turnpike Trust between 1762 and 1872, at a gate in the Hempstead Road, near Ridge Lane. The locally listed Home Farm Lodge (No. 191 Hempstead Road) was also constructed in 1872 as a lodge to the Cassiobury Estate. Located on the western side of the Hempstead Road, the lodge

marked the junction with a track heading west towards Home Farm, which was the principal group of agricultural buildings on the Cassiobury Estate. Garden Lodge, also Grade II listed (No. 129 Hempstead Road) also remains, and was probably built after 1837, as it was not included in Britton's book.

Russell Farm also remains as a reminder of what Cassiobury once was. It was one of two dower houses, and at the time of their marriage in 1754, the Dowager Lady Essex moved into the dower house at Russell Farm. In 1837, Britton refers to 'The lodge, to the seat called Russell Farm has recently been erected on the road side, between Watford and Berkhamstead. The seat is occupied by General Sir Charles Colville, Bart. under the Earl of Essex.'[6] It was clad in patterns of split logs and is now known as South Lodge. Other owners of 'Russells' have included William Copeland, a former Lord Mayor of London and the owner of Spode China, as well as the Maharaja of Baroda who reputedly planted many interesting trees in the area. The building, now Grade II listed, has been converted to flats. Locally listed West Lodge, on Hempstead Road, was built in 1911 as a lodge to the Russell's Estate. Along with eastern and southern lodges, which date from 1912 and 1935, this western lodge was located at one of the principal gateways to the estate grounds. Number 139 Ridge Lane was built a year later, and is also a remaining lodge to the Russell estate.

A row of rather quaint but architecturally interesting houses are found at Nos 195–199 Rickmansworth Road. This terrace of houses was built in 1890 on land close to Cassiobridge Farm. The date plaque on the front of the building features a motif that is associated with the Earl of Essex, which suggests that the houses were built by his estate.

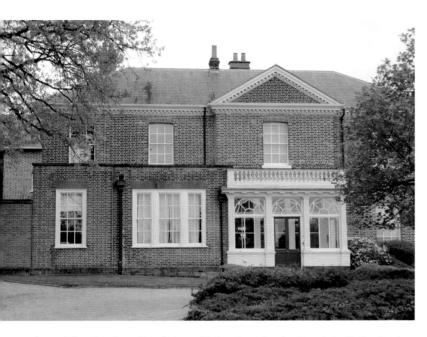

Above: The Grade II listed Russell's in Greenbanks Road, built in the late eighteenth century as a dower house, for the mother and unmarried sisters of the Earl of Essex. Later it was the residence of the Maharaja of Baroda, and now converted into flats.

Right: Ridge Lane Cottage (No. 235 Hempstead Road), the Grade II listed former entrance to the park from the north.

Above left: Grade II listed Garden Lodge (No. 129 Hempstead Road).

Above right: Home Farm Lodge (now No. 191 Hempstead Road), which marked the junction with a track heading west towards Home Farm.

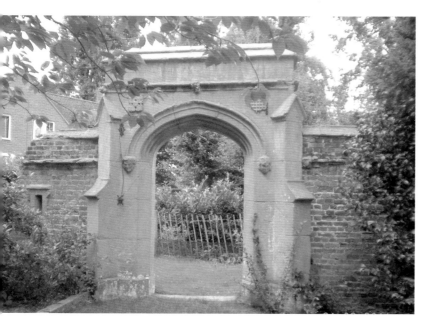

Above: A Grade II listed gateway and walls survive, © Watford Borough Council.

Right: The former icehouse, in a back garden on the Cassiobury Estate, © Watford Borough Council.

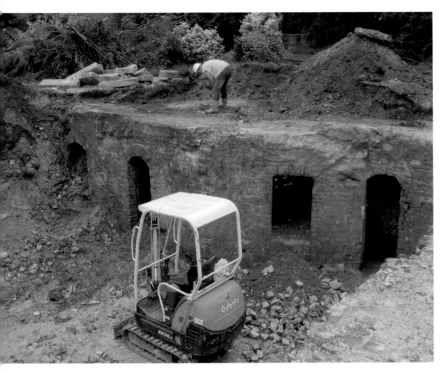

Above left: Cassiobury House cellars uncovered, during building work in recent years, © Watford Borough Council.

Above right: The remains of the mill in 2014.

To the rear of many of the gardens on the Cassiobury Estate, a number of features remain. Ranging from small sections of wall, architectural features to a now locally listed icehouse from the former Cassiobury House, which remains at the back of a property in Cottage Drive. The icehouse would have been filled with ice and used for keeping drinks and foodstuffs chilled throughout the year. With a modern entrance to a narrow brick corridor, it leads to a domed room, of brick. It was built around 1800, and it is set into an earth bank. In the centre of the wooden floor is an opening where the original trap door would have been. Below the floor is another chamber. At the rear of Capel House is a brick cellar with a vaulted ceiling. Originally part of Cassiobury House, it was used as an air raid shelter in the Second World War. More cellars remaining from Cassiobury House are in the same rear garden, with further cellars in neighbouring gardens, as when the house was demolished, many of the cellars were not filled in. Many of these cellars would have originally been located close to the main kitchens, and used for storing food and wine.

Other remnants are less well known, but are numerous throughout Watford. These include a gateway and attached wall, from the old estate and now in a back garden on the Cassiobury estate.

Building materials from Cassiobury were certainly reused elsewhere. It is thought that the chimney stacks and brickwork on Monmouth Place, on the High Street, are reputedly from Cassiobury House. There are numerous suggestions of garden features, chimneys or architectural features around the Cassiobury estate – although not all of these may be original.

Nevertheless, it is at St Mary's church, the Grade I listed parish church, and the Essex chapel, the mortuary chapel of the Earls of Essex, that remains and provides an insight into the lives of both the Morisons and Capels. It was built on the site of the original sacristy or vestry by Bridget, widow of Sir Richard Morison, and Francis, the 2nd Earl of Bedford in 1595. The two Morison monuments in the Essex Chapel were built by the celebrated sculptor Nicholas Stone who agreed in a very specific contract, dated '3rd day of March, 1628' with Dame Mary Morison 'of Kashbury' to undertake the work. An 1880 description of the church applies with barely a few exceptions now.

> This church is deservedly celebrated for the number and splendour of its monuments, especially those in the mortuary chapel of the Morison and Essex families, in which is a grand old tomb of the memory of Sir Charles Morison, Knight of Cashiobury, who died in March 1599, aged 51. At each end of the tomb is a figure kneeling which represent his son and daughter … On the opposite side is another monument to Sir Charles Morison, Bart. (son of the above), who died in August, 1628, aged 41, and to his wife also … in the middle of the chapel are two large table monuments; the one to the east is to the memory of Bridget, Dowager Countess of Beford, who died in 1600, aged 75 … the other large central monument on the west side, is to the Lady Dame Elizabeth Russell, the wife of William Lord Russell … she died in June, 1611, aged 43 … Among other memorials to the Capel family in the chapel, is a mural monument to the memory of George, 5th Earl of Essex, who died 23 April 1839, in his 81st year … Another tablet is to Harriet, the daughter of George, fifth Earl of Essex, who died 14 May 1837, aged 29.

The visitor today would notice that the monuments in the middle of the Essex chapel are no longer there. Those to the

Dowager Countess of Bedford and Lady Elizabeth Russell made their final journeys to the Bedford family chapel at Chenies, Buckinghamshire, in 1907. After the removal of the founder's tomb, the chapel remained derelict until it was restored in 1916 by Adèle, Dowager Countess of Essex, in memory of her husband, the seventh earl. Several other Capel graves are also to be found in West Watford's Vicarage Road cemetery.

Further evidence of the importance and influence of the Morison family can still be found even closer, and still in the historic centre of Watford. Richard Morison's wife, Bridget, went on to remarry twice, to the Earl of Rutland and Earl of Bedford. In 1580, she established the Bedford Almshouses, charitable accommodation for eight poor women from the local area. This characterful Grade II listed Tudor building still maintains its original function, as almshouses run by a charitable organisation for eight older people of limited income.

Any further exploration of Cassiobury heritage should begin at Watford Museum, where Cassiobury has been researched for over thirty years, and where can be found a world renowned collection of Cassiobury art. Highlights include oil portraits donated by Lady Essex in 1989, and watercolours by J. M. W. Turner, Thomas Girtin and the 6th Earl of Essex. The most significant addition to the collection was the purchase in 2002 of 'A View of Cassiobury Park' by John Wootton. The significance and scale of Cassiobury's heritage is world acclaimed and can be estimated in the representation in so many museum collections in the UK and USA. These include The National Portrait Gallery, The V&A Museum, The British Museum, Tate, Courtauld, The Metropolitan Museum of Art in New York, The Museum of Fine Arts in Boston and the Philadelphia Museum of Art.

But what of the Capels today? The 8th Earl who sold off Cassiobury was Algernon George de Vere Capell, who was born on 21 February 1884. He was the son of George Devereux de Vere Capell, the 7th Earl of Essex and Ellenor Harriet Maria Hartford. Algernon married, firstly, Mary Eveline Stewart Freeman, daughter of William Russell Stewart Freeman, in 1905. He and Mary Eveline were divorced in 1926. He married, secondly, Alys Montgomery Falkiner, daughter of Robert Hayes Falkiner, in 1926. He and Alys were divorced in 1950. He then married Mildred Carlson of Los Angeles, California, in December 1950. He and Mildred were also divorced in 1956 and he married, fourthly, Christine Mary Davis, daughter of George Frederick Davis, in 1957. He died on 8 December 1966, aged eighty-two. Algernon was educated at Eton College, and later gained the rank of lieutenant in the service of the 7th Hussars. He gained the rank of lieutenant in the service of the Hertfordshire Imperial Yeomanry and also gained the rank of temporary captain in the service of the Remount Service. On 25 September 1916, he succeeded to the title of the 8th Earl of Essex. He had a son with his first wife, Reginald George de Vere Capell, who was born in 1906, and became the 9th Earl of Essex.

Reginald had the title Viscount Malden. He was educated at St Cyprian's School, Eastbourne, Eton and Magdalene College, Cambridge. He served in the army during the Second World War and was awarded the Territorial Direction Medal for long service. In 1947, he became Lt-Col., and was commanding officer of the 16th Airborne Division Signals Regiment (Territorial Army) in 1948. After the war, he began farming in Buckinghamshire. He retained his military connections and became Honorary

Colonel of the 16th and 40th Signal Regiments in 1957 and, on its replacement, of the 47th Signal Regiment in 1962. In 1966, Reggie inherited the Earldom of Essex on the death of his father, and took his seat in the House of Lords. In his maiden speech in 1971, he opposed the recommendation of the Roskill Commission for the siting of a third London airport at Cublington in Oxfordshire. The third airport was eventually provided by the development of Stansted Airport. On his death in 1981, the title became dormant, but it was revived eight years later by a distant cousin Robert Capell. Capell married, firstly, Mary Reeve Ward, daughter of F. Gibson Ward, on 2 March 1937. They were divorced in 1957. His second wife was Nona Isabel Miller (1906–97), daughter of David Wilson Miller, whom he married in November 1957. He had no children by either marriage.

It was ultimately Robert Edward de Vere Capell, who became the 10th Earl of Essex. Robert was born in 1920, the son of Arthur de Vere Capell and Alice Capell née Currie. His father died when he was three. He spent some time in an orphanage, where he was bewildered when the head told him he would be the Earl of Essex someday. This interest was revived when many years later he received a newspaper clipping from a friend, saying that the heir to the Earls of Essex may be an American, Bladen Horace Capell. This led to an exhaustive search by de Vere Capell with much correspondence with many distant and formerly unknown relatives. Eventually, he managed to prove that his great-grandfather Algernon Capell was the elder brother of Bladen's great-great-grandfather Adolphus Capell. Robert Capell married Doris Margaret Tomlinson, daughter of George Frederick Tomlinson, in 1942 and they had one child,

Paul, who would later become the 11th Earl of Essex. When the ninth earl died in 1981, it took eight years for Robert to be permitted to take his seat in the House of Lords, a seat which he lost due to the House of Lords Act 1999. He died in 2005, and was succeeded as Earl of Essex by his son Paul.

Born to Robert Capell and his wife, Doris, the current Lord Essex began his life as Frederick Paul de Vere Capell. His father having proved that he was the heir to the earldom in 1989, Paul became entitled to call himself Viscount Malden. However, few people at Skerton County Primary School in Lancashire, where he was deputy headmaster, knew of his aristocratic status. He has since retired. Lord Essex has also never married and has no children. If he dies without a legitimate son, the earldom will pass to William Jennings Capell, his fourth cousin once removed. William's father, Bladen Horace, was a strong claimant to the heirship of the earldom, before the 10th Earl proved his superior claim.

William Jennings Capell, now Viscount Malden, (born 9 August 1952), is a retired grocery clerk from Yuba City, California, and is the heir presumptive to the Earldom of Essex and could be the twelfth earl. He had considered renouncing the earldom if it would require him to give up his United States citizenship (Under the United Kingdom's Peerage Act 1963, a person may disclaim a hereditary peerage.) United States law requires only government officeholders without Congressional authorization and persons wishing to become naturalized citizens, however, to renounce titles of nobility. As Mr Capell is in neither category, there would be no legal impediment to his use of the title as a US citizen. On becoming Viscount Malden, he visited Watford with his family, who all continue to delight in the history of Cassiobury.

William Jennings Capell, Viscount Malden,
and family, 2014, © William Jennings Capell.

Interior view of the monumental chapel in Watford church, from *History of Cassiobury* by John Britton, © Watford Museum.

Crest of the 5th Earl of Essex, from *History of Cassiobury* by John Britton, © Watford Museum.

Yet there is a distinct irony to the existence of Cassiobury Park – over 100 years ago, local people did not want it. As referred to previously, there was a majority of nearly 3,000 who voted in the poll of September 1908, against the purchase of the land from the developers Ashby and Brightman. Yet in 2014, many visitors pass through the park annually to either take in the peace and quiet, to simply exercise, or to holiday in the park every summer by the pools. Others prefer the wilderness of Whippendell Wood, or the engineered ambience of the Grand Union Canal. Whatever the reason for the visit, such numbers of visitors impact on the day to day management, maintenance and sustainability of Cassiobury Park. The irony is greater reinforced in that the park now has one of the largest and most active Friends Groups in the country. In 1973, the Friends of Cassiobury Park were formed following concern that some proposals for development in the park were inappropriate, given the historical significance and landscape character of the park. They now have over 250 members. The Friends are still active in assisting Watford Borough Council to maintain and improve Cassiobury Park. Yet Cassiobury means many things to many people, and its place at the heart of Watford's heritage isn't limited to earls or the great house. Former Watford Football Club manager Graham Taylor remembers Cassiobury Park as a place of happy memories. In 1977, when he arrived as an ambitious young manager at Watford, he soon realised it was more than just a place to walk his dogs. Watford had no training ground in his early years with the club, so Cassiobury Park and Whippendell Wood were used for players' training. Graham Taylor's cross country training for players there has become a much-told anecdote by players of the time including

John Barnes. Graham describes it as '2½ miles of fun', but he didn't trust the players not to attempt to take short cuts. Occasionally, he and two or three colleagues would position themselves hidden in trees at points along the route, where temptation might strike. Taylor remembers, 'If they attempted to cut a corner or miss out the hill a voice from nowhere would boom out at them to go back and do it again'.

But today it is the former Home Park and High Park which are now so loved and valued by Watford residents. Watford's jewel is Cassiobury Park. As Moses Cook quoted in 1676, 'what noble Essex did on us bestow, for we our very being owe to him'. Cassiobury remains as 'the ancient seat of the Earls of Essex'

Opposite left: Ian Bolton, 1977–78 photograph. Watford Football Club used Cassiobury Park as a training round in the 1970s, and as a location for official club photographs, © Alan Cozzi.

Right: View from a north-east angle, drawn by H. Edridge, engraved by J. Hill, from *History of Cassiobury* by John Britton, © Watford Museum.

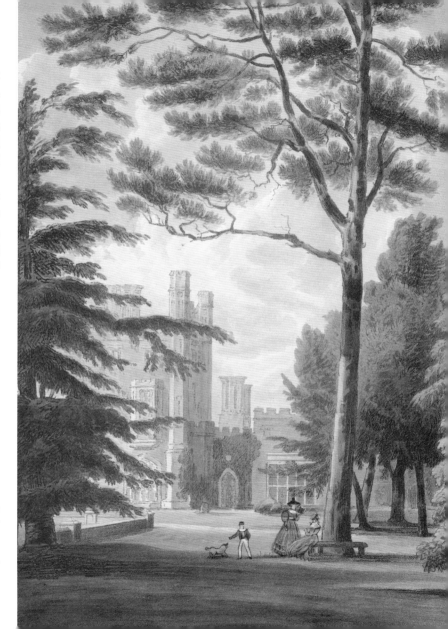

ENDNOTES

INTRODUCTION

1. Giles Worsley, *England's Lost Houses; From the Archives of Country Life* (Aurum Press Ltd, London, 2011)
2. John Martin Robinson, *Felling the Ancient Oaks; How England Lost its Great Country Estates* (Aurum History, London, 2011)
3. *Ibid.*
4. Paul Rabbitts; *Richmond Park; From Medieval Pasture to Royal Park* (Amberley Publishing, Stroud, 2014)
5. John Martin Robinson, *Felling the Ancient Oaks; How England Lost its Great Country Estates* (Aurum History, London, 2011)
6. J. Norden, *A Description of Hertfordshire* (Ware, 1598, reprinted 1903)
7. Anne Rowe, *Medieval Parks of Hertfordshire* (Hertfordshire Publications, 2009)
8. John Martin Robinson, *Felling the Ancient Oaks; How England Lost its Great Country Estates* (Aurum History, London, 2011)
9. *Ibid.*

THE MORISONS OF CASSIOBURY

1. William Camden, *Britannia*, 1586 (transcribed from Poole 1985, p. 42)
2. Llewellyn Jewitt & Samuel Carter Hall, *Stately Homes of England*, (Volume 2, 1874, pp. 308–21)
3. Helen Poole, *A Fair & Large House Cassiobury Park 1546–1927* (Watford Museum, 1985)
4. Ibid.
5. John T. Smith, '*English Houses 1200–1800; The Hertfordshire Evidence*' (RCHME, 1992)
6. *The Victoria History of the Counties of England; A History of the County of Hertford*, (Vol. II, 1908 pp. 453-54)
7. Nathaniel Salmon, *The History of Hertfordshire* (1728)
8. *The Victoria History of the Counties of England; A History of the County of Hertford* (Vol. II, 1908, pp. 453–54)
9. G. M. Trevelyan, *English Social History* (Longman Green, 1942)
10. William Shakespeare, *Richard II*, Act III, Scene 2
11. A. Boorde, *Advice on Building a House*, F. J. Furnivall, (ed.) Introduction and Dietary (EETS, X, 1870, pp. 232–42)

CASSIOBURY AND THE CAPELS

1. *The Victoria History of the Counties of England; A History of the County of Hertford* (Vol. II, 1908, pp. 453–54)

2. *Ibid.*

3. Daniel Defoe, *A Tour Through the Island of Great Britain* (4th edition, London, 1748, Vol. 2)

4. HRO 6542 Particulars of Manor of Cassiobury

5. Moses Cook, *The Manner of Raising, Ordering, and Improving Forrest Trees* (1676)

6. *Ibid.*

7. *Ibid.*

8. *Ibid.*

9. Guy de la Bedoyere (ed.), *The Diary of John Evelyn* (Bangor, 1994, pp. 265–66)

10. *Ibid.*

11. *Ibid.*

12. *Ibid.*

13. William Andrews, *Bygone Hertfordshire* (Wakefield, 1969, first published 1898)

14. Ray Desmond, *Dictionary of British and Irish Botanists and Horticulturalists* (London, 2nd edition, 1994)

15. D. Walker, *General View of the Agriculture of Hertfordshire* (1795)

16. Journals of Visits to Country Seats (Walpole Society, XVI, 1927–28, p. 37)

17. Prince Herman Puckler-Muskau, *Tour in Germany, Holland and England in the years 1826, 1827, 1828* (1832, pp. 195)

18. Rayn Desmond, *Dictionary of British and Irish Botanists and Horticulturalists* (London, 2nd Edition, 1994)

19. William Wrighte, *Grotesque Architecture* (1767, Bodleian Vet. A5.d. 566)

20. Ray Desmond, *Dictionary of British and Irish Botanists and Horticulturalists* (London, 2nd Edition, 1994)

21. REC. Acc. (1767–68)

22. *Ibid.*

23. John Hassell, *Tour of the Grand Junction*, (London, 1819, p. 19)

24. D. Walker, *General View of the Agriculture of Hertfordshire* (1795)

25. John Hassell, *Tour of the Grand Junction* (London, 1819, pp. 22–23)

26. Paul Rabbitts, *Regent's Park; From Tudor Hunting Ground to the Present* (Amberley, Publishing, Stroud, 2013)

27. Daniel Carless Web, *Observations and Remarks during Four Excursions made to various parts of Great Britain in the Years 1810 and 1811* (4 vols, London, 1812)

28. REC. Survey 1798; H. R. O. D/EX 736/E2 Survey and Valuation by Kent, Claridge and Pearce (1798)

29. James Grieg (ed.), *The Farington Diary* (Hutchinson, London, 1923, Volumes 4, 5 and 7)

30. Robert Havell, *A series of picturesque views of noblemen's and gentlemen's seats with historical and descriptive accounts of each subject* (1823)

31. John Martin Robinson, *James Wyatt; Architect to George III* (Yale University Press, 2011)

32. N. Pevsner & B. Cherry, *Hertfordshire* (2nd edition 1977)

33. John Britton, *The History and Description with Graphic Illustrations of Cassiobury Park, Hertfordshire: The Seat of the Earl of Essex* (London, 1837)

34. *Ibid.*

35. John Hassell, *Tour of the Grand Junction* (London, 1819, pp. 18–19)

36. *Ibid.*

37. Humphry Repton, *Report concerning Montreal in Kent, a seat of the Right Honourable Lord Amherst by H. Repton 1812*

38. Dorothy Stroud, *Humphry Repton* (1962)

39. *Gardeners Magazine*, (1828, part 2, Vol. 4)

40. Patrick Connors, *The Chinese Garden in Regency England* (Garden History, 14/1, 1986)

41. Robert Havell, *A series of picturesque views of noblemen's and gentlemen's seats with historical and descriptive accounts of each subject* (1823)

42. John Gore, *The Creevey Papers* (1963, reprinted The Folio Society, 1970)

43. Humphry Repton, *Memoir*, British Library Add. 62112

44. Robert Havell, *A series of picturesque views of noblemen's and gentlemen's seats with historical and descriptive accounts of each subject* (1823)

45. Prince Herman Puckler-Muskau; *Tour in Germany, Holland and England in the years 1826, 1827, 1828* (1832, pp. 194–202)

46. Ray Desmond, *Dictionary of British and Irish Botanists and Horticulturalists* (London, 2nd Edition, 1994)

47. William Sawrey Gilpin, *Practical Hints upon Landscape Gardening* (Cadell, 1832)

48. John Britton, *The History and Description with Graphic Illustrations of Cassiobury Park, Hertfordshire: The Seat of the Earl of Essex* (London, 1837)

49. *Ibid.*

50. John Hassell, *Tour of the Grand Junction* (London, 1819, pp. 18–25)

51. *Ibid.*

52. Michael Baxter Brown, *Richmond Park; The History of a Royal Deer Park* (Hale, 1985)

53. Anon, *Ancient Hertfordshire* (Gerish Coll., HRO, 1880)

54. W. Kennard Head, article in the *Observer* (24 October 1975)

55. *The London Journal* (21 November 1846)

56. James Grieg (ed.) *The Farington Diary* (Hutchinson, London, 1923, Volumes 4, 5 and 7)

57. HRO 8742/24,34 Accounts of George Bennett, Gamekeeper, Jan–Oct 1770

58. Michael Baxter Brown, *Richmond Park; The History of a Royal Deer Park* (Hale, 1985)

59. *The Illustrated London News* (24 October 1846)

60. *Gardener's Chronicle* (29 May 1886)

61. *Country Life* (Vol. 28, 17 September 1910)

62. James Thorne, *Handbook to the Environs of London* (1876)

63. *The Illustrated London News* (12 September 1846)

64. David Setford, 'Earl Arthur was ecologically sound', *Watford & West Herts Review* (5 September 1985)

65. Marian Strachan, *A Victorian Teenager's Diary; The Diary of Lady Adela Capel of Cassiobury 1841–184* (Hertfordshire Record Society, 2006)

66. David Setford, 'Earl Arthur was ecologically sound', *Watford & West Herts Review* (5 September 1985)

67. Helen Poole, *A Fair & Large House Cassiobury Park 1546–1927* (Watford Museum, 1985)

68. *The Book of Watford*, a compilation volume of newspaper extracts and illustrations (published in 1987, pp. 154–55)

69. Helen Poole, *A Fair & Large House Cassiobury Park 1546–1927* (Watford Museum, 1985)

70. Alice Herring, *My Memories of Cassiobury*, courtesy of the 11th Earl of Essex (unpublished)

71. Oliver Phillips, 'Homes were once lodges to Cassiobury House', *Watford Observer* (20 March 1998)

72. John Martin Robinson, *Felling the Ancient Oaks; How England Lost its Great Country Estates* (Aurum History, London, 2011)

73. Stephen Switzer, *The Nobelman, Gentleman and Gardener's Recreation, or Ichnographia Rustica* (1715, p. 62)

FROM COUNTRY ESTATE TO PUBLIC PARK

1. G. T. Clark, *Report to the General Board on a Preliminary Inquiry into the Sewerage, Drainage and Supply of Water, and the Sanitary Conditions of the Inhabitants of the Town of Watford* (1848)
2. J. Pigot, *Directory of Hertfordshire* (London, 1839)
3. F. M. L. Thompson, *English Landed Society in the Nineteenth Century* (London, 1963)
4. Robert Bard, *Watford Past*, Historical Publications (London, 2005)
5. Minutes, Council Meeting in Committee, Watford Urban District Council, 14 July 1908
6. Minutes, Council Meeting in Committee, Watford Urban District Council, 21 June 1910
7. Minutes, Council Meeting in Committee, Watford Urban District Council, 3 May 1910
8. Minutes, Council Meeting in Committee, Watford Urban District Council, 6 July 1909
9. Cassiobury Park, Watford; Outline Conservation Statement, LDA Design, 2011
10. Paul Rabbitts, *Bandstands of Britain* (The History Press, Stroud, 2014)
11. *Watford Observer* (September 1983)

CASSIOBURY TODAY

1. Cassiobury Park – Stage 2 Conservation Management Plan, Land Use Consultants (2014)
2. Raymond Desmond, *A Wood in Watford – Wildlife of Whippendell Wood, Secrets of its Natural History* (1985)
3. http://www.sssi.naturalengland.org.uk/special/sssi/unitlist.cfm?sssi_id=1002543
4. Historic Building Recording: Little Cassiobury, Archaeological Services & Consultancy Ltd (February 2008)
5. John Britton, *The History and Description with Graphic Illustrations of Cassiobury Park, Hertfordshire: The Seat of the Earl of Essex* (London, 1837)
6. *Ibid.*

BIBLIOGRAPHY

Andrews, William, *Bygone Hertfordshire*, Wakefield, 1969, first published 1898

Bard, Robert, *Watford Past*, Historical Publications (London, 2005)

Britton, John, *The History and Description with Graphic Illustrations of Cassiobury Park, Hertfordshire: The Seat of the Earl of Essex* (London, 1837)

Carless Webb, Daniel, *Observations and Remarks during Four Excursions made to various parts of Great Britain in the Years 1810 and 1811* (4 vols, London, 1812)

Cook, Moses, *The Manner of raising, ordering, and improving Forrest trees* (1676)

Defoe, Daniel, *A Tour through the island of Great Britain* (4th edition, London, Vol. 2, 1748)

Desmond, Ray, *Dictionary of British and Irish Botanists and Horticulturalists* (London, 2nd edition, 1994)

Grieg, James (ed.) *The Farington Diary* (Hutchinson, London, 1923)

Hassell, John, *Tour of the Grand Junction* (London, 1819)

Havell, Robert, *A series of picturesque views of noblemen's and gentlemen's seats with historical and descriptive accounts of each subject* (1823)

Jewitt, Llewellyn and Carter Hall, Samuel, *Stately Homes of England* (1874, Vol. 2)

Norden, J, *A Description of Hertfordshire* (Ware, 1598, reprinted 1903)

Penrose, Raymond, *A Wood in Watford – Wildlife of Whippendell Wood, Secrets of its Natural History*, (1985)

Pevsner, N. & B. Cherry; *Hertfordshire*, (2nd edition, 1977)

Pigot J, *Directory of Hertfordshire* (London, 1839)

Poole, Helen, *A Fair & Large House Cassiobury Park 1546–1927* (Watford Museum, 1985)

Rabbitts, Paul, *Bandstands of Britain* (The History Press, Stroud, 2014)

Robinson, John Martin, *Felling the Ancient Oaks, How England Lost its Great Country Estates* (Aurum History, London, 2011)

Robinson, John Martin, *James Wyatt – Architect to George III* (Yale University Press, 2011)

Rowe, Anne, *Medieval Parks of Hertfordshire* (Hertfordshire Publications, 2009)

Salmon, Nathaniel, *The History of Hertfordshire* (1728)

Strachan, Marian, *A Victorian Teenager's Diary – The Diary of Lady Adela Capel of Cassiobury 1841–1842* (Hertfordshire Record Society, 2006)

Stroud, Dorothy, *Humphry Repton* (1962)

Thompson, F. M. L., *English Landed Society in the Nineteenth Century* (London, 1963)

Thorne, James, *Handbook to the Environs of London* (1876)

Trevelyan, G. M., *English Social History* (Longman Green, 1942)

Victoria History of the Counties of England, *A History of the County of Hertford, 1908* (Vol. II)

Walker, D., *General View of the Agriculture of Hertfordshire* (1795)

Williamson, Tom, *The Parks and Gardens of West Hertfordshire* (The Hertfordshire Gardens Trust, 2000)

Worsley, Giles, *England's Lost Houses – From the Archives of Country Life* (Aurum Press Ltd, London, 2011)

Pictured above are the authors, Sarah Kerenza Priestley and Paul Rabbitts.

List of Photo Credits (Not in Order)

Watford Museum, Watford Borough Council, National Portrait Gallery, London, Private Collection, Ben Howard, Justin Webber, Debbie Brady, Paul Rabbitts, Sarah Kerenza Priestley, William Jennings Capell, Hertfordshire Archives and Local Studies, Watford Central Library, Watford Observer, Alan Cozzi, English Heritage (Aerofilms Collection), TfL from the London Transport Museum collection, The Samuel Courtauld Trust, The Courtauld Gallery, London, Tate, London 2014.

Supported by Watford Borough Council.